MASTERPIECES
OF THE TWENTIETH CENTURY

Sponsored by **THE PRESIDENT'S COUNCIL**
OF THE ART GALLERY OF NEW SOUTH WALES

Supported by **PRO HELVETIA** ARTS COUNCIL OF SWITZERLAND

THE **BEYELER** COLLECTION

THE ART GALLERY OF NEW SOUTH WALES
7 December 1996 to 2 March 1997

Published by
The Art Gallery of New South Wales
© The Art Gallery of New South
Wales

National Library of Australia
Cataloguing-in-publication data:
Masterpieces of the
twentieth century
Bibliography
ISBN 0 7310 9480 8

1. Galerie Beyeler–Exhibitions
2. Art, Modern–20th century–
Exhibitions
3. Art–Private collections–Exhibitions
I. Art Gallery of New South Wales
709.040074

Editors
Ewen McDonald and Karen Regan
Design
Analiese Cairis, ACD
Production
The Design Department,
The Art Gallery of New South Wales
Printing organised by
Mandarin Offset, Hong Kong

Catalogue contributors
Reinhold Hohl
Anthony Bond **T.B.**
Caroline Butler-Bowdon **C.B.B.**
Ursula Prunster **U.P.**
Wayne Tunnicliffe **W.T.**

Distribution
The Art Gallery of New South Wales
Art Gallery Road The Domain
Sydney NSW 2000 Australia

Exhibition dates
7 December 1996–23 February 1997
The Art Gallery of New South Wales
Sydney

Cover detail
Fernand Léger
Leaves and fruits 1927
Feuilles et fruits
oil on canvas 65 x 54 cm

PRESIDENT'S COUNCIL

The role of the corporate community in fostering the great public galleries of the world has always been a critical one. The establishment of the President's Council is an initiative which furthers this tradition at The Art Gallery of New South Wales in a most vital and energetic manner. Established in 1995, the Council is a partnership of a select group of chief executives from major corporations dedicated to providing continued support to the Gallery's ambitions and inspired programmes.

Masterpieces of the Twentieth Century, The Beyeler Collection provides a fitting opportunity for the President's Council's inaugural sponsorship of exhibitions at the Gallery. This extraordinary collection of Western masterpieces is arguably the finest of its kind in private hands, and offers Australian audiences a rare opportunity to view a perfect summary of modern art. Beginning with Monet and Cézanne and continuing with Picasso and Matisse, Giacometti and Bacon, the exhibition reveals the potent progression of twentieth-century art.

On behalf of the member's of the President's Council I wish to thank our Director, Edmund Capon, for enabling, yet again, such an outstanding event to be presented by The Art Gallery of New South Wales. Our particular thanks to Ernst and Hildy Beyeler, and the Beyeler Foundation, for allowing this remarkable collection to be shared by Australian audiences.

FRANK LOWY AO

President Board of Trustees
Chairman President's Council

DIRECTOR'S FOREWORD

Whilst many of the great fine art museums around the world boast collections that have their foundations in the diverse riches of private collections, it is a rare occurrence that a single private collection is of such strength, quality and artistic resource that it alone forms a museum collection. However, that is the case with the Beyeler Collection. Here is an assembly of works of painting and sculpture formed over a period of forty years, during which time Beyeler the dealer has been and remains a potent influence in the art world. It is the most perfect, if private and succinct, summary of the progression of twentieth-century Western art from the dawn of the modern that was heralded by the Impressionists to the present day.

It is a collection that has been guided by two principles: the singular eye of Ernst Beyeler and the history of the progression of twentieth-century art as determined by the outstanding masters of the century. Whilst the latter principle has guided the evolution of collections around the world, it is Beyeler's eye that gives this collection both its homogeneity and its strong sense of personality. However objective a collector may seek to be in acquiring works of art the private aesthetic is bound to be revealed; it is here, in the individuality of the works of art and in the concentration on certain artists, such as Picasso, Léger, Klee and Giacometti, that the critical quality of taste, conditioned of course by profound knowledge, harmonises this magisterial display of twentieth-century masterpieces. Beyeler's personality is revealed too in the concentration on certain artists. Even in the encyclopaedic display of Masterpieces from the Guggenheim held at the Gallery in 1991–2 we did not see such a perfect demonstration of Léger's progress from the lyrical post-Cubist works of around 1912 to the more dramatic and mechanically structured works of the thirties; and Paul Klee, an artist not often seen in Australia, takes his place in the history of art in the Beyeler Collection with his graphic, but mysterious, images of fantasy.

In a variant form, which included a greater range of more contemporary works, this selection of the heart of the Beyeler Collection has been shown in Madrid, at the Reina Sofia, and in Berlin, at the National Gallery. The Art Gallery of New South Wales is the third and final venue, for in the middle of 1997 the new Beyeler Foundation Museum designed by Renzo Piano, currently in the final phase of construction on the outskirts of Basel, will open. We are delighted and privileged to bring such an exhibition to Australia. We are immensely grateful to Ernst and Hildy Beyeler and the Beyeler Foundation for their co-operation, and to the gallery staff, particularly Claudia Neugebauer and Pascale Zoller, who have overseen so much of the adminstrative work.

This is the first exhibition to be sponsored by the President's Council of The Art Gallery of New South Wales. Established some twelve months ago the Council is an association between the Board of Trustees of the Gallery and select members of the business community which seeks, through regular contributions, to sponsor and thus make possible exhibitions in this Gallery's critical and active programme. It would be hard to think of a more illustrious and rewarding manner in which to launch this crucial initiative. For her work and tenacity in establishing the President's Council, I would like to pay tribute to Margot Capp without whom it simply would not have happened. My thanks also to the President and the Board of Trustees for their unstinting support and co-operation and, above all, to the members of the corporate community who have joined the Council, paid their dues, and made it all possible.

EDMUND CAPON AM
Director The Art Gallery of New South Wales

THE BEYELER COLLECTION

AN INTRODUCTION REINHOLD HOHL

The Beyeler Collection is a product of uncommon circumstances combined with remarkable expertise; a blend of Ernst Beyeler's intimate knowledge of the art world, his personal acquaintance with artists, and his professional success as both collector and art dealer.

The Beyeler Gallery is one of the most influential and important forces in the market of nineteenth and twentieth-century art—a status confirmed by the great number of solo and thematic exhibitions organised by the gallery over the decades. These exhibitions often incorporated loans from other private and public collections—a situation made possible because of Beyeler's own generous loans to other exhibitions and museums. Indeed, although an exhibition of the important paintings and sculptures sold by the Beyeler Gallery over the last forty years would be an exemplary representation of twentieth-century art history—including as well, several major works from the late nineteenth century—the character of the collection and the present exhibition is quite different. Distinctly personal and complete within itself, the selection for **Masterpieces of the Twentieth Century, The Beyeler Collection** at The Art Gallery of New South Wales is an independent creation. Further, in selecting for a particular exhibition, the uniqueness of each work to be included is the key—a factor that epitomises Beyeler's collecting.

Initially Ernst and Hildy Beyeler collected small and medium-sized paintings, sculptures and drawings—works appropriate for a private house. However, despite their size, distinguished pieces were acquired, such as Cézanne's *Seven bathers*, c. 1900, Picasso's *Woman (period of Demoiselles d'Avignon)*, 1907, and Giacometti's *Walking man in the rain*, 1948. But as larger and more extraordinary paintings and sculptures were added, the Beyelers began thinking about a more apt "home", a museum for their expanding collection. The transition from a private collection to one of public interest happened in 1982 with the establishment of the Beyeler Foundation (Beyeler-Stiftung), which has been holder of the Beyeler Collection (Sammlung Beyeler) ever since. They recognised that eventually art cognoscenti from all over the world would want to see their collection, which by then included such unique works as Rousseau's *The hungry lion*, 1905, Monet's magnificent *Waterlilies* triptych painted between 1917–20, and Giacometti's figural group originally commissioned in 1958 and intended for the Chase Manhattan Plaza in New York City. These examples alone tell of a determination to maintain exacting standards. Beyeler's acquisition policy has focused on works by outstanding twentieth-century artists, a major work in some instances, but often several works from differing periods in order to do justice to an artist's contribution. It is intended to be a lasting testimony of personal expertise rather than a testimony of acquired

possessions. Acquisitions made for the Beyeler Foundation (Beyeler-Stiftung) reflect the ability to recognize those art works that best embody the artist's creative performance.

In private as in business, Ernst Beyeler has developed a reputation for being alert and open to challenges; he is an attentive observer and listener, a fast and penetrating thinker. Not surprisingly, he prefers powerful, often 'difficult' pieces, art that is not easily accommodated, works that demand concentration and challenge the viewer. In this sense they transcend the private house—ostentatious display has never been the intent, for Beyeler's statement is one based on a particular and unique connoisseurship.

The collection has been guided by stringent principles, exemplified by the selection of works by Paul Klee. Although he had bought and sold entire Klee collections, Beyeler preferred for himself, a few distinct works for personal inspiration. In this sense, and despite its focus on twentieth-century art, the collection was never intended to be a panorama of art history—more a precise focus on outstanding achievements. While not all collectors would subscribe to Beyeler's philosophy, all would unhesitantly acknowledge his insistence on exceptional quality. With all acquisitions Beyeler's irrevocable standard is applied; works must epitomise the phrase "Sonderklasse".

Sonderklasse

Sonderklasse, incidently was the term that Paul Klee used to indicate those works in his own catalogue with which he did not want to part. The label (meaning "Special Class") may well be applied to Beyeler's purchase of Kandinsky's *Improvisation 10*, 1910. Indeed each acquisition in this collection has its particular story, but the events associated with *Improvisation 10* are certainly noteworthy. It was this painting that converted Ernst Beyeler, the young gallery owner, into a dedicated collector and further, the young collector into an important art dealer. And ultimately, it is Beyeler's tenacity as a dealer that has made him a great collector.

Before the Second World War *Improvisation 10* initially belonged two renowned German private collections (Kluxen and Küppers). It was subsequently displayed at the Provinzmuseum in Hanover where it was confiscated in 1937 to be exposed to public ridicule at the Entartete Kunst (Degenerate Art) exhibition in Munich. Afterwards the painting was sold to the art dealer Ferdinand Möller from Dresden. It survived the war in a zinc container in Möller's back garden in Berlin. At the end of the war Möller considered it wise to transport his treasure—which also included works from German Expressionists—to West Germany. (He dug up the container at night and started his journey in the early morning hours.) The journey ended in Cologne where Möller resumed his work as an art dealer, operating from a scanty attic flat. The twenty-seven year-old Beyeler visited him there in 1948. Three years earlier Beyeler had taken over an antiquarian bookshop in the old part of Basel, and by now he had transformed it into an art gallery. The place and address are still the same: Bäumleingasse 9. Möller pulled out the abstract Kandinsky from behind a cupboard—and Beyeler has been completely taken with the painting ever since. (Apart from commercial training and ecomomics studies at university, the future art dealer had completed courses in art history. Especially Georg Schmidt, former director of the Basel Museum, had opened Beyeler's eyes to modern art.) The art market at the time was still sluggish and clientele for works such as Kandinsky's were scarce: Beyeler, however, needed little persuasion, but a few months to pay off *Improvisation 10*.

With all acquisitions Beyeler's

irrevocable standard

is applied; works must epitomise

the phrase "Sonderklasse".

At that time (1947–50) exhibitions and sales at Beyeler's gallery—then named Galerie du Château d'Art—were consitituted by Japanese wood engravings, drawings ranging from Rodin to Picasso (1948), and graphic art from Daumier to Klee (1949). The gallery's first exhibition of paintings in 1951 included works by Bonnard, Gauguin, Matisse and Picasso. One of the pieces from the gallery's inventory, Matisse's *The river bank*, 1907, was sold to the Basel Kunstmuseum. It was originally bought in 1939 by a Swiss collector at the Degenerate Art auction in Lucerne. Kandinsky's *Improvisation 10* however, remained unsold. It was shown again in the gallery's summer exhibition of 1952 or 1953, and at last it found a buyer—a woman from Winterthur who, having inherited some money, decided to emulate another citizen of the same city, the famous collector Oskar Reinhart. Though she had never heard of Kandinsky or his works, she sensed the importance and visionary quality of *Improvisation 10*. Ernst Beyeler told her that this painting was one of the earliest works of abstract art: she bought it for 28,000 Swiss francs. Over time her collection grew, but eventually she encountered financial difficulties and was forced to dispose of *Improvisation 10*. She brought it back to the Beyeler Gallery. By now the fifties had brought on a first price boom, not only for Impressionist artworks but also for contemporary modern art. Beyeler paid her double the original purchase price and thus *Improvisation 10* was incorporated into his private collection.

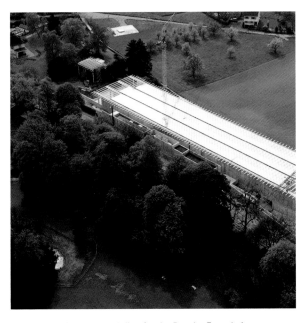

Aerial view of the new building for the Beyeler Foundation Museum on the outskirts of Basel in Riehen, Switzerland. Designed by Renzo Piano the Museum will exhibit the twentieth-century Collection together with Beyeler's tribal works now part of the Foundation.

The story continued in 1960 when Ernst Beyeler visited David G. Thompson, a "steel baron" and renowned art collector, in his legendary art-filled home in Pittsburg, Pennsylvania. Thompson, who had a reputation for being "difficult", and Beyeler soon got on well as they shared similar views on art. However that did not make negotiations any easier. After hours of talking and long calculations they agreed on a purchase price for one hundred Paul Klee paintings from the immense Thompson art collection, to be paid in cash and in artworks. It was around midnight when a tired Beyeler got up to say good-bye and when David G. Thompson, still wide awake, surprised him with one last demand: He requested Kandinsky's *Improvisation 10* to be thrown into the bargain. He had seen the painting five years earlier at Beyeler's private home. He made it clear that the Klee deal would be cancelled and any further acquisitions out of the question should Beyeler not include the painting. It was obvious that Thompson, a tough businessman was trying to play Beyeler the art dealer (who had been on par with Thompson until then) against Beyeler the inexperienced art collector. The collector passed the test and the art dealer was dismissed without a bargain being concluded. However the following morning, just as Beyeler was on his way to the ariport, Thompson arranged for the car to stop at his house. The Klee deal was literally confirmed on Thompson's doorstep—and there was no mention of Ernst and Hildy Beyeler's Kandinsky painting. It was a test of strength and it determined success in the following years. It became part of the Beyeler Gallery story. Buying and selling Thompson collections earned the gallery its reputation in art dealing and in museum history.

From Monet to Mondrian, from Cézanne to Giacometti, from Picasso to the present.

In the history of the Beyeler Collection, Kandinsky's *Improvisation 10* sets the benchmark for all subsequent acquisitions. Though not all acquisitions provide similar anecdotes, each work has to hold its ground in comparison with the best of twentieth-century art—both within the context of an artist's individual oeuvre as well as within the historical developments this century. After World War II, first American then French painters discovered Claude Monet's

"Art is there to wash off the everyday dust

from your soul... It is necessary to arouse

enthusiasm, because enthusiasm

we need most—for ourselves and for the

younger generation."

relevance to modern art, succinctly expressed by the painter Jean Bazaine who declared "Toute la peinture moderne est là-dedans." This coincided with the beginning of Ernst Beyeler's collecting and although Beyeler could not yet afford paintings by Monet for himself, the gallery had been exhibiting Monet's late works in both solo and collective surveys since 1962.

Appropriately, the present selection from the Beyeler Collection begins chronologically with a work by Monet. Like the other Monet in the collection, the thirty-foot long *Waterlilies* triptych, 1917–20, *The Rouen cathedral: the portal (morning)* painted in 1894 is a seminal work in contemporary painting. The significance of the earlier and overwhelming triptych lies in its scale and the elimination of horizon line, an innovation crucial to understanding painters such as Mark Tobey and Mark Rothko. The impact of Monet's cathedral pictures—conceived as a continuous series—can be traced in contemporary work such as the multiples or connected series of Andy Warhol.

Looking at developments in early twentieth-century art, there is an obvious link between Monet's versions of the cathedral tower and Mondrian's church towers painted between 1909 and 1910 and his cathedral facades of 1913–14, even though Mondrian was more decisively influenced by the Cubist works of Picasso and Braque. At one stage a reduction-drawing of the Saint-Sulpice facade by Mondrian had been part of the Beyeler Gallery holdings but was sold before the (unforseen) acquisition of Monet's *The Rouen cathedral* for the collection. It could have been the exhibition's "road to modern art", but one must remember Beyeler's concern was not comparative art history. Mondrian holdings begin with *Composition 1, trees*, painted in 1912–13, a reduction-work that is far more original.

In placing Monet before Cézanne, the significance of Cézanne is not diminished in terms of his importance in the collection. Cézanne's *Path leading from Mas Jolie to the Black Castle,* c. 1895–1900, the figural painting *Seven bathers*, c. 1900, and two late watercolours, *Still life with cut watermelon*, c. 1900 and *Road with trees on a slope*, c. 1904, provide crucial links to an understanding of Cubist paintings by Picasso, Braque and Léger. Examining Cézanne's structural planes in these works also reveals a strong and by no means accidental relationship with later works by Mondrian and Klee. Further to this, Cézanne's powerful influence is evident in Giacometti's drawings, yet their methods in painting and sculpture appear contrary.

Picasso's creative genius is represented by exceptional paintings and drawings from his different periods, from 1907 to 1969. The large number of paintings and drawings as well as a special selection from different artistic periods demonstrate Picasso's intense creative capacity. Some of these acquisitions reflect Beyeler's personal connection with the artist, yet Picasso does not dominate the collection. In order to determine what is so special about Picasso one can compare his works with contemporaries as far as the initial years of the artists are concerned. A clear picture emerges: artists such as Braque or Léger, Miró, Klee or Dubuffet —even Mondrian and Giacometti—created their most original and daring works or developed their style within a limited period of time. Picasso, on the contrary, was a consistently audacious innovator throughout his long life.

The Beyeler Collection owns some of Picasso's most expressive "furioso" painting epitomised by the screaming yellow mask figure, *Woman (period of Les Demoiselles d'Avignon)* painted in 1907, the allegorical *The rescue* from 1932, and the later painting, *Vase of flowers on a table*, 1969. Cubist works showing Picasso's analytical capabilities include: *The mandolin player*, 1911; the drawing *Head of a man (head with moustache)*, 1910/12; the witty collage

Bottle on a table, 1912; two magical still lifes from 1926, *The wine bottle* and *Musical instruments on a table*; and the later *Reclining woman playing with a cat* from 1964. The collection contains three sculptural works: a large and graphic charcoal drawing on canvas from 1932 titled *Sculpture of a head* (the plasticity of which when compared with the constructed composition of *Head with moustache* exemplifies the polarity of these two styles); the monumental bronze *Head of a woman (Dora Maar)* from 1941, and a cheerful coloured welded-metal construction *Woman with hat* from 1961–63. These metal sculptures are outstanding examples of the polarity between modelling and construction in modern sculptural trends. Though not a complete list of Picasso works in the collection, these examples reveal the artist's incredible output.

The Cubist selection is completed by four Cubist-related paintings by Léger—from 1912, 1913, 1914 and 1918. Equally, these paintings illustrate Léger's divergence from the Cubism of Picasso and Braque—evidenced by two later still life compositions of 1924 and 1927. Likewise a post-Cubist painting by Mondrian from 1912–13 provides an important link between this earlier period and the more characteristic later abstract compositions of the 1930s. Paul Klee's musical picture of 1931 augments eight works from his final 'catastrophic' years, the period from 1936 to 1940. All of these are carefully selected from the most significant periods of these artists' careers.

Such groupings of works from certain periods are also a useful source of information as far as other artists are concerned. Matisse is represented by one drawing *Seated young woman in lattice dress*, 1939, an early bronze head *Jeanette IV*, 1911, and later works—the incredible painting *Interior with black fern*, 1948, and an impressive group of four coloured paper cut-outs from 1947 to 1953 which includes the monumental nudes *Blue nude I* and *Blue nude: the frog*, 1952, and the mural-like *Acanthus*, 1953.

Jean Dubuffet is another artist represented by two significant groups: four works of his "art brut" period (1947–56) and two of his "Hourloupe" style (1963 and 1974). Dubuffet—as most of the other artists—has been honoured by the Beyeler Gallery with several solo exhibitions and catalogues, which have contributed decisively to the comprehension and estimation of his work.

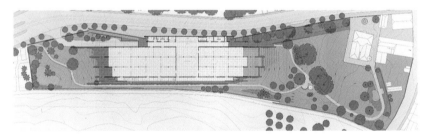

Plan of the new Beyeler Foundation Museum.

Alberto Giacometti is another who retains an eminent place in the Beyeler Collection. In 1963 the Beyeler Gallery exhibited Giacometti paintings and sculptures from the Thompson Collection spanning the years 1925 to 1957. This collection then went "en bloc" to the Giacometti Foundation in Zürich in 1965. The Giacometti works that remain in the Beyeler Collection were obtained from other sources: including bronzes and paintings in the typical "Giacometti Style" dating from 1948 to 1952; three late portraits painted between 1959 and 1961; the monumental bronze group for the Chase Manhattan Plaza, and the artist's last sculpture *Elie Lotar III (seated)* completed in 1965.

While this summary—concentrating on the focal points of the collection—reveals works of museum quality, they were not collected with a prospective museum of twentieth-century art in mind. Paintings by Klee, Miró and Max Ernst alone, for example, could not cover the range one would expect of a Surrealist section. Quite the opposite, these works were selected because they show to the utmost, the personal characteristics and essential qualities of these extraordinary artists. American art was selected in the same way. Instead of providing

a survey of the myriad ideas and accomplishments associated with twentieth-century American art, the collection concentrates on American artists whose sensibilities correlate with those of the collection—Josef Albers, Mark Tobey, Mark Rothko, Robert Rauschenberg, Roy Lichtenstein, Frank Stella and Sam Francis. Many American artists extended their practice to encompass "happenings", performance art, landscape art or conceptual pieces—but these were forms beyond the scope of a private collection dedicated to the domain of "painting on canvas" and figurative sculpture. The particular spiritual associations of paintings by Albers, Tobey and Rothko, and the specific cultural awarenesses expressed in works by Rauschenberg and Lichtenstein, were concerns that connected with the philosophical basis of the essentially European character of the Beyeler Collection.

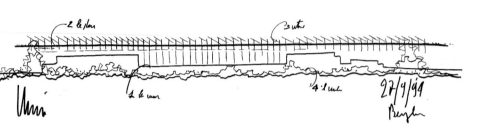

Sketch of the new building for the Beyeler Foundation Museum, Riehen, Switzerland, by Renzo Piano.

Sculptural works in the collection exhibit characteristics comparable to the paintings: figural representations by Matisse, Picasso and Giacometti for instance, fall within the framework of traditional sculpture. Even Jean Tinguely's motorised 1954 construction *Detatched element 1 (Meta-Kandinsky III)*, a constantly changing pictorial constellation, fits within this context. Ernst Beyeler's attitude to sculpture was revealed in two important exhibitions: *Sculpture in the Twentieth Century* featuring works from Rodin to Serra in a suburban park near Basel, Switzerland, in 1980, and in 1984 with an open air exhibition in another public park near Basel, of sculptures from the nineteenth century to the present. Both exhibitions included outstanding native African and Pacific art—whose influence on twentieth-century art has been well documented. It should be mentioned that Beyeler recently transferred his collection of tribal art to the Beyeler Foundation.

There are exceptions to the rule that the Beyeler Foundation's selections must remain within the bounds of painting on canvas and figurative sculpture. Such as works by two Spanish artists—a material painting, *Graffiti on the wall*, 1971 by Antoni Tapiès and Eduardo Chillida's abstract iron sculpture, *From the horizon*, 1956. These are non-figurative but each expresses a particular commitment to humanity.

The most recent works in the collection are paintings from 1978 to 1983. Beyeler likes to say, with a more symbolic than literal meaning, that each of these painters, Francis Bacon, Georg Baselitz, Anselm Kiefer, represents in different ways the persistence of the painting tradition. Although quite different, Beyeler's collector's eye detects a deeper connection between Bacon, Baselitz and Kiefer and van Gogh and Picasso—especially their expressiveness and mode of painting. Two paintings by Francis Bacon from 1966 and 1959—transferred in 1987 from a retrospective in Beyeler's gallery to his private collection—are of particular importance as these confrontational works set the standard for contemporary art in the collection.

Finally, mention must be made of the drawings, watercolours and collages. The oldest work, Georges Seurat's *Reclining man*, 1883–84 (one of the main figures in his painting *Bathing at Asnières*, National Gallery, London), is a superb example —definitely in the "Sonderklasse." Other highlights include Cézanne's frequently reproduced watercolour, *Still life with cut watermelon*, c. 1900 and *Road with trees on a slope*, c. 1904. That Cézanne is numerically surpassed by Picasso in this section—eight works on paper in addition to eight paintings and two sculptures—reflects Picasso's exceptional personality and immense creativity as well as Beyeler's professional and personal acquaintance with Picasso.

The collector and the artist

Picasso was already familiar with Beyeler Gallery catalogues when Ernst Beyeler first visited him in Mougins in 1966. Picasso had read them intently, noting the luxurious, excellent presentation and, above all, the discriminating selection by Beyeler of his own works.

Both artist and dealer agreed about important, demanding, and "difficult" art. Although other art dealers were welcomed in Mougins, only Beyeler had a privileged position. Once Picasso opened a door to a room containing several hundred works from difference periods and said to Beyeler: "Choissez!". (An extraordinary move, considering that even for his gallery dealer Daniel-Henri Kahnweiler, Picasso personally selected every work for sale). Of the forty-five paintings selected by Beyeler, Picasso retained nineteen he would not part with. Together with the gallery's Picasso stock, Beyeler still had work for two exhibitions: Picasso 1900–1932 and Picasso 1932–1965. Later followed exhibitions of painted linoprints and, in 1971 to celebrate Picasso's ninetieth birthday, ninety drawings were selected from Mougins. When Beyeler showed Picasso the catalogue, the artist then toyed with the idea of an exhibition of one hundred sculptures for his centenary. Unfortunately, this was not to be. However, the Beyeler Gallery commemorated Picasso's centenary with a retrospective of one hundred works of all genres, and it was Ernst Beyeler who initiated the Basel Kunstmuseum's exhibition of Picasso's late works in 1980.

Professionally Beyeler met and worked with many artists, among them Georges Braque, Marc Chagall, Jean Arp, Max Ernst, Ben Nicholson, Josef Albers, Alberto Giacometti, Jean Dubuffet, Henry Moore, Mark Rothko, Barnett Newman, and Francis Bacon. The gallery's exhibitions led to additional contact with younger artists, from Eduardo Chillida, Antoni Tapiès, Bridget Riley, Robert Rauschenberg and Roy Lichtenstein, to Georg Baselitz and A.R. Penck. An especially close relationship developed with Mark Tobey who, in 1960, settled in Basel—assisted by Beyeler— where he remained until his death.

The content of the Beyeler Collection mirrors not only the collector's personality but also his perception of the artist's personality. This, in turn, has informed his acquisitions. The entire collection—the Beyeler Foundation—and the selection for this current exhibition at The Art Gallery of New South Wales have to be understood in terms of someone, a non-artist, who experiences art as a necessity of life, as something crucial to comprehending the meaning of life. Ernst Beyeler's philosophy is best summarised by Picasso, whose words he often quotes: "Art is there to wash off the everyday dust from your soul... It is necessary to arouse enthusiasm, because enthusiasm we need most—for ourselves and the younger generation."

JEAN DUBUFFET

Mark Tobey

PABLO PICASSO

JOAN MIRÓ

Georges Seurat

PAUL KLEE

CLAUDE MONET

Fernand Léger

Andy Warhol

Francis Bacon

Alberto Giacometti

MAX ERNST

HENRI MATISSE

PIET MONDRIAN

Wassily Kandinsky

PAUL CÉZANNE

Georges Braque

Eduardo Chillida

CLAUDE MONET

1840–1926

1

The Rouen cathedral: the portal (morning) 1894
La cathédrale de Rouen: le portail (effet du matin)

oil on canvas • 106.5 x 73.5 cm
signed and dated lower left
Catalogue Wildenstein, vol. 3, no. 1347

The label "impressionism" was derived from the title of Monet's *Impression, soleil levant*, 1872, which was included in a Salon des Artistes Indépendants exhibition in Paris. The paintings in that exhibition contained observations of fleeting light and colour that surprised the public and challenged the accepted values and methods of nineteenth-century art.

These developments were soon synthesised and twenty years later, Monet's work shows another new and decisive step towards twentieth-century painting. Objective observations of optical and atmospheric phenomena gave way to an interest in conveying the subjective impressions of constantly changing light and space. In order to accomplish this, Monet needed an immobile object as a vehicle for portraying this subtle optical phenomenon which evokes different moods, and he needed to create a series of images.

In 1892 and 1893 Monet spent several weeks studying the western facade of the Rouen cathedral from a window opposite. He studied the effects of the morning light, shining from the east behind the cathedral, and the play of reflections and shadows on the facade. During 1894 Monet worked in his studio in Giverny on this series, probably using a photograph by Neurdein taken out of the same window around 1885. His intent was to capture transient and immaterial images not merely as mood, but as worldly perceptions of space and time.

To present his thematic concept, Monet combined these paintings in an exhibition entitled *La cathédrale de Rouen, nos 1–20* at the gallery Durand-Ruel on 25 May 1895 (this work was no. 12). When Cézanne visited this exhibition, he commented, "It is the work of a wilful and self-disciplined man pursuing the elusive nuances of impressions.

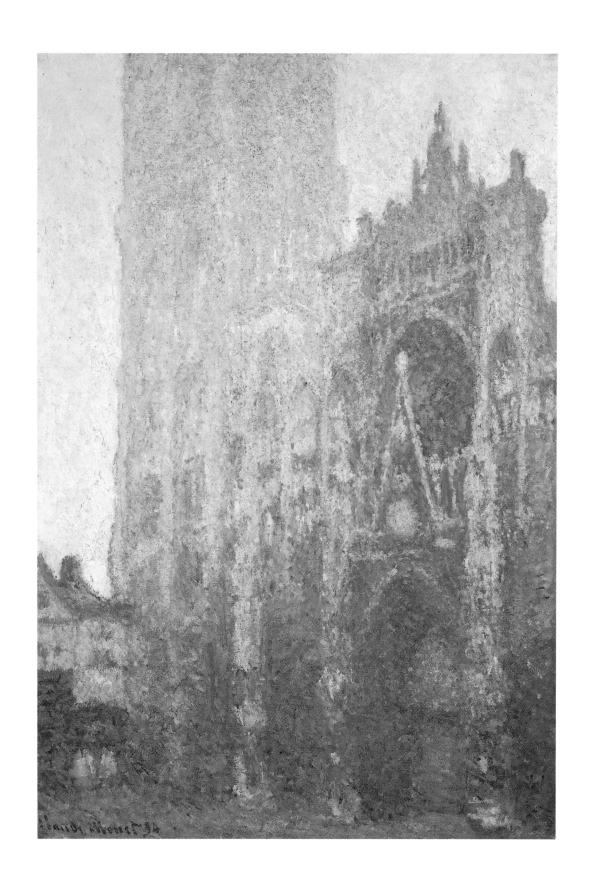

GEORGES SEURAT

1859–1891

2

Reclining man (study for _Bathing at Asnières_) 1883–84
L'homme couché (étude pour _Une baignade, Asnières_)

conté-crayon on Ingres paper "Michallet" • 24 x 31 cm
Catalogue de Hauke, vol. 2, no. 589

Bathing at Asnières (Une baignade, Asnières) at the National Gallery, London, was Seurat's first major painting and was exhibited at the Salon des Artistes Indépendants in Paris. This drawing is one of ten preliminary sketches of the poses which detailed the modelling and lighting. These studies resulted in a series of finished motifs which indicate Seurat's superb talent as a draftsman. They were eventually gathered in a painting and thereby instilled with new life through the addition of colour and brushwork.

The model's pose appears on three sheets. Each depicts another detail of a reclining man who rests his head on his arm while contemplating the flow of the river. _Reclining man_ is a full-length representation. The open space above the figure corresponds to the extension of the landscape and the luminous area over the water in the final painting.

This drawing already exhibits the same compositional balance and rich atmospheric modelling as the painting. But here light and shadow are more powerfully expressed, especially on the body. Seurat applied conté-crayon to the fibrous Ingres paper to create a texture of bright and shaded tones, and the dense velvety black contrasts with the originally white (now yellowed) paper. Subtle, gradual transitions and even the grainy surface of the paper are incorporated in the modelling and in the portrayal of atmospheric nuances.

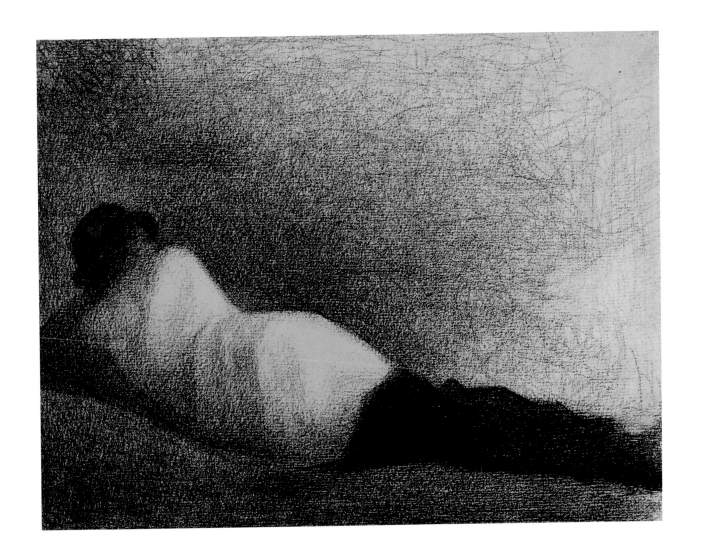

GEORGES SEURAT Reclining man (study for *Bathing at Asnières*) 1983–84

PAUL CÉZANNE

1839–1906

3

Path leading from Mas Jolie to the Black Castle c. 1895–1900

Chemin du Mas Jolie au Château Noir

oil on canvas • 79.5 x 64.5 cm

Catalogue Venturi, no. 1527 • Catalogue Rewald, no. 864

The setting of this painting which was formerly known as *Sous-bois* (Forest scene) has recently been located by the art historian John Rewald as a section of the forest path leading from the Mas Jolie farm to the hill of the Château Noir. Cézanne walked along this path innumerable times in his youth with his friends Emile Zola and Baptistin Baille, and later, when he went "devant le motif" with his paint box, canvas and easel on his way to Montagne Sainte-Victoire. The Montagne Sainte-Victoire is often the subject of Cézanne's masterpieces and is always seen in the distance.

Cézanne selected a subject, and created or "realised" it in his paintings. Very likely, he set up his easel on the spot, yet in this work, Cézanne conveys a rather synthetic description of the area based on a variety of artistic insights and decisions. The topography, the abundance of trees and leaves, the depth of the path, the placing of light and shadow as well as the unity of space and nature is transposed into pure pictorial equivalents.

There is an almost symmetrical composition with an orthogonal construction, using curves as a rhythmic counterpoint in the predominantly diagonal brushwork. This creates a wonderful counterbalance between the physical and representational qualities of pigment. In the lower centre a small, light, unpainted semi-circle is the core of this painting, both as vanishing point and as the destination of the path.

The blue shading in the upper sides may allude to the blue of the sky or it is the basic colour for the unfinished tree tops. This ambiguity, which is found in all elements of this painting, gives it a unified artistic vision that corresponds to the unity of nature. The light-blue of the upper part is balanced with darker shades in the lower and links both depth and height.

The greatness of Cézanne's art is a brushstroke which fills the surface as well as the pictorial space in an absolutely masterful way. The short, brown, broad strokes in the upper centre creating open space for the air and branches of the tree is but one example.

PAUL CÉZANNE Path leading from Mas Jolie to the Black Castle c. 1895–1900

Paul Cézanne

4

Seven bathers c. 1900
Sept baigneurs

oil on canvas • 37.5 x 45.5 cm
Catalogue Venturi, no. 387 • Catalogue Rewald, no. 840

There must have been summer days in Cézanne's youth that gave him immense pleasure, when he had a notion of the unity of man and nature, of poetic creation and being, and of sensual desire and fulfilled life. In those days he strolled with his schoolmates Emile Zola and Baptistin Baille through the outskirts of his hometown Aix-en-Provence, taking a plunge in the river Arc, resting or engaging in long discussions while sitting in the shade of a tree.

The theme of bathing figures enters Cézanne's oeuvre in the 1870s. He used it to allude to old masters paintings or classic mythology or to create compositions of timeless modern content stripped of historical allusion. Cézanne experimented with the theme of the lost paradise, which he imbued with a modern spirit. This is evident in innumerable sketches, designs and paintings.

Many representational problems were apparently not yet solved in this version of seven bathers. Only one element which has been brought to a conclusion is the elliptical "frame". It is shaped by a tree (left), its branches advance along the top to join the tree (right) which continues advancing down to the lower right of the canvas. Apart from this nothing seems final in this painting, neither the figures enclosed within this "frame" nor some spaces between this "frame" and the canvas edges. But this openness, the process of growth, is the actual source of "nourishment" for an attentive viewer.

Each brushstroke searching for contour, each patch of colour defining light and space implies both questions and answers. We recognise some hesitancy in the final shaping of the frontal nude. In comparison, the nude depicted from the back which is adapted from a prototype, fully reveals Cézanne's mastery and leads us to the essence of his art which is the act of painting as the application of pigment to canvas.

Modern painting begins with these works which Cézanne painted at the beginning of the new century. Now, approaching the end of the twentieth century, one could argue that few modern paintings provide more sustenance to the eyes and spirit. Cézanne served as a father figure for many artists, including Matisse, Picasso and Giacometti and his works are key to the comprehension of modern art.

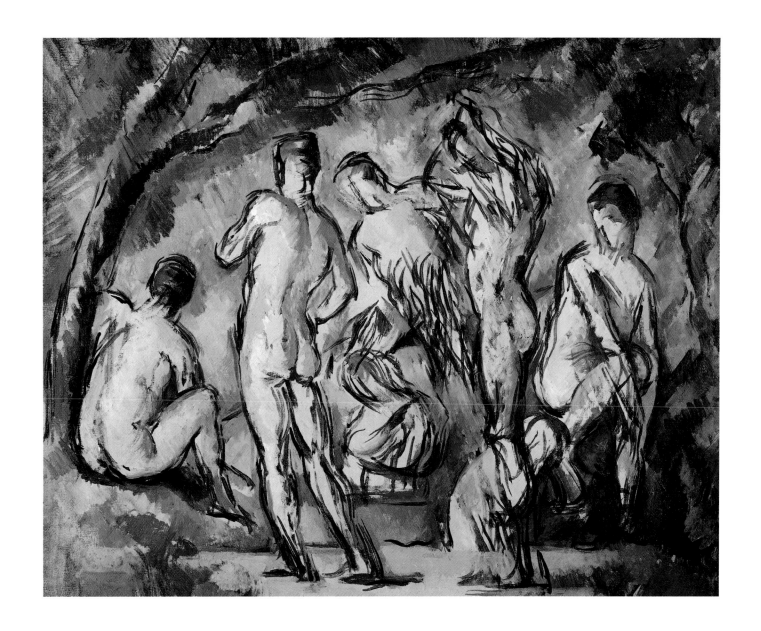

Paul Cézanne

5

Still life with cut watermelon c. 1900
Nature morte avec pastèque entamée

pencil and watercolour on paper • Verso: unfinished watercolour sketch • 31.5 x 47.5 cm

Catalogue Venturi, no. 1149 • Catalogue Rewald, no. 564

Cézanne worked with pencil, oil, gouache and watercolour throughout his life and developed a unique style and supreme mastery in each of them. Originally he probably used watercolours just to colour pencil drawings. But in the 1880s Cézanne applied the same discipline and thoughtfulness to his watercolours as to his oil paintings. His later watercolours deal with the same subjects as his oils. He painted still life and landscape motifs, rarely portraits or figural compositions. With watercolour these paintings have a very different character, yet they are equal to his oils in their influence on modern painting.

Most art historians interpret the major object in this still life as a "pomegranate", but in 1923 the art historian George Rivière and later John Rewald identified the big, round fruit with a greenish, bluish, yellowish outside and a bright red interior as a watermelon. The melon certainly represents the most important object on the table, contextually as well as artistically. (In the Provence melon is a common source of refreshment.) The red wine, knife, spoon, and glass are randomly arranged on the table.

The painter Louis Le Bail watched Cézanne prepare a still life in 1898 and reported that the impression of randomness was intentional. It is the intervals of colour—like harmonic steps in music—rather than perspective or shading which constitute the foundation of Cézanne's depiction of form.

On the reverse of *Still life with cut watermelon* is a landscape study in watercolour (see Cézanne, Aquarelle; Tübingen and Zürich 1982, p. 275).

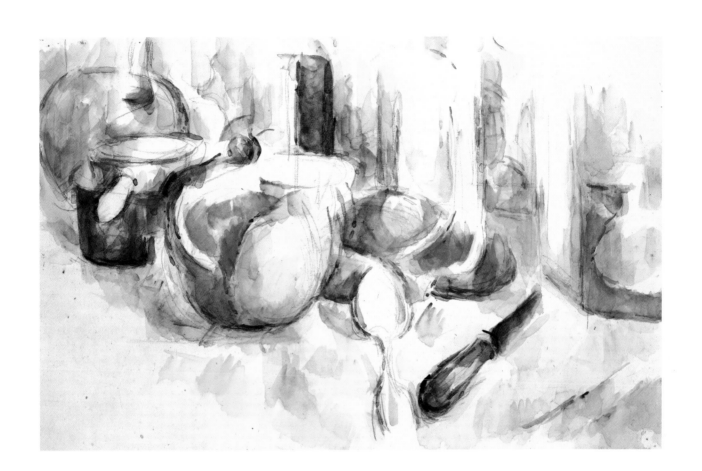

PAUL CÉZANNE Still life with cut watermelon c. 1900

Paul Cézanne

6

Road with trees on a slope c. 1904
Route avec arbres sur une pente

pencil and watercolour on paper • 46.7 x 30.5 cm
Catalogue Rewald, no. 625

The art historian John Rewald renamed this watercolour as *Road with trees on a slope* in recognition of its setting on the bend on the Petite Route du Tholonet. It was formerly titled *Trees on the wayside.* The unfinished watercolour on the verso of the preceding *Still life with cut watermelon* (p. 27) represents an example of how Cézanne started work on a landscape motif similar to this.

Though the paper is largely unpainted, this is a finished work. The white of the paper is incorporated into the composition, granting it equal value to the brushwork and creating a delicate balance. The sunlit road has the tone of the paper and contrasts with the colour patches and lines of the foliage and its shadows.

A tree dominates the middle axis. Its unpainted trunk is reminiscent of the white patches of the spoon and melon in the preceding still life. Both watercolours share the same strategy, but the brushwork is different due to Cézanne's stylistic development during the four years separating these works. *Road with trees on a slope* is an example of Cézanne's last period characterised by shorter, more succinct and compact brushstrokes and richly differentiated colouring and overall harmony. If the colouring depended on the subject, green should dominate. But green is applied sparingly in a final procedure to set a few accents over ochre and violet. Pink hues are used to connect the unpainted surface with the more densely coloured parts.

Cézanne's stylistic changes arise not from increased mastery but from a changed sensibility toward a motif which compelled him to seek new methods of realisation. His late works reflect a lyrical and emotional understanding of the natural world as a tapestry of inexhaustible plenitude which permeates all the material and optical elements of nature, himself included. In Cézanne's own words: "The landscape becomes human, becomes a thinking, living being within me. I become one with my picture ... We merge in an iridescent chaos".

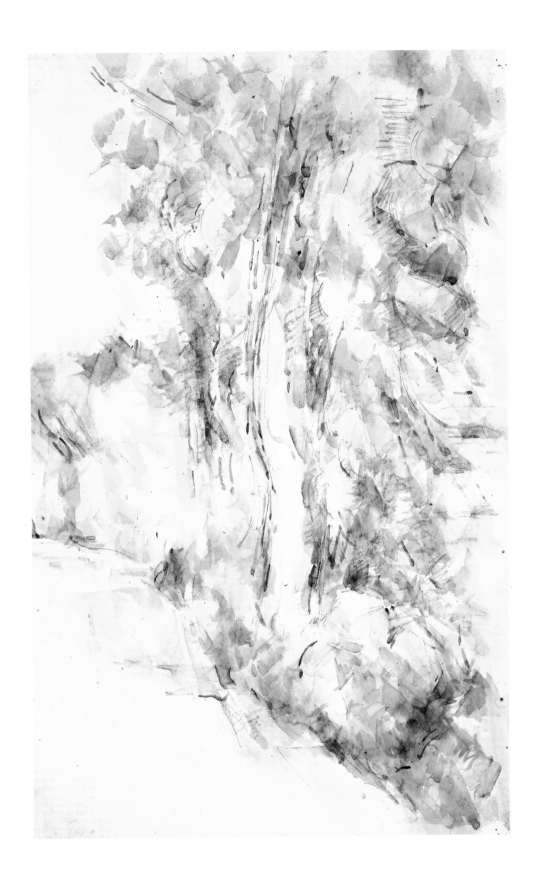

PABLO PICASSO

1881–1973

7

Woman (period of Demoiselles d'Avignon) 1907
Femme (époque des Demoiselles d'Avignon)

oil on canvas • 119 x 93 cm

signed upper left

Catalogue Zervos, vol. 2 (2nd ed.), no 631 • Catalogue Daix-Rosselet, no. 75

In July of 1907 Picasso finished a large painting that was later titled *Les Demoiselles d'Avignon*. Since 1939 it has been in the permanent collection of the Museum of Modern Art in New York. Within the work, five prostitutes turn provocatively towards the viewer. Final touches, which add an African mask motif were applied to the heads of the two women on the right, one standing, the other squatting.

Picasso continuously captured his creative ideas in sketchbooks or in major works such as *Nude with drapery* (Hermitage Museum, Leningrad) which was painted in August or September of 1907. *Woman* dates from the same period, and is within the same context. While it is sketchlike in execution, it is consummate in expressive force.

A nude woman with arms raised and hands behind her neck, stands in a lascivious pose. She is framed by yellow curtains in front of a green and blue background, which suggests vegetation and sky or water. It is possible that with this painting, Picasso renews the theme of a sailor and companion in a bordello with grotesquely provocative prostitutes. This was the theme with which he began the preparatory design of *Les Demoiselles d'Avignon*.

Woman is based on the same provocation. This is expressed through the bold outlines and loud yellow. The mood of the (invisible) sailor is signified by the green and blue colours behind the figure. However, Picasso's primary intention during this period was the transmutation of figures and space onto a flat surface. This was a problem he finally solved in his Cubist works from 1910. Meanwhile, as in his "African" works of 1908, his figures appear rather wooden yet they partially penetrate the pictorial background. In this work, the contour of the left breast is painted over with green, here covering the yellow foreground. The adjacent space, as well as the upper right and lower left of the painting is raw canvas. Figure, foreground and background lie on the same plane, the canvas itself.

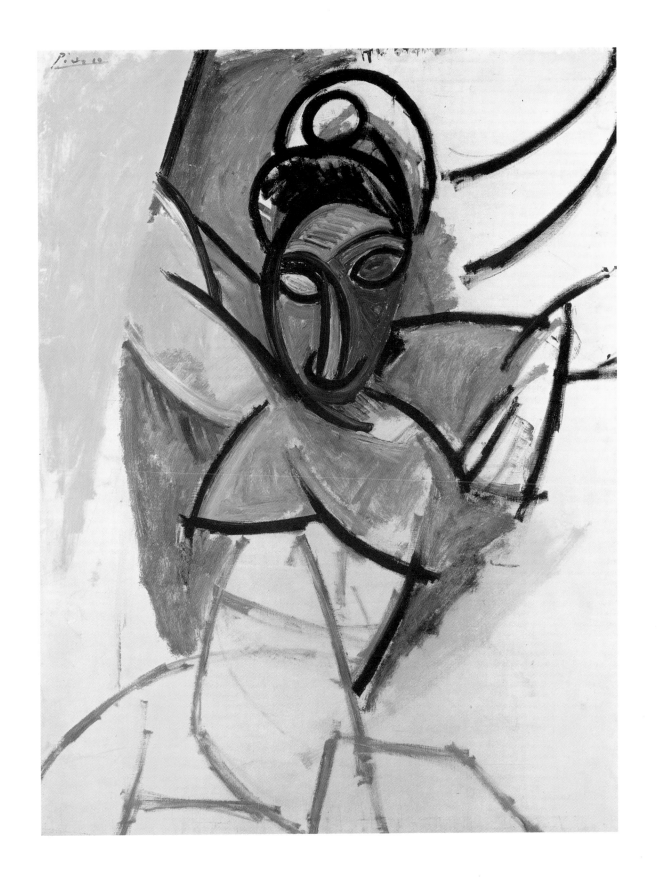

PABLO PICASSO *Woman (period of Demoiselles d'Avignon)* 1907

Pablo Picasso

8
The mandolin player 1911
Mandoliniste

oil on canvas • 97 x 70 cm
reverse signed
Catalogue Zervos, vol. 2, no. 270 ("La Mandoliniste") • Catalogue Daix-Rosselet, no. 425 ("La Mandoliniste")

This picture was painted in the autumn of 1911 and was sold by Daniel-Henri Kahnweiler, Picasso's gallery dealer, to the art dealer Alfred Flechtheim in the spring of 1912. It was exhibited in Cologne in 1912 and Munich in 1913 as *The mandolin player*. Since the Cubist art historical and aesthetic approach seems to be founded on geometric ("Cubist") structure and the blending of figures and pictorial planes, it is apparently unnecessary to ask questions concerning the subject. Yet the idea behind this image is of importance. Picasso indeed renders a mandolin player in his studio in his new apartment on the Boulevard de Clichy no. 11 in Paris, which he furnished in middle-class taste.

Contemporary photographs such as the one reproduced in *Pablo Picasso, A Retrospective* (William Rubin, ed., The Museum of Modern Art, New York, 1980, p. 122) shows Picasso sitting on the couch represented in this painting by fringes, cord and tassels (lower left, above the centre to the left and right). He keeps his legs crossed (centre bottom). The mandolin in the photograph is approximately in the middle of the painting. It is referred to by the flexed neck and tuning peg of the instrument. The cloth with stitched and printed flower motifs on the left wall of the apartment is depicted on the left side of the painting. If we discover the plectrum for plucking the strings of the mandolin we can determine where the right hand of the musician is placed, but all we can detect are the fingers on his left hand resting on the fingerboard next to the pegbox.

Here quick identification stops. We sense that the bust, neck and head reach beyond the back of the couch and that the buttocks indent the seat cushions, but we cannot grasp the real body and the floating border between figure and surroundings. This is in fact the intention of Picasso's Cubism. The fragmentary perspectives as well as the light and shadow define a corporeality comparable to "cubes". Then the outlines of the objects dissolve through flat brushstrokes. Picasso described his Cubist art as "trompe l'esprit", as an illusionism that decisively contradicts the rules of painting established since the Renaissance.

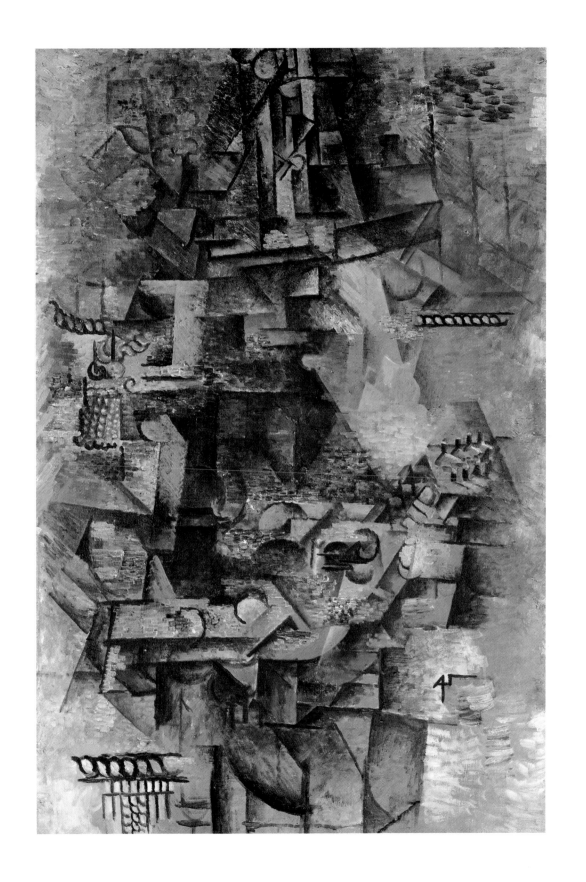

Pablo Picasso

9

Head of a man (head with moustache) 1910 or 1912
Tête d'homme (tête moustachue)

charcoal on paper • 64 x 48 cm
reverse signed and titled
Catalogue Zervos, vol. 28, no. 81

Even viewers unfamiliar with Picasso's Cubism will recognise the face of a man with a moustache. Contours of a head and shoulders are clearly set off against the background. The bridge of the nose lies in the vertical middle axis which ends in the curved wings of the nose. His moustache is twirled. His chin is a crescent-shaped line and he wears a shirt with a collar. The eyes, ears and mouth are diffused. He is possibly smoking a pipe.

The Cubist principle of rendering a subject by geometric elements and ambiguous shading or, conversely, constructing a subject by these configurations is obvious in this drawing.

The dating of this drawing is controversial. Zervos, in his oeuvre catalogue of 1974 (vol. 28), and Pierre Daix, in the text to the catalogue raisonné beginning with Picasso's Cubist works, (Daix-Rosselet, 1979, p. 109) argue for 1912. William Rubin (*Pablo Picasso. A Retrospective*; New York, 1980, p. 143) assigns it to 1910, placing it between the *Portrait of D. H. Kahnweiler* (Art Institute, Chicago) made in the autumn of 1910 and the drawing *Head of a Spanish woman* (Musée Picasso, Paris) from 1911. Gary Tinterow gives autumn 1910 as the date of execution (*Master Drawings by Picasso*; Folk Art Museum, Cambridge, MA, 1981). This confusion about the date or origin cannot be considered a mere quirk.

Picasso's Cubism developed month to month with constantly surprising innovation. Although the transitions were abrupt and he did not adhere to a scientific logic, his work evolved according to an inner logic. In 1910 Picasso had not yet developed the means he used in 1912, and he did not attempt to resolve the problems in 1912 that he had solved in 1910. But art historians need to establish a reasonable chronological order conforming to the artist's sequence of development of creative logic, thereby contributing to the understanding of his art. The sequencing problem is aggravated by the fact that Picasso did not date many of his works of this period.

The problem of chronology is significant because the development of Cubism can only be understood in its chronological sequence. This drawing and other Cubist works need to be studied in detail, line for line, in order to gain access to Picasso's representational principles which are more important than the actual subject.

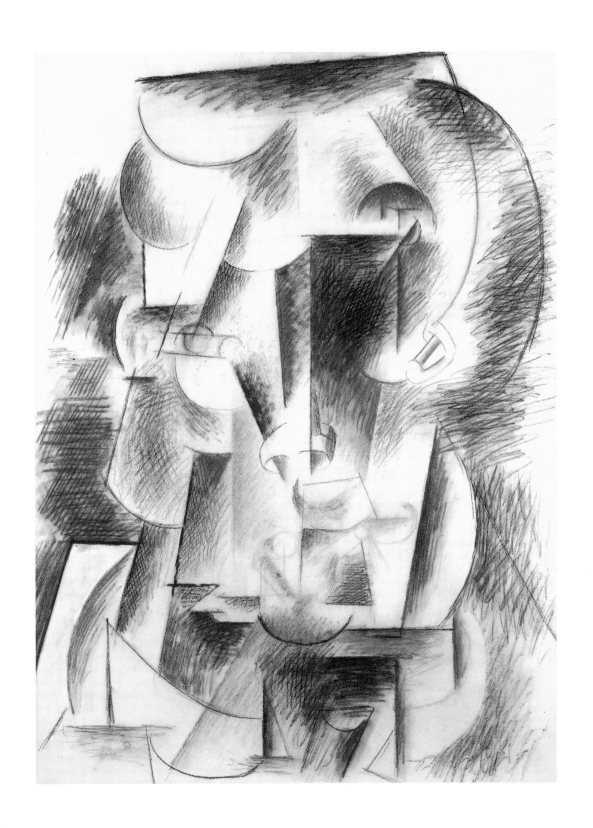

PABLO PICASSO Head of a man (head with moustache) 1910 or 1912

Pablo Picasso

10
Bottle on a table 1912
Bouteille sur une table

charcoal and cut-out newspaper on paper • 60 x 45.5 cm
reverse signed upper left
Catalogue Zervos, vol. 28, no. 204 • Catalogue Daix-Rosselet, no. 552

The newspaper article in this "papier collé" was from *Le Journal* of 8 December 1912. It contains an advertisement for a clinic that promises to cure syphilis, euphemised as "affections intimes". The long column lists theatrical and musical matinées of the day. The newspaper date furnishes a clue for the execution of this work, probably not later than December 1912, assuming that Picasso did not save newspapers indefinitely.

Straight and curved lines form the basic structure with a middle axis. Its top depicts mouth, neck and shoulder of a wine bottle.

The bottom of the bottle is cut out of the newspaper and outlined in charcoal. The tripartite view of this bottle is remarkable. The mouth represents a combination of a profile and an oblique top view. The neck and shoulder illustrate a front view and the bottom is an elevation. At a small table, indicated by the curvature on the left, below the newspaper, probably sit two people vis-à-vis. One presumably reads the newspaper because the column stands on the headline, therefore readable for the person sitting opposite; the second person seems to observe or sketch.

Other "papiers collés" from the same period and of the same subject show a curve with an angle that can be identified as the stem of a wine glass.

The newspaper cut-out serves as both pictorial anecdote and artistic tool because its own shadow (right) and cast shadow (left) give volume to the bottle although this shading is contrary to nature. This otherwise linear, black and white drawing attains some colour in the grey hues of the print and the yellowed newspaper.

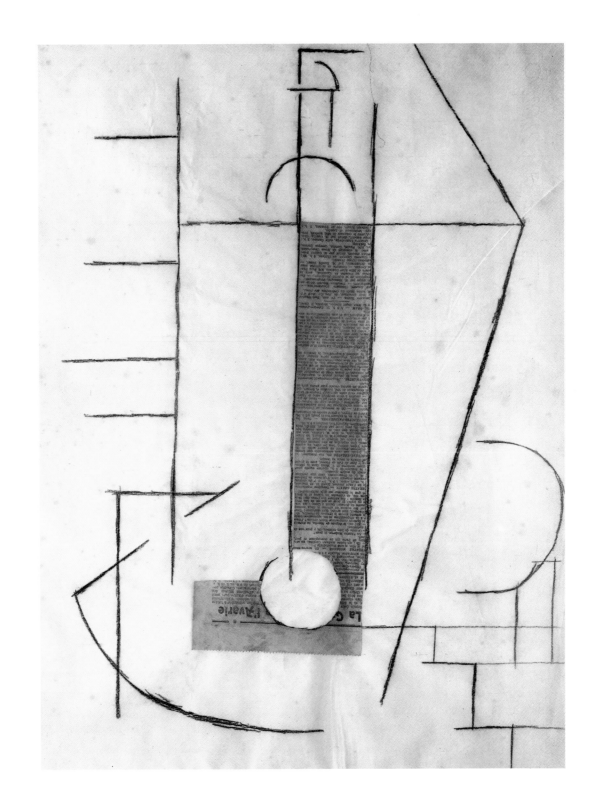

Pablo Picasso

11
Head of a woman 1921
Tête de femme

pastel on paper • 63.5 x 48 cm
signed lower right
Catalogue Zervos, vol. 4, no. 349

Picasso spent the summer of 1921 with his wife Olga and his baby son Paulo not as usual on the Riviera but in a villa at Fontainebleau, where he worked on the monumental painting *Three women at the spring* (Museum of Modern Art, New York). As with all his major works, he made innumerable studies on paper and canvas of which this pastel is an example. This is a drawing of the head of the contemplative woman standing on the left in *Three women at the spring*. It is not known, however, if this work was made prior or subsequent to the painting. This head exudes the same power as the final painting, a characteristic of several of Picasso's studies such as *Woman (period of Demoiselles d'Avignon)* (p. 31).

This neo-classic image is indebted to Poussin and Roman architecture and painting with which Picasso became familiar when he visited Italy in 1917. While preparing the decor and costumes for Diaghilev's Ballets Russes he met his future wife, Olga Koklova and visited Naples and Pompeii. Neo-classical forms as exemplified in the charcoal drawing titled *Sculpture of a head* (p. 49) do not appear in Picasso's sculpture until the 1930s. From 1921 to 1923 Picasso employs classical stylistic elements to create static, voluminous, phlegmatic figures. These pictures are certainly coded expressions of personal thoughts and problems.

For the interpretation of this head, we have to refer to *Three women at the spring*. The oldest woman sitting on the right fills a pitcher with water from the spring. A second, younger woman in the centre holds one hand directly in the water, the other hand touches her chin. A third woman standing on the left carries an empty pitcher while looking at the sitting woman as if the latter possesses female maturity that yet awaits her. This young woman looks to the right (the future), not the left (the past), nor at herself which would indicate the preoccupation of youth with itself.

All these elements are already contained in *Head of a woman*. She has a well-lit (meditative) forehead and her hair is combed like a bride. Her mouth is small and sealed in silence while she glances wide-eyed and firmly into the future.

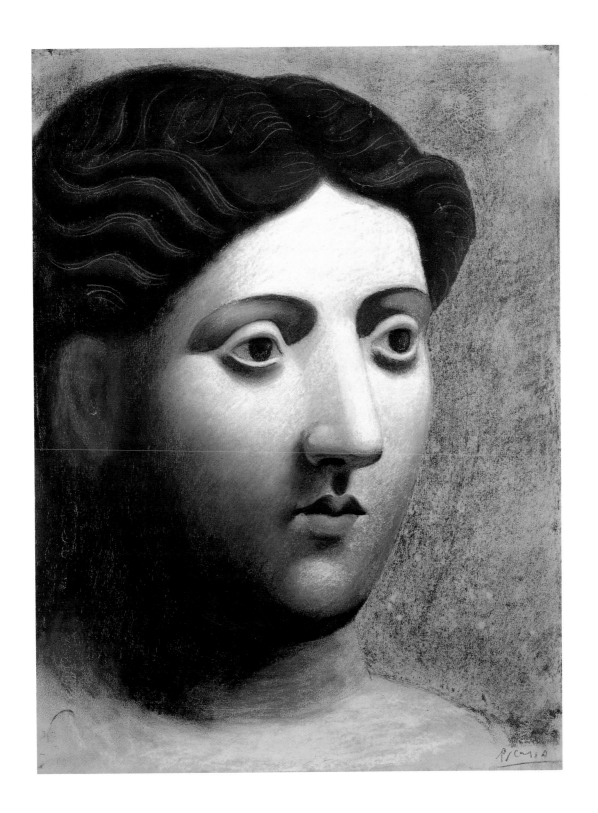

PABLO PICASSO Head of a woman 1921

Pablo Picasso

1 2
The wine bottle 1926
La bouteille de vin

oil on canvas • 98.5 x 131 cm
signed and dated lower left
Catalogue Zervos, vol. 6, no. 1444 ("painting, 1925 and dated 1926")

This colourful still life from 1926 exhibits a strong Cubist influence. Since the 1920s most paintings as well as sculptures were in some way affected by Cubism, yet twentieth-century art developed in disparate directions, towards abstract compositions or symbolic Surrealism. Cubism eliminated the spatial coherence, liberated the subject from its figurative integrity and disposed with the formal unity of outlines and colours. Art no longer depended on nature.

Picasso's interior with guitar, wine bottle, fruit bowl, glass and music sheet on a table hardly resembles a real room. These objects which are rendered as flat coloured forms on a flat canvas are similar to easily intelligible pictographs. It is easy to read and understand the letters VIN. However it is difficult to find a context for the lines and colour patches which represent a room illuminated by the light coming through a window in the background. The irregular black and white spots and the patches above and adjacent to the outlines of the objects would then fall into place as lights and shadows. Colours fit the characteristics of the objects with one exception, the blue hues around the guitar. Knowledge of Picasso's personal colour dictionary is necessary for understanding the juxtaposition of the guitar and the blue, as blue symbolises music.

In Picasso's lexicon of symbols, still life objects are metaphors for "male" and "female." They appear in pairs. The guitar with the wine bottle on the dark side of the room is more intimate than the second pair which is the fruit bowl (containing lemons and grapes) and the glass (filled with red wine). A magnificent apple between the fruit bowl and glass symbolises Eve's offer to Adam. Two more apples are on the music sheets which surely contain a love-song. These apples are painted as white as the fruit bowl and are endowed with ambiguous meaning. They may represent female breasts.

This is an example of Picasso's development from Cubism to ambiguous Surrealism.

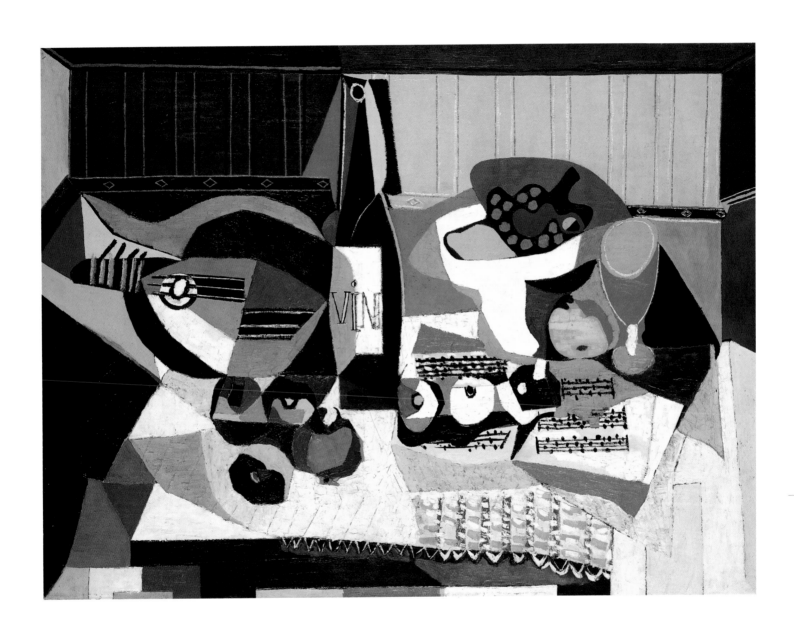

Pablo Picasso

13

Musical instruments on a table 1926
Instruments de musique sur une table

oil on canvas • 168 x 205 cm
signed lower left
Catalogue Zervos, vol. 7, no. 3

The content of this large picture is determined more by warm brown and black tones than by the depicted objects. These tones evoke a mournful mood. However, this strong effect does not preclude exact analysis. Picasso narrates in tones, lines and forms that have to be decoded in terms of physical objects.

A simple wooden table covered with a table-cloth stands in a room with closed shutters (fragmented horizontal black and white lines in the upper background) and curtains (vertical white lines in the lower centre). Two guitars

and a fruit bowl (upper centre) with grapes (fruit in black, stem in white) are placed on the table. The mood, however, is far more important than identifying the objects. This painting exudes a calm yet sensual atmosphere. There are two "sleeping women" which are indicated by the two guitars, according to Picasso's pictorial language. One is perhaps dreaming. This is referred to by the white form above the guitar on the right.

An artist (or other man or woman) observing a sleeping woman was one of Picasso's themes

that can be traced throughout his oeuvre. The metaphor "woman-guitar" had been part of his pictorial repertoire since his Blue Period. The two guitars apparently possess opposing temperaments, black versus white, fingerboard versus strings, the small, precisely incised sound-hole versus the large white sound-box. In spite of the ostensible calmness there is a detectable underlying drama. Embedded in the infinite brown of the canvas the two guitars find a common, soothing bed.

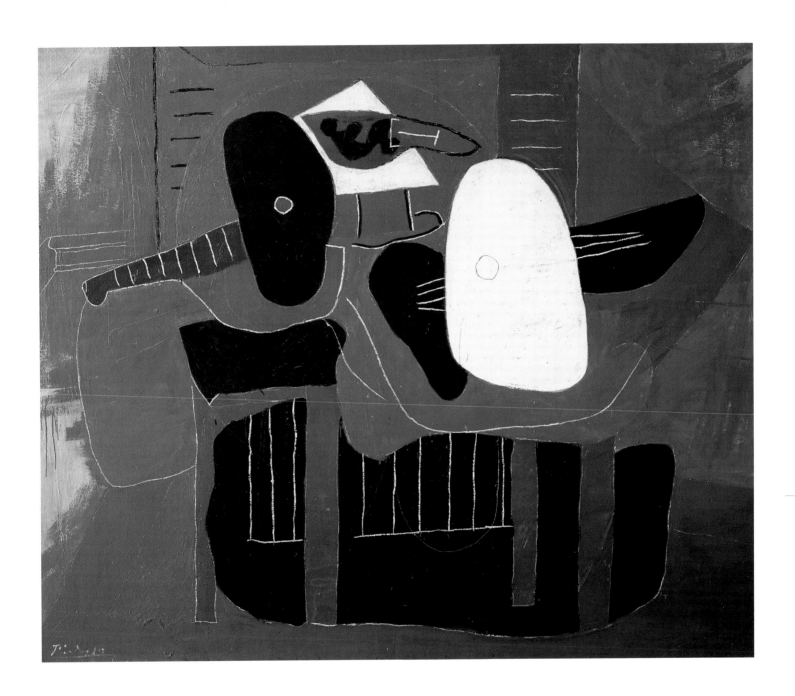

Pablo Picasso

14

Figure (seated woman) 1930
Figure (femme assise)

oil on wood • 66 x 49 cm
signed and dated upper left
Catalogue Zervos, vol. 7, no. 314

This painting can be called a "portrait" in that it adheres to that perennial task of painting to capture a figure and physiognomy. It refers to the style developed during the bourgeois period from Ingres to Cézanne of a half-length portrait of a woman sitting in an armchair. Picasso's *Figure (seated woman)* can easily be placed in this context.

The setting is a room with wood panelling indicated on the right. Various shades of colours refer to the spatial extension into one corner of the room and different lights reflect on the walls. The armchair is defined by the high wicker backrest. The design of the figure is peculiar. Two eyes, a nose and a mouth depict a face with ears attached to the left (curved) and right (straight) outline.

Picasso's point of departure from portraiture was a childlike cheerfulness. He also creates a rich colourful composition of double-entendres containing geometric elements reminiscent of Mondrian. Each element has two meanings. They can be read as two or three-dimensional, concrete or abstract, and as "ground" or "figure".

The female identity is indicated by the bright yellow segment to the right of the head (the thick long hair) and the grey-black curvature in front of the wicker (a breast in profile). The dark rectangular form to the right of her white, thin throat could represent a frontal view of the other breast.

An anatomy assembled in this manner,

together with the missing arms, would correspond to Picasso's, as well as a child's sign-magic. In the early 1930s Surrealists Miró, Arp, and Giacometti worked with such sign-magic. The childlike form (white elements) are transformed into a child-woman through the appended hair and breasts. It is an extremely young woman still possessing the open brazenness of childhood, possibly Picasso's young companion Marie-Thérèse Walter.

This representation of a female bust, a white structure with engraved facial features, anticipates the sculptures Picasso created in 1957–58.

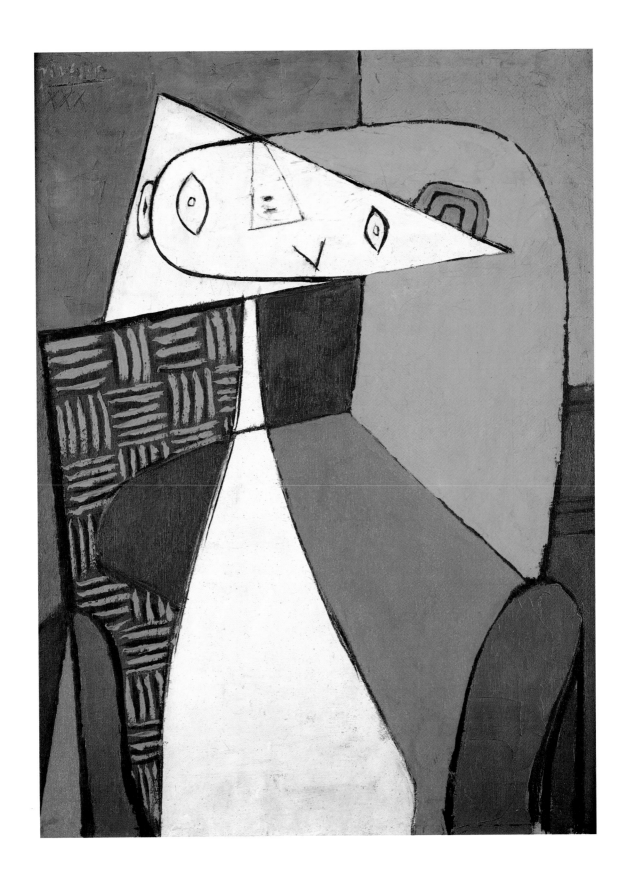

PABLO PICASSO Figure (seated woman) 1930

Pablo Picasso

15
The rescue 1932
Le sauvetage

oil on canvas • 130 x 97 cm
signed upper right and dated reverse
Catalogue Zervos, vol. 8, no. 66

In the interpretation of Picasso's art it has become fashionable to establish a connection between his intimate life and the contents of his oeuvre following the motto "art as autobiography". This particular method of psychoanalytical study reveals more about the authors than about Picasso's work. Such analysis of paintings from 1932 of bathing, swimming or rescued women invariably note the competition of Picasso's wife Olga with the young Marie-Thérèse Walter. At that time Marie-Thérèse, who was a minor at the beginning of the affair, was indeed Picasso's secret love (see *Figure (seated woman)* p. 45).

Marie-Thérèse's facial features and body are recognisable in many paintings and sculptures created between 1927 and 1937. At least two of the women in this painting have her profile and long blond hair. In fact, Marie-Thérèse was an athletic swimmer with the sensual body of a young woman and a youthful frame of mind. This painting shows her head and hands surfacing from the water (lower right) and her body against the background of grass. Two women rescue a third, unconscious or perhaps dead woman from the water, and lay her down on the grass.

Psychoanalysis is not needed to infer the name implied in this picture, only familiarity with Greek mythology. Flowers with elongated lance-shaped leaves and white crucifers grow in the grass, standing close together above the head of the rescued woman. Their botanical name is "narcissus poeticus" (on the shore grows pancratium maritimum). The generic name is derived from the Greek *Narkissos*, the son of a god and nymph. Beautiful, young Narcissus was courted by many women and men, but repulsed all. When the nymph Echo fell in love with him and pined away to a mere voice, Narcissus' rejection of her love drew upon him the vengeance of the gods. He fell deeply in love with his own reflection in the water and died or wasted away in his futile passion. Flowers of infatuating, intoxicating fragrance sprang up where he died. In Picasso's picture the narcissistic young person is obviously a woman. The artist associated the allegory of Narcissus and the nymph with his own young love.

46

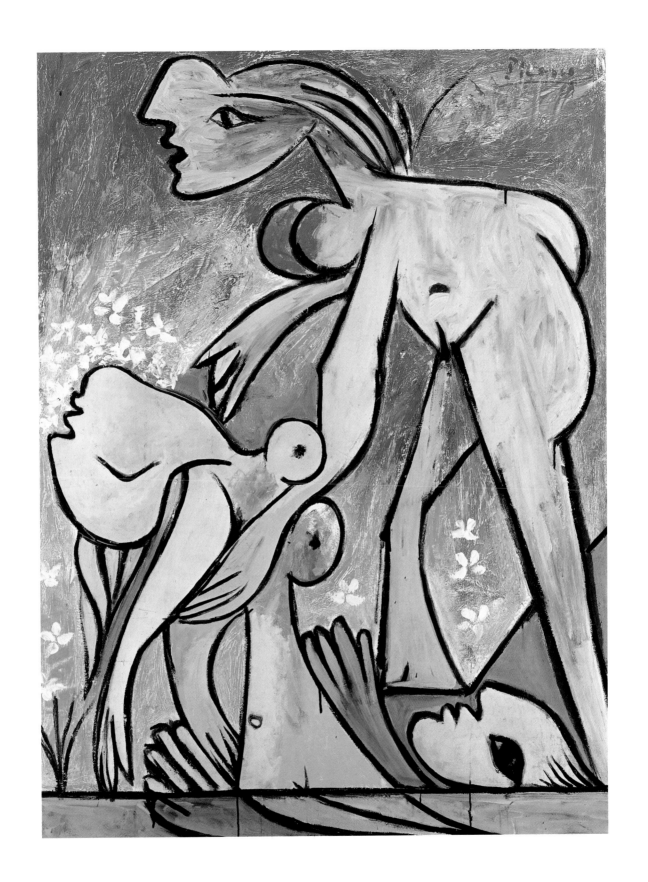

PABLO PICASSO The rescue 1932

Pablo Picasso

16

Sculpture of a head 1932
Sculpture d'une tête

charcoal on canvas • 92 x 73 cm
signed lower right

In spring 1931 Picasso bought the Château de Boisgeloup (ninety kilometres west of Paris) and converted the stable into a sculpture studio. Throughout 1931 and 1932 he created a number of sculptures as well as the lyrical and erotic engravings that became part of the *Vollard suite*. Most of these works were inspired by the young, sensual Marie-Thérèse Walter, who was also the model for *Sculpture of a head*.

This is a rather peculiar head on a massive throat, which looks like the gluing together of modelled forms. The cheeks are two masses, the eyes and lips are small globes. Two facial views, nearly frontal (left half) and profile (right half), are dwarfed by the "clump" of the forehead.

The nose and hair resemble sausages. Deep grooves between the individual features—cheeks, lips, nose, eyes, hair—intensify the exaggerated plasticity. The encounter between lips and nose is evidently erotic. In this period Picasso invested a variety of innovative forms, in drawing, painting and sculpture, with sexual double-entendres (see also *The wine bottle*, p. 41, and *Musical instruments on a table*, p. 43, both from 1926). In the Boisgeloup sculptures and in this drawing, the artist fused sexual metaphors in one object to represent a woman's head with strikingly palpable sensuality.

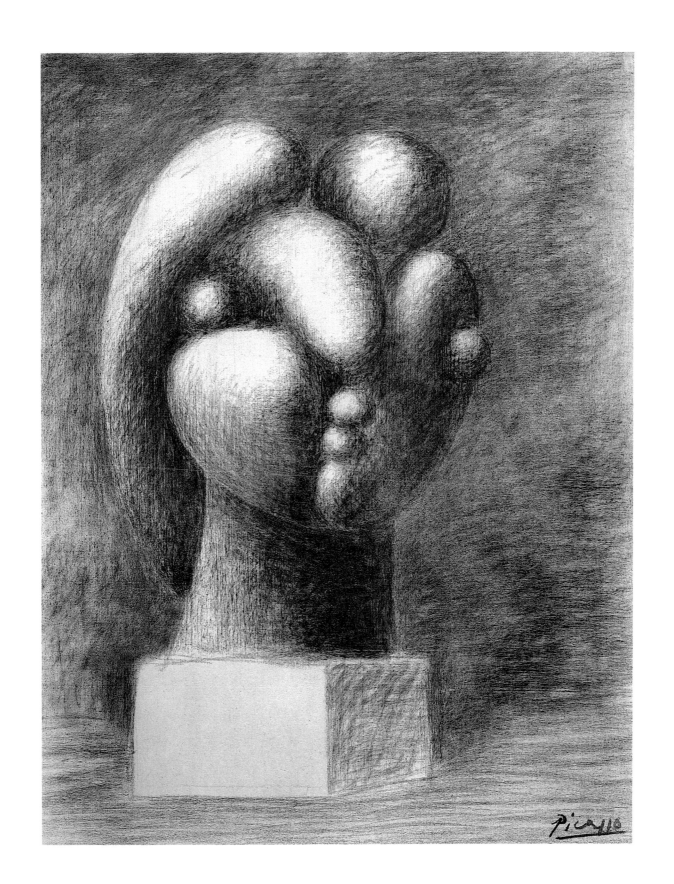

Pablo Picasso

17
Seated woman 1938
Femme assise

ink, gouache, and coloured chalk on paper • 76.5 x 55 cm
signed lower right and dated "27.4.38"
Catalogue Zervos, vol. 9, no. 133

Picasso could render a simple motif such as a woman's head a thousand different ways and he added to his repertoire daily. He was inspired by the motif itself or the material in which he worked. In this piece it is ink, gouache and coloured chalk.

A woman, possibly Dora Maar, sits on a wicker chair which is insinuated by thin strips. The bright blue background, her straw hat and summer dress evoke sunshine. Her face is depicted both in three quarter profile and full face. She looks either sideways and out of the picture or into herself. She listens both left and right, and she is totally integrated in the situation. This existential view of momentary being is expressed in aggressive detail and harmonious unity through a common pictorial language of lines, pastel hues and Cubist and Surrealist conventions.

Since his Cubist period Picasso could combine different perspectives of a figure in one picture. The first time was *Portrait of Wilhelm Uhde*, in 1910, showing one eye in frontal perspective, the other in profile. Already in 1909, in a landscape series of *Horta de Ebros* in Spain, he presented light and shadow from both left and right as with the different chairposts in *Seated woman*. And still earlier, the African masks taught Picasso to render eyes and ears not as anatomical objects but as symbols for "looking" and "hearing".

In his Surrealist works Picasso enhanced these symbols with emotional and grotesque inventions, especially in the satirical etching *Dream and lie of Franco I*,1937. Dora Maar, who is presumably the model for *Seated woman*, is primarily known as the model for Picasso's weeping women, created in connection with the Spanish civil war. But here, although solemn, she seems to enjoy a moment of respite in the sun.

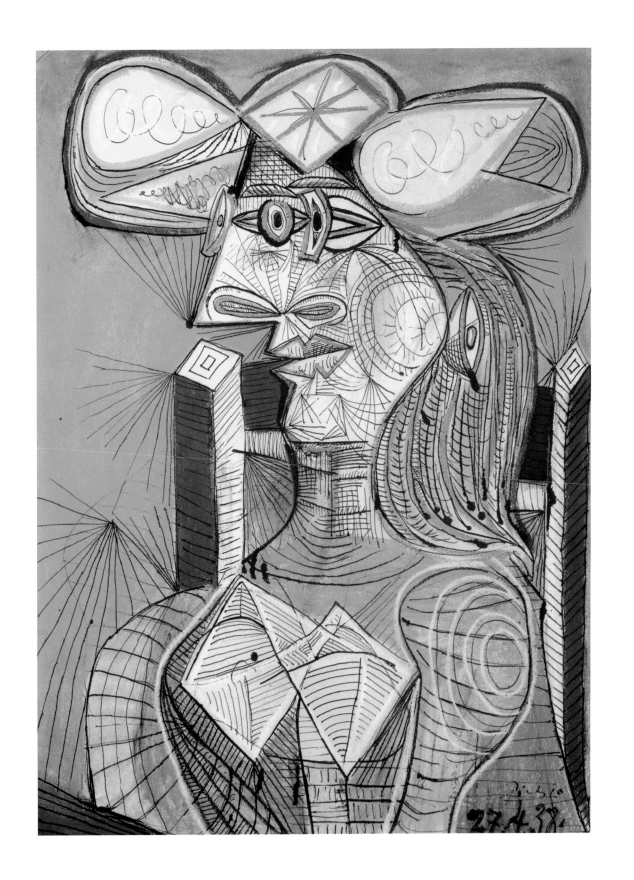

Pablo Picasso

18

Woman sitting in an armchair 1938
Femme assise dans une chaise

china ink on paper • 65 x 50 cm
signed lower left, and dated "4.7.38"
Catalogue Zervos, vol. 9, no. 179

A series of drawings created in the summer of 1938 and the preceding coloured work exploit the same motif and style as this drawing. A woman with straw hat sits in a wicker chair typical in the Provence. Her elbow leans on the armrest while her right hand lightly touches her chin.

Twenty years earlier, Picasso demonstrated the drafting skill of an Ingres or Raffael. During this period, he draws as if with spider webs. He constructs figures as if from wire grating and chairs as if from tapered blocks of wood. One detects a great deal of fun, even joy, in

this style he termed "contre nature". It is against all tradition and reality, thus the execution itself becomes the pictorial subject.

Picasso became engrossed with the simple but surprising possibilities of pen and ink. This becomes obvious when comparing this drawing to Matisse's *Seated young woman in lattice dress* (p. 109), which depicts an identical motif in a mesh of lines in charcoal and wash.

Although both drawings exude sensuality, Picasso's arises from the manner of drawing

and not from the figure or the intimacy of the setting as in the Matisse work. Open and hidden symbols for the rounded parts of the female anatomy contrast with the pointed edges of the chair. The impression of the peaceful self-satisfaction of Picasso's woman is perhaps analogous to the depiction of tortured saints as she conceals her endurance of the masculine aggression of that time.

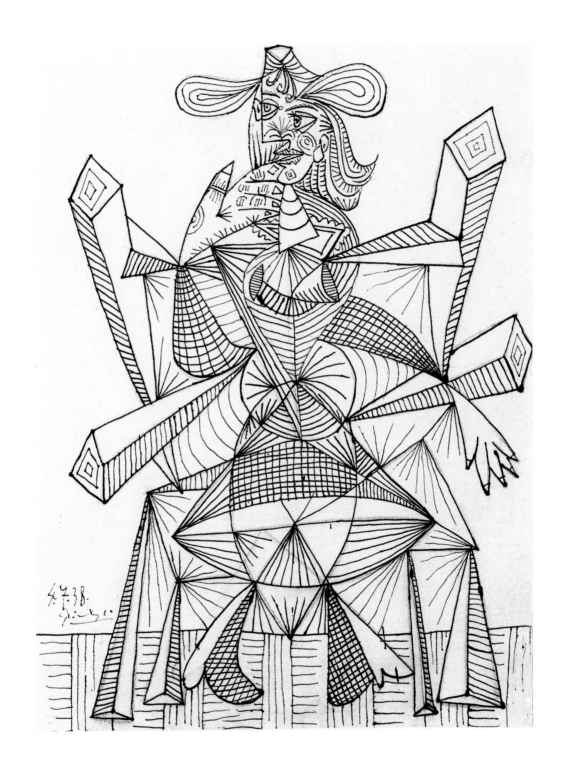

PABLO PICASSO Woman sitting in an armchair 1938

Pablo Picasso

19

Woman with a crown of flowers 1939
Femme à la couronne de fleurs

oil on canvas • 54 x 32.5 cm
signed lower left and dated upper left
Catalogue Zervos, vol. 9, no. 311

This work was painted at a difficult time for Picasso. The war in Europe was imminent, following on the heels of the horrific Spanish civil war which had so deeply affected him. At this time many of his paintings were bitterly twisted and ugly—even when his subject was his new lover and friend, Dora Maar or Marie-Thérèse, the mother of his daughter Maya. After his great masterpiece *Guernica*, he vented his rage at human suffering through his art and often in images of those he most loved. This particular image however is remarkably gentle and may represent a tender moment enjoyed with Marie-Thérèse and Maya at Royen where they spent the summer of 1939.

The distortion of the head is common in paintings of this period. The profile has been doubled to allow us to see both eyes, thus magnifying the volume of the nose and fore-head in relation to the chin. This juxtaposition of two bulging volumes was a striking feature in the sculptural portraits he made in the early thirties. The simple curves of the features are echoed in the arch of the shoulders and the two arcs which form the breasts. These harmonious colours are complemented by the tiara of flowers and the sweet juxtaposition of pinks and yellow.

While the image contains residues of analytic Cubism, in the placement of the eyes for example and faint echoes of collage in the way a flat patch of pink check stands for the dress, it prefigures a looser more light-hearted style which is to emerge some time after the holocaust.

T.B.

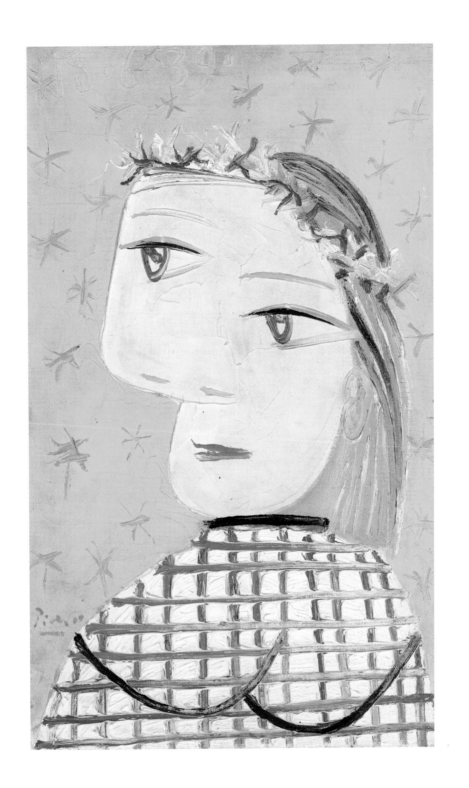

Pablo Picasso

20

Head of a woman (Dora Maar) 1941
Tête de femme (Dora Maar)

bronze • 80 x 40 x 55 cm
one of four unnumbered casts
Casting stamp "Susse"
Catalogue Spies-Piot, no. 197

Picasso's importance as a painter did not preclude or overshadow his standing as a sculptor and as a significant contributor to the development of sculpture. No artist shaped the history of sculpture in his century as decisively as Picasso had from Cubism onward. His sculptural work is full of innovation from one epoch to another—and full of masterpieces.

During the German occupation of Paris, Picasso created *Head of a woman (Dora Maar)* in the same studio where he painted his seminal work, *Guernica*, 1937. The studio was located on the Rue des Grands Augustines in Paris. His *Head of a woman* transcends mere portraiture and is a monument of resistance and human dignity as well as an immortal artistic ideal.

In previous years Picasso painted and sketched the Spaniard Dora Maar numerous times. She was his model for the weeping women expressing the horrors and sufferings of civilians during the Spanish civil war. The serene expression of this sculpture is comparable to archaic statues of gods. The mass of the head and base and the nearly symmetrical composition combined with frontal directness impart its votive character. Hair and ears are indicated as incisions and emphasise the power of the plasticity of the face and forehead, the rounded cheeks, prominent nose and strong chin. Her mouth is small and closed, showing no emotion. Her large eyes are wide open and staring. Behind the surface one senses that she is full of life.

This archetypal head may be construed as an allegory for a goddess or muse of life and survival, but there is no definitive clue for this interpretation. However, a further cast from 1959 was erected as public monument for Picasso's friend the poet Guillaume Apollinaire in front of the church Saint Germain-de-Près in Paris.

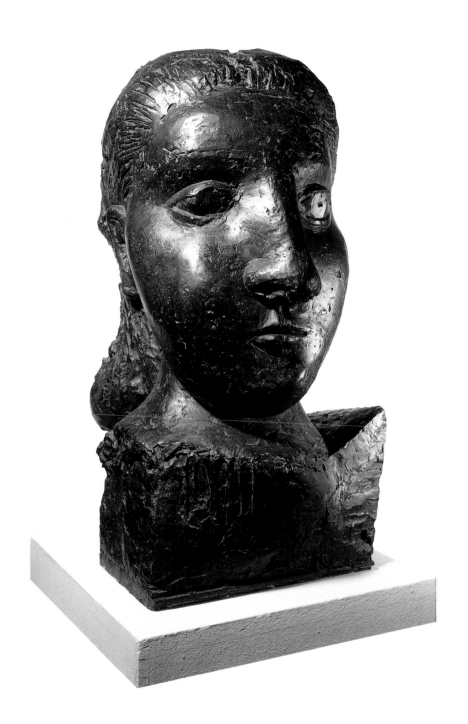

PABLO PICASSO Head of a woman (Dora Maar) 1941

Pablo Picasso

21
Painter and model 1953
Peintre et modèle

ink on paper • 26 x 21 cm
signed upper left, and dated "Vallauris 24.12.53"
Catalogue Zervos, vol. 16, no. 78

In November 1953 Picasso began a series of drawings on the theme of *Painter and model* which he completed in February 1954. During this winter he created 180 drawings showing an aged painter with an attractive female model. They illustrate the problems and psychology of an artist encountering the tension between the erotic and creative impulses and between art and reality. Each drawing is a variation on the theme with different characters and anecdotes.

The complete series *Painter and model* was published in the September issue of the journal *Verve* in 1954 (no. 29/30). It "reads" like a pictorial story rich in witticism. The old and tired painter is no longer the potent lover (unlike Picasso), but still lusting after the female. His artistic endeavours become only a partial alibi for his desires.

This drawing shows a young woman, perhaps the same age as Françoise Gilot, Picasso's companion at the time. The bound hair (turban), the placid countenance and the demure demeanour (hands folded over the stomach) reflect an attitude of unassailable decorum.

Like a protective wall, the easel shields her from the prurient artist who is apparently engrossed in his work. But his erotic motivation is unintentionally exposed by the brushes on his knee and the manner in which he aims his brush like Amor's arrow towards the woman. The bent brush handle pointing to the artist's forehead makes the clear statement that art transforms sensuality, as Leonardo da Vinci said, into a "cosa mentale".

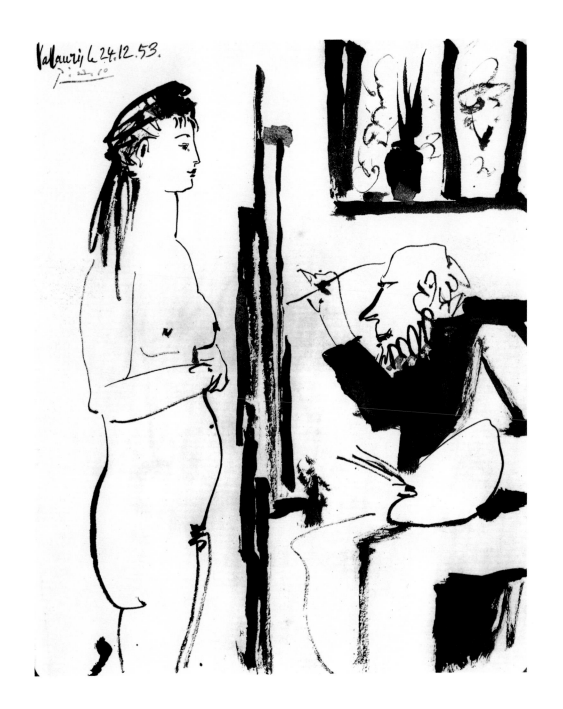

Valauris le 24.12.53.

Pablo Picasso

22
Woman with hat 1961
Femme au chapeau

metal cut-out, folded, and painted 1963 • 126 x 73 x 41 cm
reverse signed
Catalogue Spies-Piot, no. 626, 2a

In 1960/61 the now eighty year-old master bestowed upon sculptural art still another innovation. He made cut-outs from sheet metal, folded it to confer stability and bent it back and forth to confer volume. Similar experiments had been done in 1914 to 1916 when he shaped small Cubist structures with still life motifs. What then was still improvisation, now fulfilled the demands of monumentality. Two unpainted examples of *Woman with hat* belong to Picasso's heirs. There is another one which is painted white in the Musée Picasso in Paris. This one was painted in 1963.

This sculpture has the features of Jacqueline Roque, who married Picasso in 1961. Her forehead and right eye are shown in frontal view. The nose and left eye are in left profile and the mouth and chin in right profile. The half-figure sits in a red upholstered chair with a winged armrest. Her blue dress with perforated collar and blue hat, suggest she is ready to go out.

The fingernails of the metal figure are cut out rather than painted, in order to convey an immaterial gloss. Her breasts are folded over the upper body, under which the painted shadow gives them considerable volume. Many "trompe l'oeil" effects are used in an amusing play between painting and sculpture, between two and three-dimensional parts, and between painted and cut-out silhouettes. These also set up the play between the subject and background, and between the imaginary and reality.

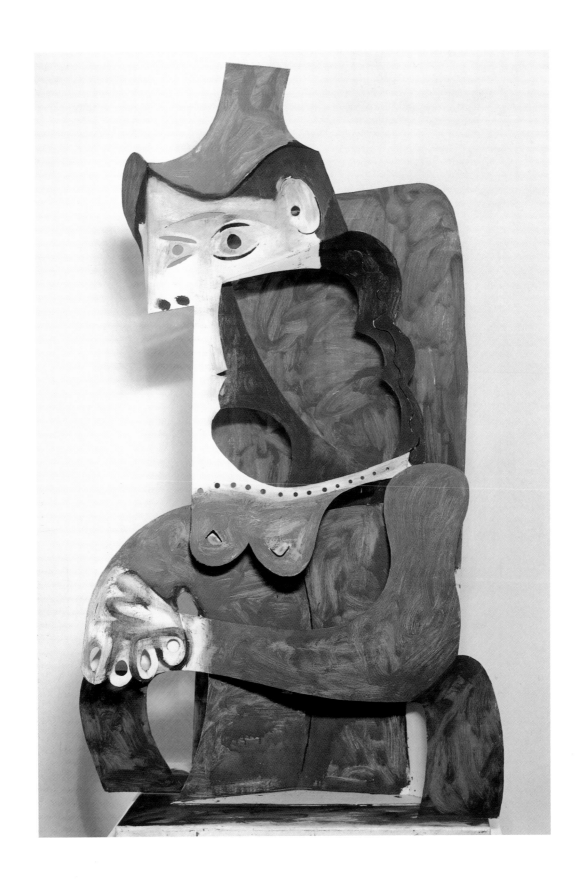

Pablo Picasso

23

Young woman with outstretched arms 1961
Petite femme au bras écartés

metal cut-out, folded and painted • 36.2 x 34.5 x 13 cm
Catalogue Spies-Piot, no. 594/2a

Picasso changed art tradition as radically as any artist in western history, by making sculpture using construction and assemblage rather than employing the carving or modelling methods which had been used since ancient times.

Between 1912 and 1915 Picasso and Georges Braque had worked closely together in an intensely creative and experimental partnership. Building on the principles of collage, they made a series of cardboard, wood and metal constructions that projected the intricate spatial illusions of Cubist paintings forward into real space. Picasso once again resorted to folding sheets of metal and painting them in his eightieth year, in a series that demonstrated his idea of a pictorialist sculpture. In this last phase of his three-dimensional explorations, Picasso followed his dictum: "to get a sculpture all you have to do is to cut out your painting".

Now more concerned with surface continuity than in the early Cubist constructions, Picasso unfurled his metal bodies into space. The small head, triangular shape and wing-like arms of this sculpture heighten the impression of lightness Picasso imparted to the work, even when the figure was expanded into the large cast concrete version of 1962.

Over and over again throughout his career, Picasso re-invented the human figure in a series of startlingly non-naturalistic forms. Like Matisse's cut-outs a decade earlier, the bold simplicity of Picasso's late figuration is achieved with an economy of means that remains extraordinarily powerful. U.P.

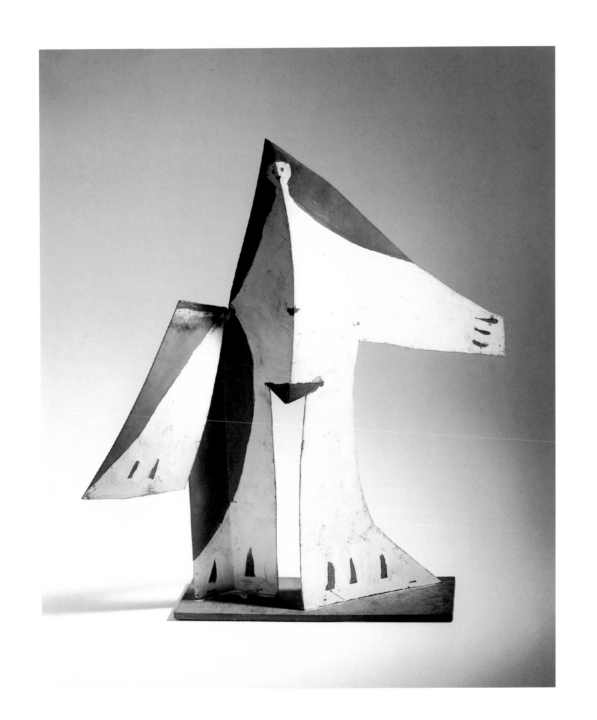

Pablo Picasso

24
Head of a woman 1961
Tête de femme

metal cut-out, folded and painted • 28 x 21 x 9.5 cm
Catalogue Spies-Piot, no. 610/2

In his later years Picasso turned again to his earlier Cubist sculpture made out of bent sheets of cardboard or tin. They were often painted and inscribed as in this example. The basic form is simply realised with two folds. One straight seam runs down the front coinciding with the nose and chin and another gently curves from the forehead through the cheek to the throat.

The folds allow the form to be free-standing even though Picasso has chosen to give the sculpture the security of a base plate. At the same time, the folds subtly define the volumes of the face, lifting a simple drawing into a fully plastic sculptural work.

The linear drawing is achieved with sgraffito, a line scraped into wet paint or plaster. This technique borrowed from antiquity and Italian fresco enhances the classical character of the face. In the early 1960s Picasso often returned to the flower-like eye and profile of Jacqueline Roque.

It is remarkable that Picasso's light touch is able to play with classical reference, create spatial compression, revive Cubist tendencies and turn drawing into sculpture in such a simple and elegant object. T.B.

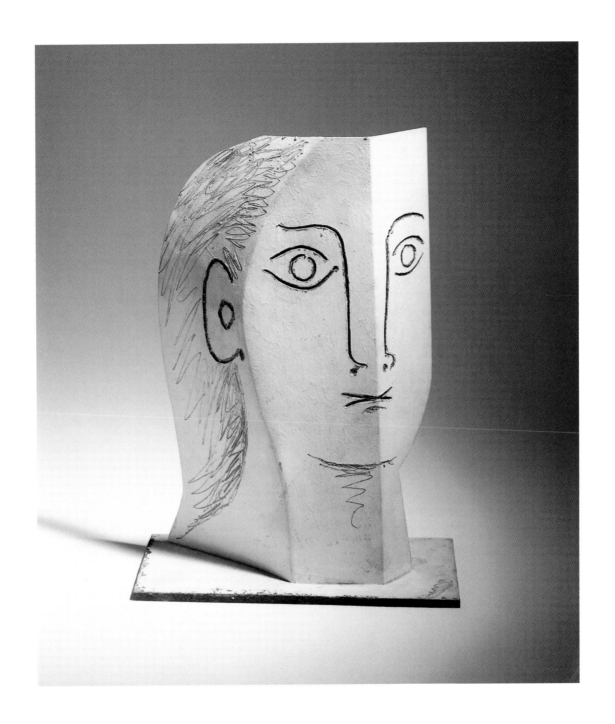

Pablo Picasso

2 5

Reclining woman playing with a cat 1964
Nu couché jouant avec un chat

oil on canvas • 114 x 195 cm
signed upper right; dated reverse "10 et 11.5.64"
Catalogue Zervos, vol. 24, no. 145

Picasso painted this masterpiece in May 1964 as he approached his eighty-third birthday. He had been married for approximately three years to Jacqueline, his inspirational model since 1954. Despite her presence which possibly assured thoughts of life and erotic vitality, thoughts of death intruded. And though he forbade mention of death in his presence, these thoughts occasionally cast a shadow on his painting. This is the most poignant in a series of similar paintings from this period.

After learning of the death of his friend Ramon Pichot, Picasso expressed death by outlining a face in black in *La danse*, 1925. Here the black outlining supplements the profile of the women like a shadow on the wall. Her reclining pose and the high relief of her full body recall funerary art. It seems a particular reference to the terracotta figures on Etruscan sarcophagi of the 6th century B.C. The figure in the painting exhibits the same vigorous stare as in the rigorous Greek profile of the 6th and 5th century B.C. and relates to the female heads of the late archaic vases of the Andokides-painter. But these connections are belied by the woman's features and her teasing of the cat. The stretched, naked female body and the cat invoke Manet's *Olympia* of 1863.

Great mythological and funeral art intimates death, but here the pictorial symmetry embraces the joyful and ephemeral. A kitten has a tickling feather in his claws while, at the same time, his claws tickle the woman. In spite of the conspicuous monumentality, the picture is like a sudden impulse. The canvas is partially covered with spontaneous black strokes and liquid grey tones that produce the flickering light which is nowhere more apparent than on the lower breast. In Picasso's predilection for ambiguity and pictorial riddles this area resembles an eye.

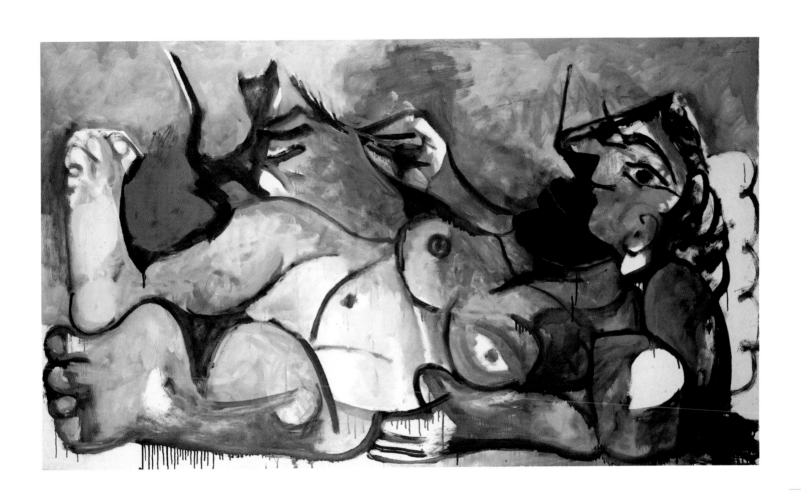

Pablo Picasso

26

Vase with flowers on a table 1969
Vase de fleurs sur une table

oil on canvas • 116 x 89 cm
reverse dated "18 octobre 1969"
Catalogue Zervos, vol. 31, no. 486

In the chapel of the Palais du Pape in Avignon in 1970, Picasso exhibited 166 pictures that he had painted in just over one year—from 5 January 1969 to 1 February 1970. These works enraged the experts who earlier had granted him all the freedom of a genius. To the question of whether these paintings and their eroticism stayed within the boundaries of accepted artistic greatness, these judgemental critics answered "no". Now they wrote that Picasso at almost ninety years old had lost his skills and that senility had caught up with him. In truth, however, Picasso had entered a new phase of maturity as well as youthful playfulness, as if compelled to contribute a message to the revolution of 1968.

When Ernst Beyeler visited, Picasso remarked that his new paintings would meet with approval ten or twenty years later. When in 1980 the Museum of Modern Art in New York showed a comprehensive survey of Picasso's oeuvre, the exhibition contained just a few late works and presented them with a certain embarrassment. But several collectors and art dealers recognised the importance of Picasso's stylistic and thematic freedom for the contemporary art of the seventies and eighties. In 1981 the Kunstmuseum in Basel dedicated a centenary exhibition to the late work of Picasso. Ernst Beyeler not only participated in this exhibition but also initiated it. These works by Picasso were subsequently shown in 1983 in New York and in 1988 in Paris and London. We know now that Picasso painted while in a contest with death and did not care about "mastery" and decency. Above all, he conveyed what he thought important, the polarity of eroticism and death.

The painting *Vase with flowers on a table*, dated 18 October 1969, was preceded by a draft. These are the only still lifes in a long succession of gallant musketeers, sensuous women and passionate love scenes. Erotic allusions are also not missing here. Sprouting spirals provide a metaphor for swelling genitals, but when painted over, thoughts of death intrude. The vase resembles the bony skull of a goat and bright forms within its shape suggest skeletons. The pleats of the tablecloth are like the wings of a bat, and grey-black obscures the rosy colours of life on the lower left.

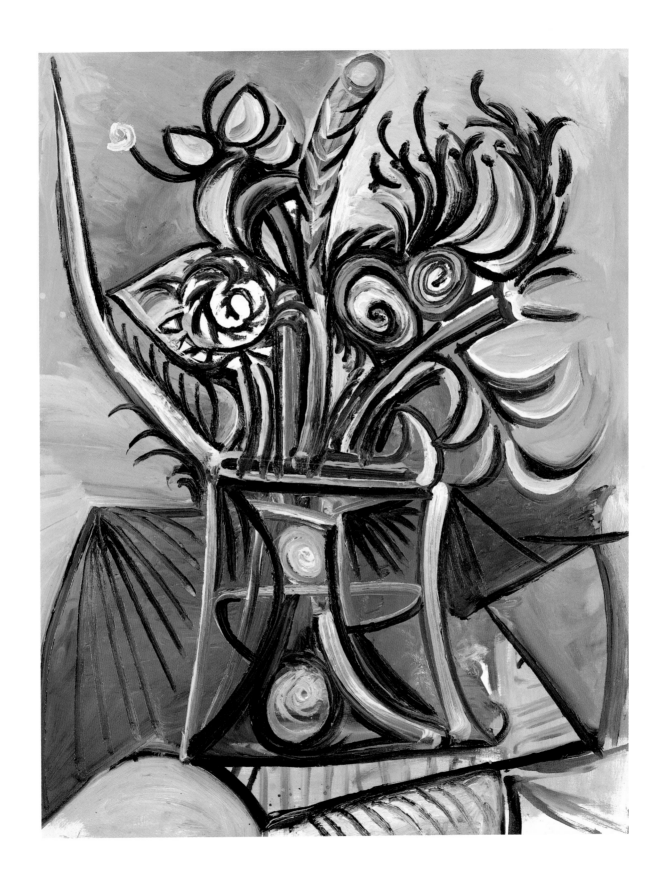

Pablo Picasso

27

Reclining nude and man with mask 1969
Nu couché et homme au masque

pencil on paper • 50 x 65.5 cm
signed upper left, and dated "5.9.69.II"
Catalogue Zervos, vol. 31, no. 414

If all of Picasso's drawings dealing with the theme of man and woman were combined into one book, the result would be an unique encyclopaedia of gender psychology comprising several thousand pages. Picasso delineates an endless variety of emotions and perceptions starting with the original protagonists—a nude woman and a man courting her.

After satisfying her desire, the nude woman has fallen asleep in a posture of plantlike tranquillity. She is a concubine. The long, lacquered nails of one hand, having fulfilled their coquettish purpose, lie on her breast warding off any intruder upon her sleep.

The psychology of the man is infinitely more complex. The loin-cloth and wild, curly hair and beard identify a primitive barbarian common to ancient art and mythology. This "wild man" is middle-aged. He is younger than the mask which symbolises chronological age. He wears the mask when confronting the woman. The shadow of his face on the wall is the shadow of death. His real identity is shielded from the sleeping woman. He lifts his mask, revealing the eye in the middle of the forehead of a cyclops. The second huge eye refers to an artist's intense visual perception. Three decades earlier, Picasso personified his struggling conflicts in the hybrid figure of minotaur.

Arabesques in Picasso's works invariably have significant meaning. The plantlike bedsheet and the nose of the mask are metaphors for male genitals.

The preceding *Painter and model* (p. 59) should not be interpreted as autobiographical as the artist shown is Matisse rather than Picasso. In this drawing Picasso, now eighty-eight years old, probably created his own caricature in the shrivelled, toothless mask by portraying his own black, buttonlike eyes.

5.9.69. II

PABLO PICASSO Reclining nude and man with mask 1969

Pablo Picasso

28

Profile of a woman 1969
Profil de femme

linocut, ink and crayon • 75 x 62 cm
signed lower right and signed and inscribed lower left "for Hildy Beyeler 1 April 1970"

The women in Picasso's life—his wives, mistresses and friends—became emblems of his art, each inspiring a new phase of his career. By turns tender, tormented or terrifying, the faces of these women recur in many guises—as muse, lover, mother, or monster. In his last years Picasso's graphic genius came to the fore and he explored printmaking techniques in a rich outpouring of images.

Linocuts were a fleeting passion with Picasso. He made his first one in 1939 but did not use the technique again until the so-called "Jacqueline years". In the 1950s he used it mainly to make posters and portraits, many with Jacqueline as the subject. In 1963 he published two linocuts in editions of fifty, after that he made others which were never published, or were only put on sale after his death. This late profile portrait is a vigorous example of Picasso's inventive use of a boldly gouged linocut technique combined with a freely executed overlay of ink drawing and sketchy crayon colour accents.

This head of a woman inscribed, "for Hildy Beyeler" is dominated by a large eye which, in the fashion of the art of ancient Egypt, Mesopotamia and Crete, is full and almond-shaped rather than in profile. It is known that Picasso associated Jacqueline with the physical types idealised in Minoan art. The symbolic eye was also a recurring obsession with Picasso, and watching or being watched was one of the key themes of his art. The associations he made between love, blindness and art caused him to say to Cocteau that, "painting is a blind man's profession". U.P.

PABLO PICASSO Profile of a woman 1969

pour Hildy
Beyeler
10 1er Avril 1970

GEORGES BRAQUE

1882–1963

29
Woman reading 1911
Femme lisant

oil on canvas • 130 x 81 cm
reverse signed
Catalogue Worms de Romilly 1907–1914, no. 92

Braque and Picasso spent the month of August 1911 in the same house in Céret in the French Pyrenees working on the style of painting that reached its climax with hermetic Cubism in 1911. From 1911 to 1915 they were familiar with each other's discoveries and pictorial jokes. Picasso's *The mandolin player* (p. 33) was painted after their stay in Céret. Braque's *Woman reading* presumably was painted earlier. Both are considered masterpieces of Cubism.

The reading woman sits in a room on an upholstered armchair, characterised by the spirals (to the left and right) and the adjacent tubular forms. Similar tubular elements indicate the upper edge of the backrest. A rising triangular structure with many fragmented parallel lines is spread across the entire figure. Her head, hair and face are easy to detect. But it is not clear if the woman is dressed, perhaps in a robe with cords, or if she is nude and the semi-circles are her breasts. She reads a book or newspaper indicated by the parallel tubular objects to the right.

An analysis of this painting cannot be based merely on the representation of a woman in a room. The primary principle is a surface structured by geometrical, vertical, horizontal and diagonal lines. By placing them side by side or joining them with semi-circular forms and spirals an illusion of tubes and semi-round bodies is created. When connected by short lines and modulated by colour, an illusion of small cubes results. These optical tricks from theories on the psychology of perception evoke protruding and receding "three-dimensional" bodies on a flat surface. Simple examples of this are the ovals and spirals attached to parallel tangents and appearing as three-dimensional "tubes" or, as in this work, as armrests of the chair.

Braque structures a plethora of geometric combinations with stereometric perception and effects. He adds arbitrary spots of light and shadow to develop a complete composition, which can be interpreted as a human figure sitting in a chair.

74

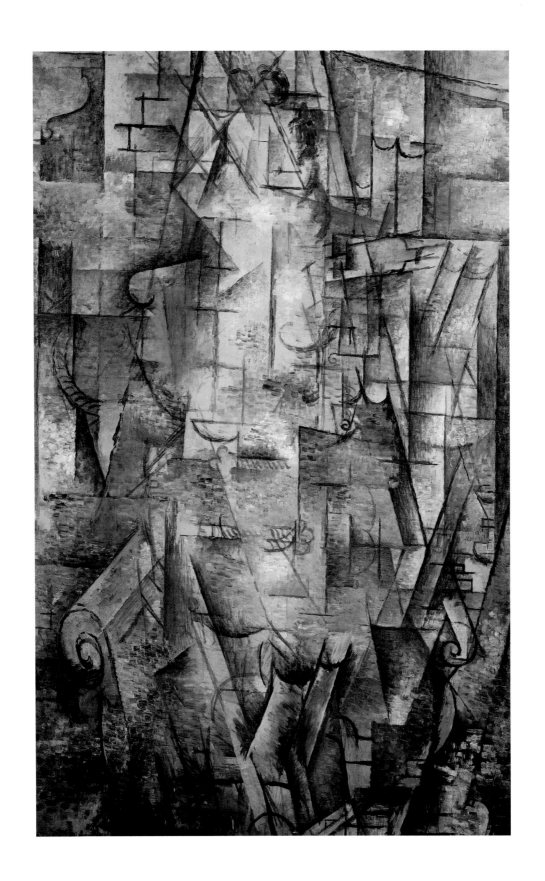

Georges Braque

3 0
Glass, bottle and journal 1912
Verre, bouteille et journal

charcoal and papier collé • 48 x 62 cm
reverse signed
Catalogue Worms de Romilly 1907–1914, no. 162

Braque told the collector Douglas Cooper that he got the idea for the "papiers collés" technique between the 3rd and 12th of September 1912. From the end of July to October 1912, Braque and Picasso worked in close contact with each other in Sorgues near Avignon. During this time they were concerned mainly with increasing the colouration and developing a more immediate recognition of objects in their Cubist compositions. Braque discovered a colourfully printed paper with imitation oak veining at an Avignon carpet dealer's, but did not buy it until Picasso left for Paris. He wanted to surprise Picasso with the first "papier collé" upon his return.

The veined paper cut-outs in *Glass, bottle and journal* were taken from the same roll of paper. Picasso immediately adopted this new technique, and employed it brilliantly with newspaper cut-outs (see *Bottle on a table* p. 37). Braque adopted the use of newspaper cut-outs in 1913.

In Braque's first "papier collé" the journal is still represented by drawn letters JOUR[NAL]. The compositional lines of the objects on the table resemble Picasso's in *Bottle on a table*. Allowing for the equation of words with pictorial elements, one may interpret the object in the left half as a bottle and that off-centre as a

glass filled with beer. The pasted-on paper may refer to a wooden table and the paper above the glass could indicate wall panelling. But it may well be that Braque just wanted to exploit the decorative colour qualities of this wallpaper. The coloured paper has an undeniably stabilising effect on the immaterial, floating lines.

The two "papiers collés" by Picasso and Braque in the Beyeler Collection represent the earliest examples of collage, a technique that became extremely important for twentieth-century artists.

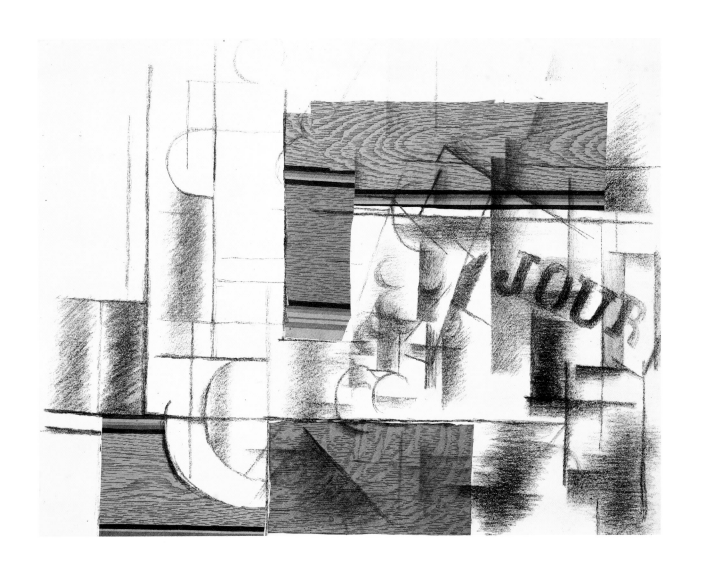

FERNAND LÉGER

1881–1955

31

The railroad crossing 1912

Le passage à niveau

oil on canvas • 93 x 81cm

signed and dated lower right; reverse signed, titled and dated

Fernand Léger is a painter of modern times. His work contains a pure expression of a twentieth-century ideal of a better and more just world. It was his robust vitality, his optimistic view of the technological age and the light-hearted view of nature as a resort for the working class that formed his vision. Léger's representations knew no problems. They even exhibit a wonderful golden age of modern man without personal neurosis or metaphysical fears. He uses colour and form in a way that can only be labelled "poster-like" or "decorative" in comparison with Renaissance paintings such as Raffael's Madonnas. A close analysis of Léger's works demonstrates how sensitive, thoughtful and contemporary they really are.

The railroad crossing, 1912, contains a summary of modern art's development from its beginnings with Cézanne to the novelties in most recent Cubism. Cézanne's *The railway cutting*, c. 1870 (the Neue Pinakothek, Munich), depicts the countryside in the foreground with a cut through a hill in the middle ground. In the depth of the landscape, there is an oscillation between the space and plane of the picture which is a principle that recurs later in Cubism. This is the phase when Léger's modern style of painting begins. The title of this work is chosen for its ambiguity. He draws a railroad crossing on even level with the ground while the street leads into the depth of space—the subject of this painting. The term "passage" was a continuous subject of the discussion among Cubist artists and was a key word that Cézanne used for his specific method of painting. It describes the way in which he structured pictorial space from front to back through small transitional steps yet without the illusionist separation of the picture plane.

Léger interweaves the representation of objects and space in a similar way through fragmentation and open outlines. From the right a small steam engine with huge steam clouds and a bumper (grid) to push cows off the track approaches the crossing with the ochre-coloured street (in the centre). Three telephone poles give perspective to the street and lead into the depth of the picture. To the right stands an iron barrier surmounted by trees and a row of staggered houses. The landscape covers the canvas from top to bottom and front to back. The longer one examines this painting the more one discovers, yet one may not identify every element such as the red patch with the black cylinder on top.

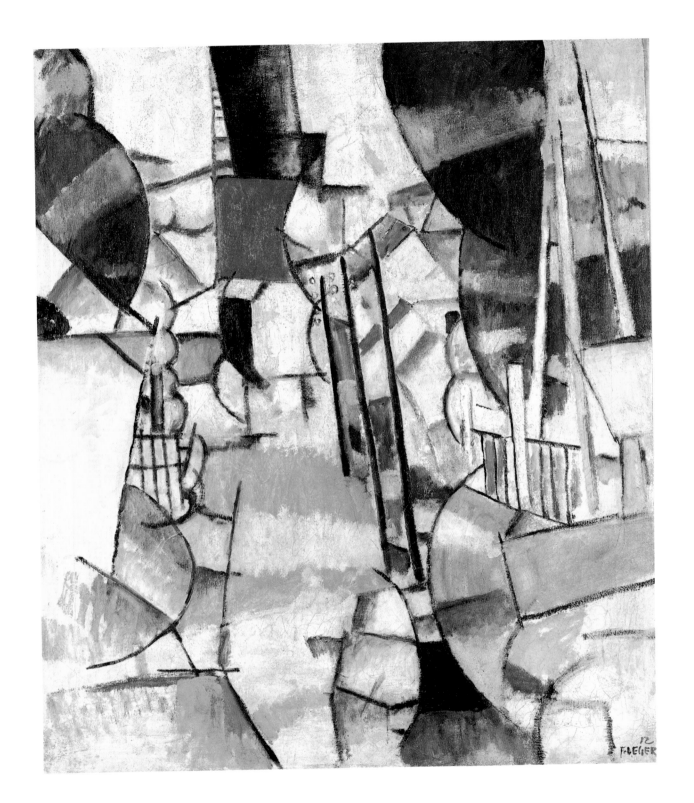

Fernand Léger

32

Woman in an armchair 1913
La femme au fauteuil

oil on canvas • 130 x 197 cm

In April of 1912 Apollinaire had declared that "the young painters of extreme schools want to make pure painting". Léger recalled his 1912–13 phase as "the battle for liberation from Cézanne". His *Woman in an armchair* of 1913 marks a decisive breakthrough in this battle. It represents the moment when his "classical" dynamic style emerges in its complete form. This is embodied in a sequence of abrupt clashes between what he called the separate *quantities plastiques*: choppy black lines, strident colour patches and curving white highlights.

Though wholly transformed, the subject is a familiar one from Cézanne's repertoire, a woman seated three-quarter view. However, the armchair, figure, table and glass have been translated into a descending sequence of component forms. Here every single surface is highlighted, giving an added effect of curvature or volume. In spite of the rough speed of his execution, Léger is careful to keep the edges of each colour patch away from the line which bounds it, emphasising the clash of opposing plastic forces within the picture.

The jointed cylinders of the arms set up a strong sense of rotation at odds with the shifting flatness of the surface described. These dissonant rhythms are accentuated by the opposition of reds and blues on the left and right arms. The importance of these newly dynamic pictorial contrasts was outlined by the artist in a lecture given that same year: "The 'rapports' of volumes, lines and colours are becoming the generators of all artistic production... Pictorial contrasts used in their purest sense (complementaries) of colours and line, of form, are from now on the armature of modern paintings". U.P.

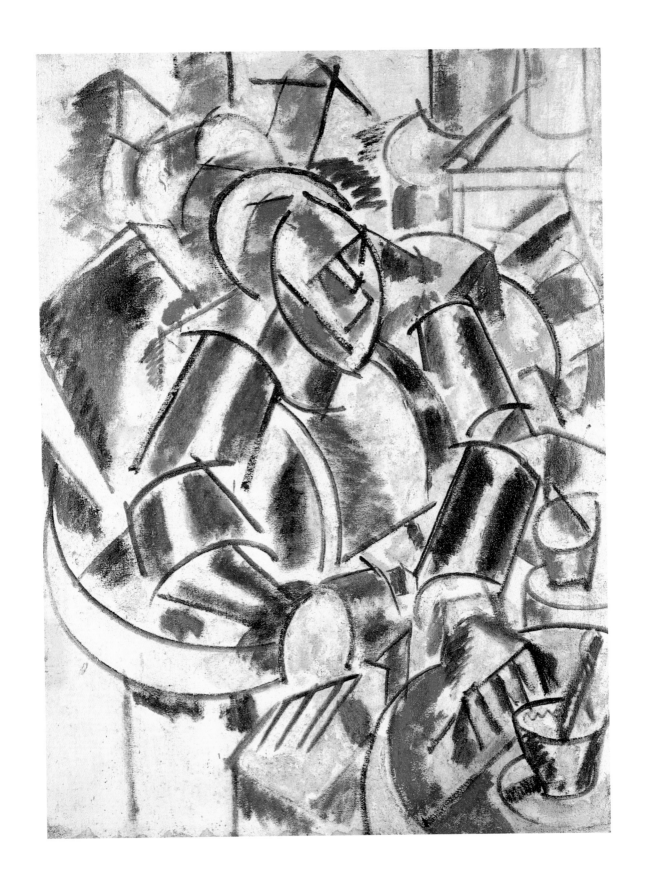

Fernand Léger

33

Still life with coloured cylinders 1913
Nature morte aux cylindres colorés

oil on canvas • 90 x 72.5 cm
signed and dated lower right; verso: another painting with title, signed and dated 1914

The Beyeler Collection owns one Léger painting from each year from 1912–14 that illustrate decisively the development of his style. The still life of colourful funnels and cylinders of 1913 intensifies the stereometry of the pictorial elements compared with the surface cohesion of the landscape from 1912 (see p. 79). The year 1913 marked the transition from the stylised depiction of objects to an object-free form. The paintings with the titles *Contrast of forms* from 1914 represent a climax in Léger's oeuvre (see p. 86).

Léger's stereometric rendition is deceiving. It consists of incomplete and contradictory allusions to perspective and volume. To understand the subject at least a few objects need to be identified. The fork (left) serves as a proportional clue to the other objects which are probably dishes and utensils on a dining room or kitchen table covered with a cloth with trimmings and tassels. The object parallel to the fork could be the handle of a spoon in a plate on top of a beaker. (This beaker is a reference to the turn-of-the-century picture puzzle such as "Mach's beaker" which was a schoolbook illustration of the psychology of perception.) The other objects might be cans or an old-fashioned coffee-grinder. There is no suitable name for the club-shaped objects shaded in white and green, arising like steam to form a cone-shaped open body. The two blue-white tubes in the upper left background seem strangely incompatible with the stereometric forms. Perhaps they are viewed from below and, not as the others diagonally from above.

But paintings of this type are not pictorial puzzles that have to be solved. The pseudo-concreteness supports the various volumes, colours and lights in combination with spaces, sounds and rhythms that endow the picture with liveliness. In the development of style this painting still exhibits the influence of the period of pure Cubist and stereometric modelling. However, Léger put special emphasis on conical and cylindrical forms. His Cubism was humorously named "tubism". From the viewpoint of cultural history, Léger was already on the path of "impersonal objectivity" which to him characterises modern times and which found an artistic equivalent in primary forms and colours.

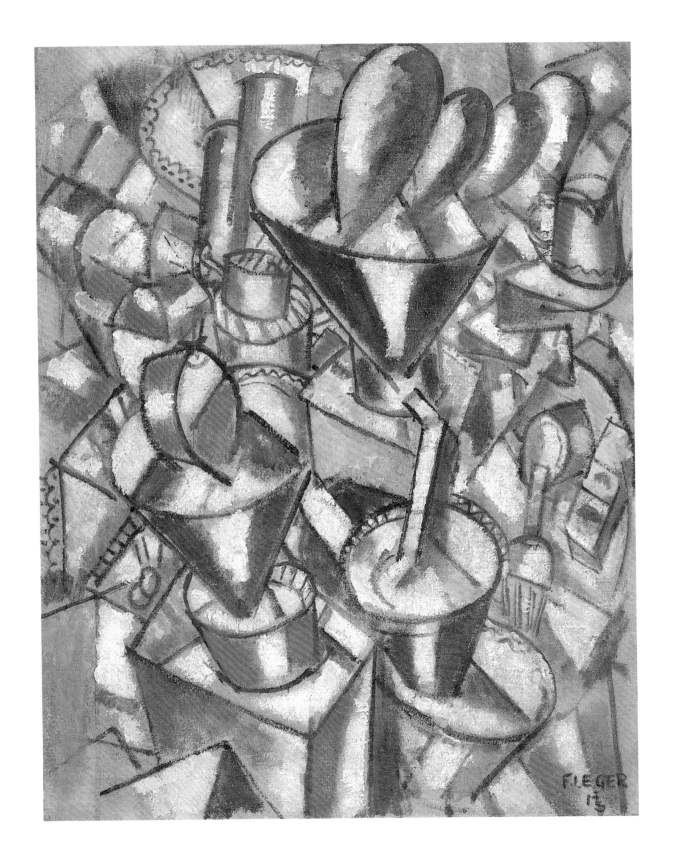

Fernand Léger

34
Contrast of forms 1913
Contraste de formes

oil on canvas • 81 x 65 cm
reverse signed and dated

This is one of a series of works, entitled simply *Contrast of forms*, that Léger began within months of delivering his second lecture at the Vassilieff Academy. In this lecture, later published in *Montjoie!*, Léger argued for the independence of painting from its traditional role of representation and proposed that it should be considered instead: "a thing in its own right, made out of the simultaneous ordering of lines, forms and colours."

Clear references to the figure or to landscape elements can no longer be discerned in his pictures. The tubular language he evolved in *Woman in an armchair* is further abbreviated. A tumble of metallic cylinders with elliptical faces bisected by oblique slashes of blue zigzag through the vertical axis of the composition. From the edges, angled planes of red and yellow invade the densely packed space, wedging in and up between the rotating cylinders. This was Léger's expression of the new beauty to be found in the modern machine-made world; a condensation of the fluid play of foliage or smoke forms across new landscapes of solidified geometries.

Like the Futurists, Léger now focused on the way that speed in cars and trains fragmented the modern consciousness, "made modern life more complex and complicated... to such an extent that our language is full of diminutives and abbreviations". It was this idea that modern life was essentially fragmented that excited Léger's insistence on opposing forms and colours, and his preference for vigorous ruptures of the canvas. If the fundamental quality of modern life was conflict, then the new beauty must reside in contrast and dissonance. U.P.

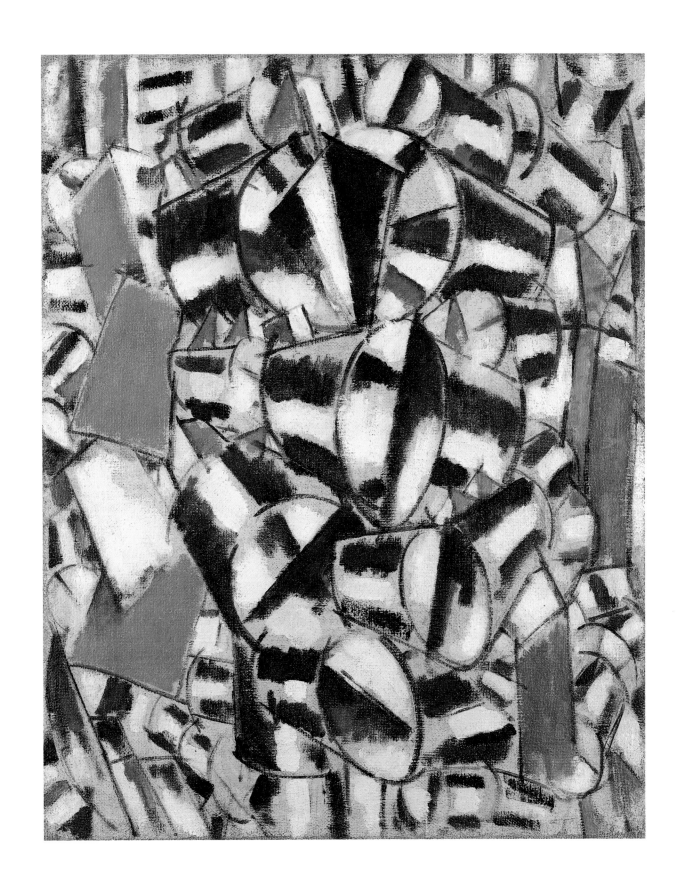

Fernand Léger

3 5
Contrast of forms 1914
Contraste de formes

oil on canvas • 61 x 50 cm
initialled and dated lower right

One of the pictorial means of Cubism is the simple geometric configuration of lines with ambiguous views. Convex and concave stereo-metric forms can be viewed from below or above and from inside or outside, yet they remain within the picture plane. Picture puzzles such as "Mach's beaker" and "Schroeder's staircase" were schoolbook illustrations of the psychology of perception from around the turn-of-the-century. The spatial impression of cylindrical forms in Léger's painting originates from these concepts. From a linear viewpoint they consist of segments of circles, on which tangents are set and connected to smaller (perspectively "distant") segments. White patches create the impression of reflecting light and enhance the material reality of floating tubes.

The central motif is framed through straight and inclined lines meeting at angles and composing boxes and cones in perspective. Various colours are used for brightening and shading these objects which fuse with the picture plane. In contrast to these immobile and stable elements, the circles' and tangents' dynamic effect could be viewed as rotating wheels and moving pistons. Herein exists the "contrast of forms." There is a symphony of counterpoint. The lines and curves and colour and tone contrast in green versus red, yellow versus blue. In an interpretative sense the contrast is movement versus rest or machine versus nature and landscape. Therein lies the essence of Léger's view of the modern world, which he himself called "realistic." Within Cubism Léger developed paintings that did not depict "objects" but rendered a plethora of concepts. This dynamic quality was further developed in Futurism.

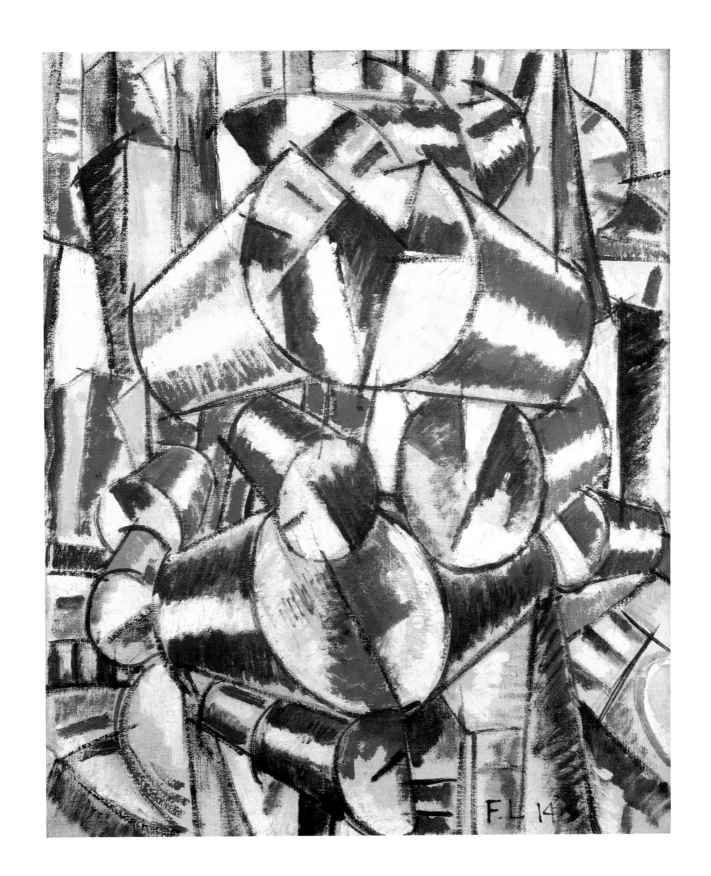

Fernand Léger

36

The clock 1918
L'horloge

oil on canvas • 50.5 x 61.5 cm

signed lower right; originally signed, titled and dated "mars 18" on the reverse (transferred to a new support)

Léger's experiences while serving in a construction unit during the First World War led him from an almost abstract Cubism to the reality of steel objects and uncomplicated masses. Starting in 1918 he selected themes for paintings which were appropriate for modern times. They came from the turbulent and florid life of the metropolis. A street lamp is referred to in this composition and a clock in the upper background indicates an afternoon hour. To the right a vertical line of letters suggests a poster or shop sign. The city, situated on a river with anchored boats, has an old quarter marked by alleys and steps on the left. The central motif is composed of shining metal disk fragments and conical forms moving in opposite directions. Five vertical tubes hanging on a pipe-like bar seem to belong to a machine and could be valves and piston rods.

On the whole the toning and modelling of the apparently stereometric prisms and tubes retain aspects of Cubist illusionism. They lack real volume in the feigned three-dimensionality. The picture plane is organised by the means of a rhythmic and rotating dynamic and it is this aspect that is the most avant-garde feature of this painting.

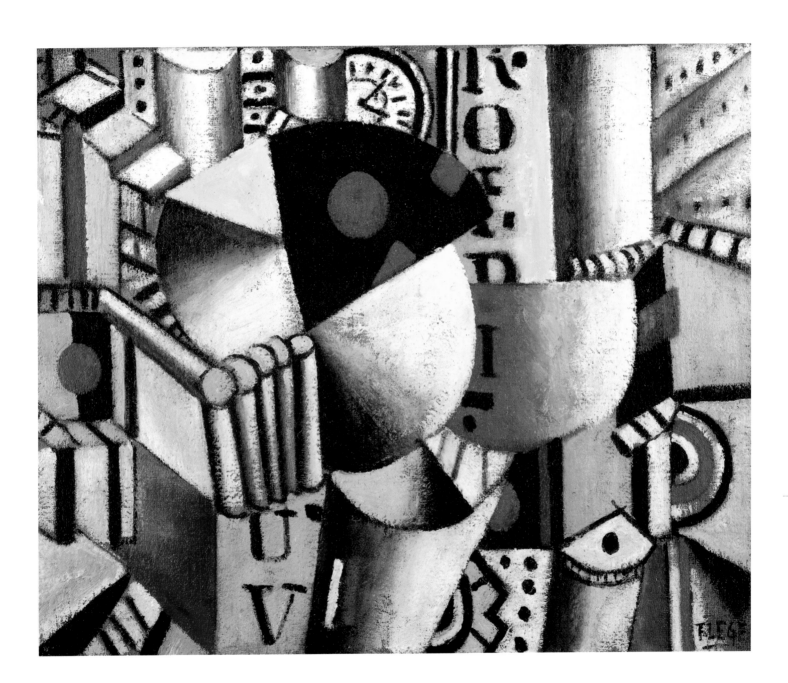

Fernand Léger

3 7
Still life 1924
Nature morte

oil on canvas • 92 x 60 cm
signed and dated lower right

The early 1920s was Léger's classic period. His classicism was characterised by his use of a clear geometry with a stable vertical and horizontal structure. It contained an architectonic order of parallel staggered planes and cool objectivity. Thus Léger promoted himself as master of Purism, a style decreed previously by Amédée Ozenfant and Edouard Jeanneret (Le Corbusier). Modern classicism was based on Nicolas Poussin's classical style. Léger studied Poussin's *Rebecca at the well,* 1648 (Louvre) and *Still life* seems almost a citation of the Poussin painting. This is evident in the shading of round forms and the green baluster which was perhaps inspired by Poussin's pedestal.

During the Art Déco period, Léger did not derive his pictorial means from a contemporary reality but from the vision of a new and better world. He envisioned a clear, rational and just world. The utopian order instils this interior of simple furniture and objects with eternal value. Objects and background are equally important. Abstract elements have the same value as depictive forms. The actual theme is harmony and stability. A phallic pod-shaped object is the one disconcerting element, as it seems to threaten the globe on the table. It is a first indication of emerging Surrealism.

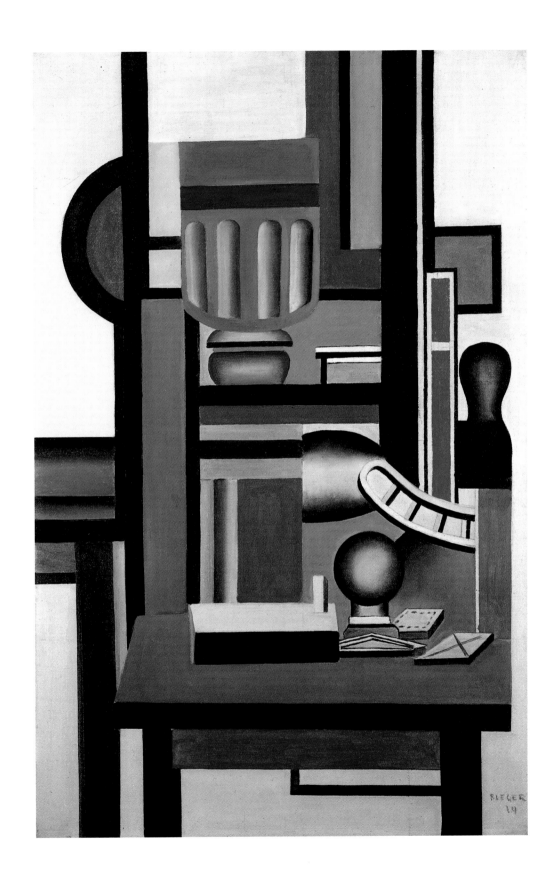

Fernand Léger

38

Leaves and fruits 1927
Feuilles et fruits

oil on canvas • 65 x 54 cm

signed lower right; reverse titled, signed and inscribed "I: ETAT"

Léger never participated in the Surrealist movement, yet its aesthetic ideas are reflected in his works of the late 1920s and they put an end to his Puristic classicism. The rational stability and to a greater degree, the mechanistic dynamic of Léger's early style were superseded by irrational weightless space. The leaves and flowers in this picture float dreamlike in space. The source of movement is indicated by a slanted seesaw. The weightlessness may be a result of dreaming, or of intoxication as indicated by the wine bottle. The silhouettes of a wine bottle are as high as the canvas. The yellow and white shapes refer to the bottle and reddish brown indicates its content. The slanted black beam on a short support depicts a fruit bowl with pears and apples. The cherry tree branches and leaves are merely suspended in space.

This painting represents one of Ernst Beyeler's early acquisitions for his rural private house with a cherry tree in front and an adjacent orchard.

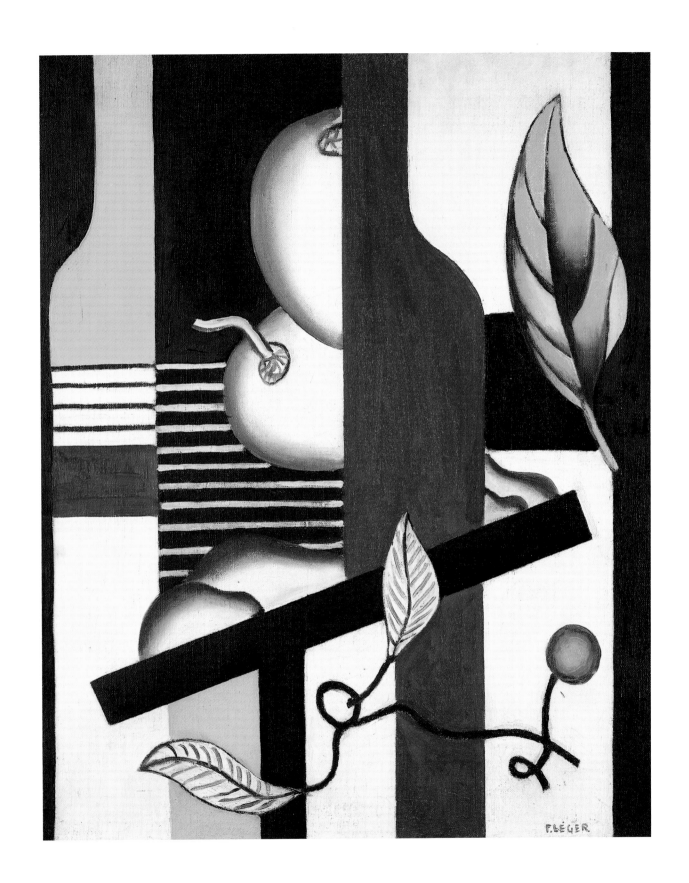

Fernand Léger

39

Still life with plaster mask 1927
Nature morte au masque de plâtre

oil on canvas • 89 x 130 cm
signed and dated lower right

Between 1925 and 1927 Léger produced a series of masterpieces. Each was the result of careful preparatory studies and an ordered, classical approach. Responding to avant-garde tendencies in book illustration, theatre and film, Léger evolved an elegantly formalised style of modernism that was close to the spirit of Le Corbusier's white architecture—simple, plastic forms organised in large, stable, compositions.

In this still life arrangement, Léger deliberately balances the profiles of disparate objects, one against the other, using representational against abstract elements, contrasting colours and equally sharp contrasts of light against dark. He makes schematic, seemingly mechanical renderings of standardised and mass-produced objects such as the door-handle and finger-plate against a rustic pipe, leafy twig and disembodied bust.

After his experience as a film-maker in *Ballet mecanique* of 1923–24, Léger's flatly painted sequences of stencil-like "close-ups", was a consequence of his newly cinematic approach to the figurative fragment and the manufactured object. Léger underlined the purity of his exclusively visual approach to film (and also by implication to painting), declaring, "No scenario. The interaction of rhythmic images that is all."

The role of the enlarged detail in Léger's images reminds some writers of the Surrealists dream sequences and of their fondness for a teasing juxtaposition of unlikely objects. However for Léger, the psychological nuances sought by the Surrealists were subsidiary to the purely visual rhythms that he was pursuing and the straightforward "plastic" effects he desired. The objects in his object-paintings are always firmly contained within rigid pictorial arrangements. They are compelled into order, reflecting his conviction that: "more and more, modern man is living in an order that is geometrically directed." U.P.

94

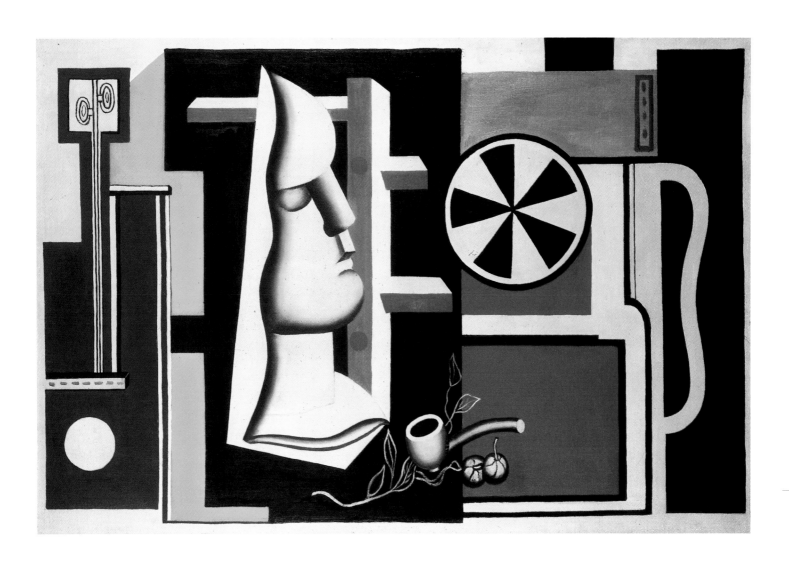

Fernand Léger

40

The two cyclists, mother and child 1951
Les deux cyclistes, la mère et l'enfant

oil on canvas • 162 x 114 cm
signed and dated lower right

Throughout his career Léger was pre-eminently a painter of modern life: machines, cities, billboards and mathematical forms. He sought to celebrate the life and entertainment of the common people, choosing to paint cyclists, steeplejacks and circus artists. These figures were usually choreographed as if performing the graceful finale of an acrobatic turn. Having stopped, they turn, and are facing us, the audience.

Léger's late works are populated by monumental figure groupings. Compared with the machine-like figures of the twenties, they seem more relaxed. Their forms are rounder, their lips curve into smiles. Their limbs are more pliant despite the sturdy physiques. The years he spent as a refugee in America during the Second World War, made Léger's modernism more uninhibited and jazzy.

He loved New York, especially Times Square at night with its flashing neon colours. He recalled, "I was struck by the coloured lights that advertisements flash on the streets. I was talking with someone. His face was blue; twenty seconds later it turned yellow." That experience led him to use stripes and patches of colour more freely and independent of the design. His use of coloured forms in red, yellow, orange and purple are the most striking feature of the vividly decorative effects Léger achieves in this painting of two cyclists.

The figures are drawn slowly and deliberately, in black lines, emptied of colour and volume, but treated with a grandeur that recalls Italian fresco painting. In spite of the increasing humanisation of his figures Léger insisted, "my painting is still object-painting... I keep to the plastic fact, no eloquence, no romanticism". U.P.

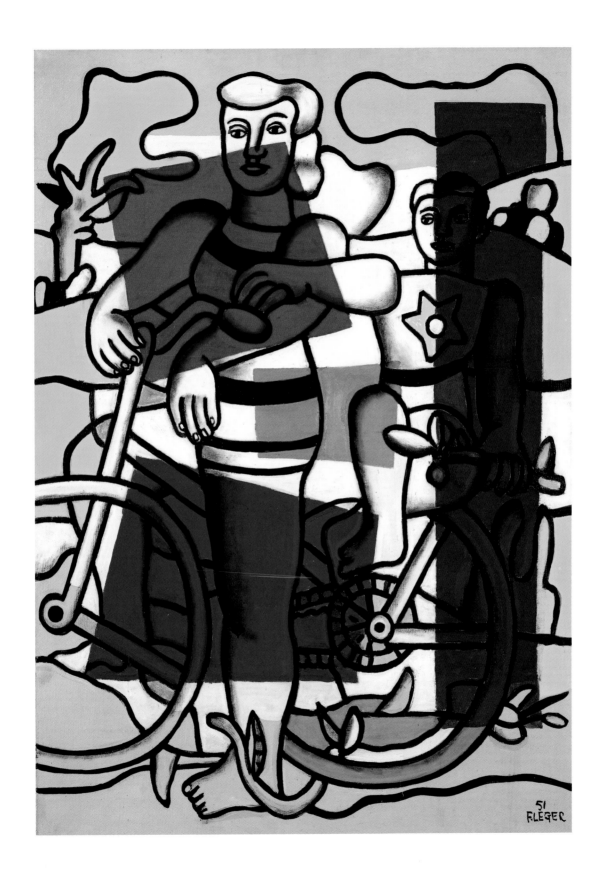

WASSILY KANDINSKY
1866–1944

41
Fugue 1914
Fuga

oil on canvas • 129.5 x 129.5 cm

This is among the last works the artist painted in Munich, before returning to Russia at the outbreak of the First World War. Although landscape associations can sometimes still be perceived, these works have moved so far away from their origins in observable nature that they have become totally abstract.

In his *Reminiscences* completed in May 1913, Kandinsky asked: "what is to replace the missing object?...Only after many years of patient toil and strenuous thought, numerous painstaking attempts, and my constantly developing ability to conceive of pictorial forms in purely abstract terms, engrossing myself more and more in these measureless depths, did I arrive at the pictorial forms that I use today..."

Kandinsky wanted to detach colour from its traditional role of describing forms and use it to explore the psychological dimension of human experience, to use it intuitively as a language of pure feeling. After 1911, the year he was deeply impressed by Schonberg, Kandinsky produced a series of works he called "improvisations" in which the colours flowed together like notes in a musical composition.

In 1914 Kandinsky was using brilliant colours to "play a whole fugue of differently toned splashes". He was striving after a kind of luminosity in his art which was "infinitely alive, unfathomably sensitive". Smearing, blurring, stroking, and dabbing at the canvas with a full brush, he orchestrated his colours to a glorious crescendo in *Fugue*. A complex colour scheme of bright pinks and yellows, is counterbalanced with the deeper reds and the black accents against iridescent blues and sparkling whites. In this painting Kandinsky realised his ambition to create visual correspondences for the soaring compositions of the Baroque and late-Romantic composers he admired. U.P.

PIET MONDRIAN

1872–1944

42

Composition 1, trees 1912–13
Composition 1, arbres

oil on canvas • 85.5 x 75 cm

signed lower right; reverse signed and inscribed on stretcher "Compositie 1 P. Mondrian"

Catalogue Seuphor, no. 348

Mondrian was forty years old when he became acquainted with modern painting from Cézanne to the new Cubist movement. By that time he had created works in a traditional academic style which was followed by a post-Impressionistic and Symbolist, or more precisely, spiritualist period. By 1911 his views were greatly influenced by the teachings of the Theosophical Society which he had joined in 1909. Mondrian's "abstract" style has set a standard for art in the first half of the twentieth century. His early phase of abstraction began when he moved to Paris in January 1912. There he started to work on a series of paintings showing an unorthodox version of Cubism.

Mondrian inscribed the title "Composition I" in Dutch on the canvas stretcher before he shipped this picture together with *Composition III* and *VII*, 1913, and more recent works to the gallery Walrecht in The Hague for his first one-man show. These paintings had already

been exhibited in 1913 in Amsterdam at the third exhibition of the "Moderne Kunstkring", a group of Dutch avant-garde artists. Dutch composer Jakob van Domselaer noted after his visit in the winter of 1912–13 that he saw "trees, nothing but abstract trees" in Mondrian's Parisian studio. Indeed, this is the theme of the numbered compositions, of which "I" seems to have been the first one Mondrian made.

"Trees" are hardly recognisable without the help of the title. But trees and the intervening space and hazy atmosphere had been a subject repeatedly chosen by Mondrian for earlier representational paintings. The new "abstract" tree compositions surpass his earlier meditative pictures of nature. No geometric stylisation of nature is attempted. Fragmented lines do not describe the contours of objects as in Cubism, but are used to transform a natural motif into a spiritual idea. Mondrian attempts to find a visual form of expression for the mystic theory of

evolution, an idea derived from the Theosophic philosophy. Among its many postulates, one belief is that in the cosmological order crossing right angles and oval forms are manifestations of a universal truth, an existence more essential than objective corporeality. They are transitional forms leading to cosmological unity. Mondrian's later, even more "abstract" oeuvre represents, in itself, such an evolution from matter to spirituality to a mystic unity.

Apart from the underlying philosophical idea, the compositional elements and colouring in this esoteric representation of trees are derived from Cubism. There are broken lines, the opening up of the plane, and the suppression of the contrast of form and ground. The substance and space and the blurring of light and shadow were clearly affected by the works of Picasso from 1909 to 1911 (see *The mandolin player* p. 33).

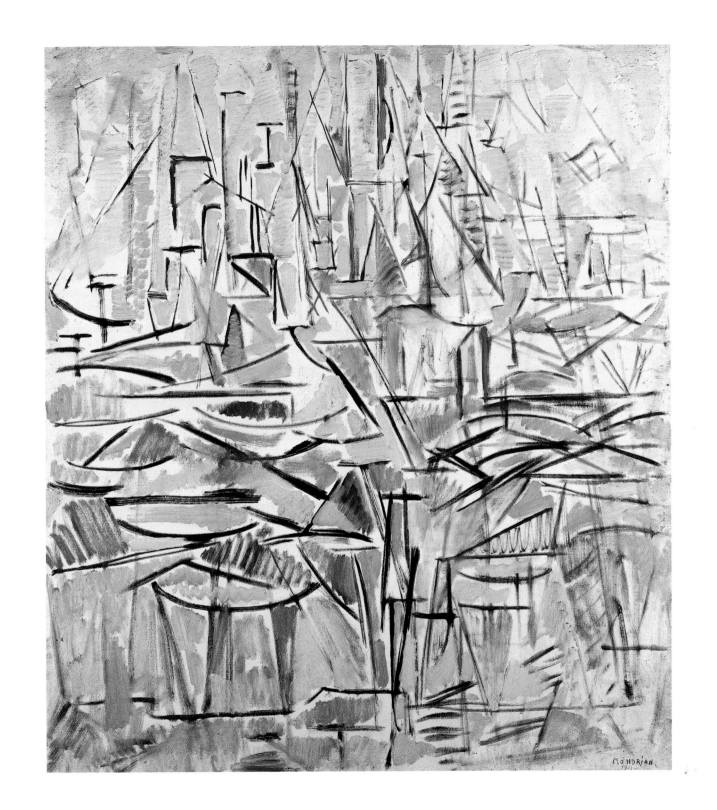

Piet Mondrian

43

Composition with blue and yellow 1932
Composition avec blue et jaune

oil on canvas • 55.5 x 55.5 cm
monogram and date lower right
Catalogue Seuphor, no. 354

In the second half of his life Mondrian advanced from mystical, contemplative pictures of nature, such as the preceding composition with trees, to the imagery of absolute (in Mondrian's sense "cosmic") perfection. This is the meaning of *Composition with blue and yellow*.

A decisive factor in the development of Mondrian's concept for these works was an exchange of ideas with the Dutch painters Bart van der Leck and Theo van Doesburg from 1916 to 1919. The result of this exchange was "De Stijl" (The Style, from the title of the journal they founded in 1917). It was to be an expression of modern spirituality. The geometric order of lines and colour planes served as vehicles for their concept. When decorative arts and architecture adopted "De Stijl" Mondrian vehemently opposed this development, because for his painting "De Stijl" meant something rather different than merely an abstract contemporary style.

After his return to Paris in July 1919, Mondrian countered van Doesburg's "De Stijl" with these manifestos of his own "neo-plasticism" as demonstrated in his mature style. On rectangular, often square canvases he created an order of the three primary colours yellow, red and blue and the non-colours black and white. He occasionally included grey. He arranged them in straight horizontal and vertical bands, and white and coloured rectilinear planes. The balance between these elements was achieved by the precisely measured length and width of the bands and carefully weighed expansion of the coloured planes.

Mondrian's spiritual message was contained therein. Mondrian wished to convey the immediate visibility of the harmony and absolute beauty of the universe. These compositions represent icons of meditative art. Unlike sacred art, neither compositional symmetry nor hierarchical structure, nor half measures are required. Thus Mondrian's disagreement with van Doesburg about the latter's diagonal compositions of 1925 is not surprising. Mondrian categorised diagonal forms as hybrids of horizontals and verticals and therefore considered them an impure element. According to his concept of the universe, they were as impure as the composite colour green, a colour he despised. He believed that all components including diagonals, mixed colours and hues as well as the dynamic of time were expressed in his painterly elements in a state of higher order and greater stability.

As an immaterial, geometric meditation picture, this work allows an experience of limitless space beyond the black bands and between the coloured planes.

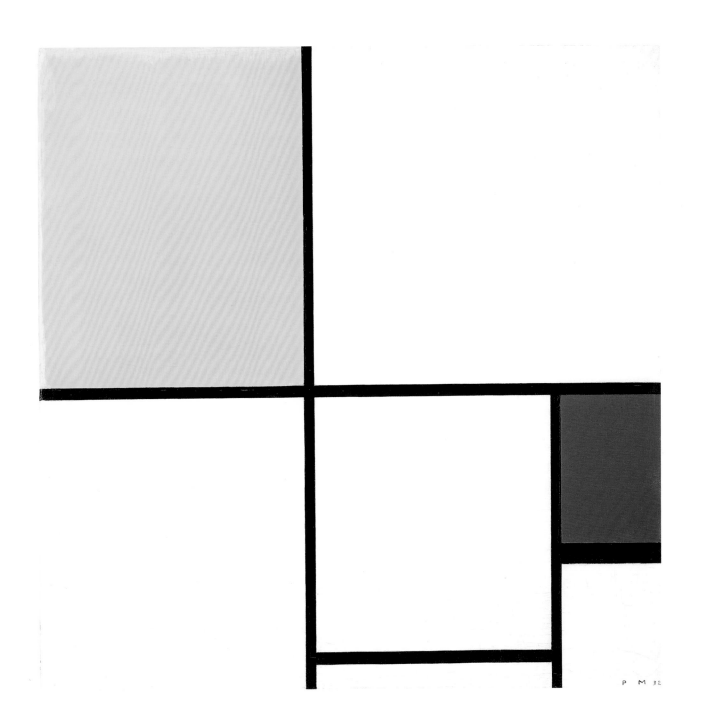

PM 32

HENRI MATISSE

1869–1954

44
Jeannette IV 1911

bronze • 61.5 cm high
Cast no. 1/10
signature and numbered; casting stamp "F. Costenoble"

Like Picasso, Matisse abandoned traditions and conventions in art to create major works. Many of these, such as Matisse's portraits of Jeanne Vaderin, became milestones in the history of modern sculpture. These bronzes, known as *Jeannette I to V* illustrate five variations on the theme "head to base". They may be understood as a bold progression from a sensitive rendition of nature to an autonomous form of art or perhaps as an assimilation of wooden African masks,

especially those from Cameroon. They testify to Matisse's detachment from Rodin's modelling style.

Jeannette IV from 1911 represents the transition from the expressive facial resemblance with the model to the nearly abstract composition of sculptural mass. The sculpture is composed of five sections, including the pedestal, shoulders, neck, head and hair.

The rendition of the hair by several clumps is most astonishing. In *Jeannette III*, Matisse modelled the hair more or less as a single unit, whereas *Jeannette V*, 1913, has no hair at all. The abbreviated form of breasts and shoulders in this version alludes to traditional sculptural representations of busts. The fragmented hair and exaggerated facial features produce a dramatic but unified sculptural entity.

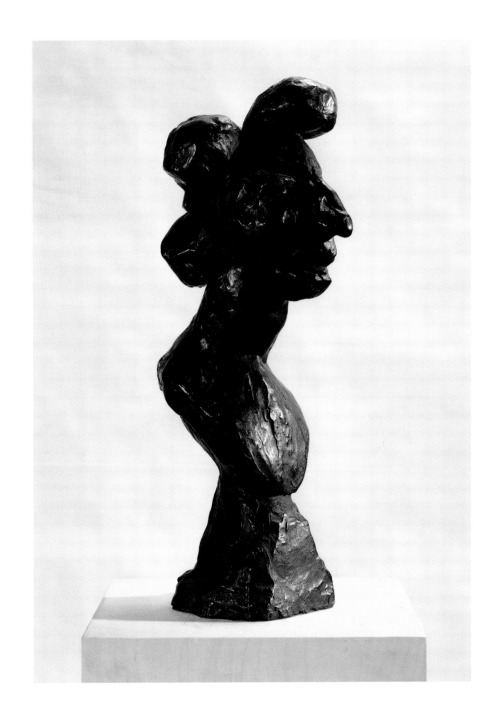

HENRI MATISSE Jeannette IV 1911

Henri Matisse

45

Garden at Issy, studio at Clamart c.1917

Jardin à Issy, l'atelier à Clamart

oil on canvas • 130 x 89 cm
signed lower left

In the spring and summer of 1917 Matisse was working in Issy-les-Moulineaux, where he had leased a house on Route de Clamart since 1909. There in the large studio he had built, he painted many of his most famous pictures, including *The dance*, 1910 (The Hermitage Museum, St. Petersburg).

During the First World War Matisse's work was characterised by a restless experimentation. He often produced severe, highly abstracted, geometrically constructed works. In this picture which was painted during that time, Matisse has dissected his subject into separate yet converging views of the garden, the pond and the studio at Issy, while miraculously maintaining a very specific description of the fall of light and shadows across earth and foliage.

The deep green and blue accents that Matisse favoured in many of the pictures he painted around this time, give a particular poignancy to the rich red-browns pervading this dreamy evocation of a shaded garden. The hedonistic exuberance of his earlier works is now countered by a more sombre, sonorous colour scale. The role of the colour black in the works of this period has prompted historians to write of "a black light" in Matisse's wartime work.

Matisse remembered this time as a difficult watershed for his art and the period of Cubism's triumph. "I was entrenched in my pursuits: experimentation, colour, problems of colour-as-energy, of colour-as-light. Cubism interested me, but it did not speak to my deeply sensory nature, to the great lover I am of line, of the arabesque, those bearers of life…" U.P.

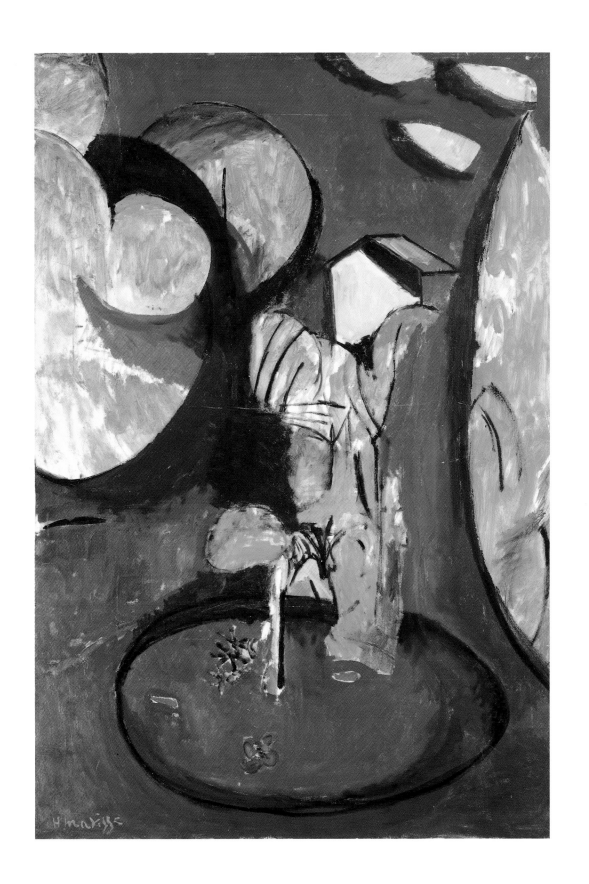

HENRI MATISSE Garden at Issy, studio at Clamart c. 1917

Henri Matisse

46
Seated young woman in lattice dress 1939
Jeune femme assise en robe de résille

charcoal on paper • 65 x 50 cm
signed and dated upper left and lower right

Charcoal is a brittle and imprecise tool for drawing. Artists usually choose it as a cheap material for studies. Charcoal is held lightly between the fingertips and crumbles easily, leaving a residue of black dust behind. To keep the tip pointed the charcoal has to be constantly rotated. This movement is comparable to a violinist who leads his bow over the strings, inspired by a melody. He makes the bow dance and touch to achieve a more personal interpretation of a motif.

Here Matisse's motif is his model Lydia Delectorskaya. This drawing was motivated by the magic of her Slavic features, her physical sensuality, the casual elegance of her informal dress with lattice pattern. His motivation was further enhanced by a bright luxurious hour in March 1939 when he interpreted his model with charcoal. Matisse often made radically different drawings, usually with pen, pencil or brush. He precisely outlined and strictly modelled the curvatures of the body in continuous lines. As in a preceding series of nudes of this model, he leads the charcoal over the paper as if touching the woman. He searches for contours with the soft, crumbling tip of the charcoal, toning and blurring the surface with his hand. The visible traces of his corrections are significant. The forms that were too large or wide were reduced. The painted effects of toning and blurring were finally confined with severe lines.

The lattice pattern of the dress is a device that transforms the softly modelled corporeality of Matisse's favourite model into a disciplined masterpiece.

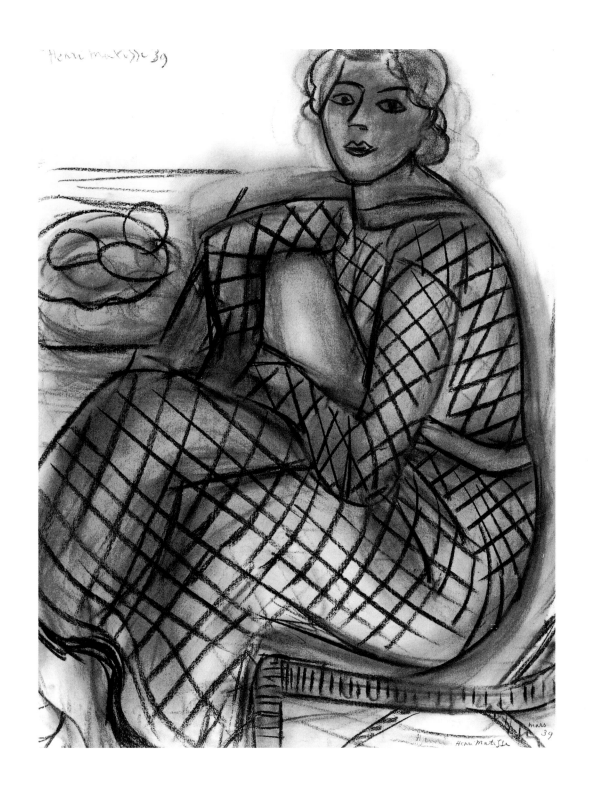

Henri Matisse

47

White algae on red and green background 1947
Algue blanche sur fond rouge et vert

cut-outs of paper, gouache on paper • 52.5 x 40.5 cm

signed lower left

Catalogue Cowart-Fourcade, no. 77

The glued coloured cut-outs, or "gouaches découpées" are a wonderful innovation in Matisse's late work. He used this technique in the past in the preparation of stage settings and bookcovers or to create variations in large paintings instead of overpainting. From 1943 to 1946 Matisse created pictures with dyed paper and scissors for a magnificent album, *Jazz* published in 1947. Nearly eighty years old and weakened through illness and operations, the bedridden Matisse cut forms and figures from coloured paper prepared by his assistants. This technique allowed him to work with an intimate connection of colour and form to create a finished picture directly from his imagination. Matisse said, "Cutting into living colours reminds me of the sculptor's direct carving."

He created two mural-size compositions of Pacific flora and fauna with this technique. *Oceania: the sky* and *Oceania: the sea*, 1946, were inspired by memories of his voyage to the South Seas in 1930. They were assembled from cut-out motifs. *White algae on red and green background* is part of this thematic group. Matisse plays with cut-out shapes or "algae" in white and coloured silhouettes. He pasted them onto monochrome or polychrome background paper. These were mounted side by side or on top of each other in his studio in Vence, yielding a two-dimensional aquarium.

The white forms are placed over the red and green ground. This achieves an optical effect which creates several planes and light zones. The algae move in all directions as if floating in water, although they are nothing more than cut-out paper silhouettes.

110

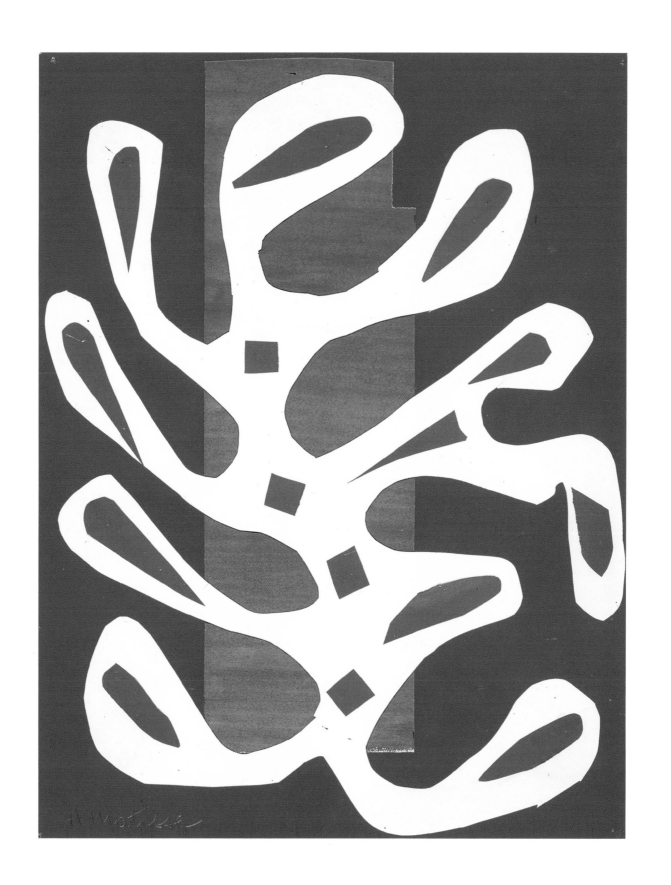

HENRI MATISSE White algae on red and green background 1947

Henri Matisse

48

Interior with black fern 1948
Intérieur à la fougère noire

oil on canvas • 116 x 89 cm
signed and dated lower centre "Vence 1948"

Henri Matisse's late works which were developed after the Second World War represent a perfect counterpart to his early pioneering paintings and sculptures created before the First World War. Though now physically frail, his work centred around the joys and fortunes in life. "Matisse has a sunny soul," Picasso remarked when he visited him in Nice or Vence during those years.

This painting demonstrates Matisse's independent use of motifs and the resources of painting. The woman in a light dress is merely an accessory of the interior. She is rendered in a vague, non-corporeal and nearly colourless manner. Her greyish dress underlines the yellow of the chair and carpet which is patterned with black dots and stripes. Her head and arms seem to have no other purpose than creating a subtle combination of pink and yellow, reversing the combination of the

colours of the lemon-filled fruit bowl on the table. The objects become equal pairs: bowl/chair—lemon/lady. The left leg of the chair ignores the woman's physical and spatial integrity and is simply drawn over her leg.

Matisse's free and fluid brushstroke is most visible in the green surface of the table. His "amateurish" manner, "sketchy" stroke and audacious colour combinations were extremely innovative at that time, and only an artist of such ability and experience could go against conventional developments so dramatically and effectively.

For centuries red and green in the picture plane signalled distance. Red was usually in the foreground, green in the middle, and blue in the background. As early as 1908 Matisse tried to nullify this spatial meaning in *Harmony in blue*. It contained an interior that he painted

over according to traditional views with red in the foreground and middle, and blue in the background. He renamed it *Harmony in red* (Moscow). Now Matisse revokes this perspective of colour and places green in front of red, even in the rectangle (upper right) with green and black foliage. This rectangle is probably a tapestry rather than a window. Several leaves leap out of the background, also serving as the fronds of the black fern on the table. As indicated by the title, "black fern" is the major motif of this interior and the colour black, including the small black carpet with Matisse's signature, is the most dramatic element in this painting.

Intérieur à la fougère noire, executed in spring of 1948, is one of Matisse's last paintings before he set aside his brush and took up coloured paper and scissors.

Henri Matisse

49
Blue nude I 1952
Nu bleu I

cut-outs of paper, gouache on paper on canvas • 106 x 78 cm
signed and dated lower left
Catalogue Cowart-Fourcade, no. 167

Matisse was confined to a bed and wheelchair during his final years. Still working, he created larger and more magnificent compositions of tropical and aquatic themes with coloured paper and scissors. On the walls of his hotel suite in Nice, he surrounded himself with an Elysian garden of exotic plants inhabited by apes, parrots and bathing women. *Blue nude I*, originally conceived as one of the motifs in his South Sea picture *The parakeet and the Siren*, 1952 (Stedelijk Museum, Amsterdam), was a concept that turned out to be too large and independent.

Matisse made four monumental figures of a seated nude woman raising one arm. This version, number I, was the second attempt and certainly is the most accomplished (IV was the first but was completed after II and III). All of these represent the sum of many drawings from models and numerous sculptures of a standing, sitting or reclining woman with a raised arm created since 1904. Matisse himself compared the technique of coloured cut-outs with the "taille directe" of the sculptor. The overlapping of limbs and the volume of each part of the body are important in sculpture as well as drawing.

This blue paper cut-out on a white background demands even greater mastery than drawing or modelling, especially in developing a disciplined analysis of postures. Without resorting to the tools of perspective, the silhouettes of the limbs are cut and assembled in a manner that creates plasticity of both bodies and space. Where one part of the body covers another part, the limbs are tapered or fragmented with white splits indicating dividing lines. Every element is complete and voluminous. Traces of brush and glue eliminate the inherent flatness of the paper. The combination of ground, form and colour contribute to the painterly and sculptural power of this picture.

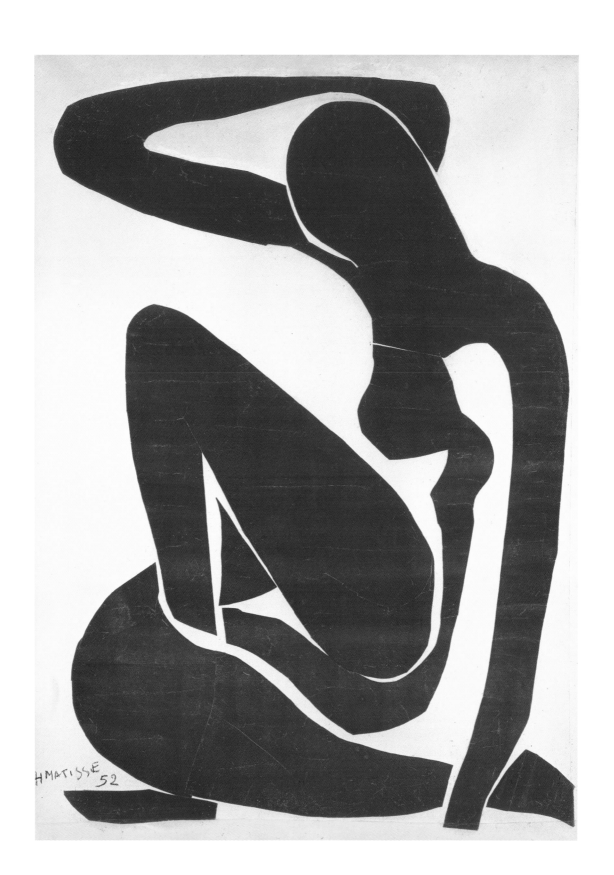

H MATISSE 52

Henri Matisse

50
Blue nude, the frog 1952
Nu bleu, la grenouille

cut-outs of paper, gouache on paper on canvas • 141 x 134 cm
monogram lower right
Catalogue Cowart-Fourcade, no. 180

Similar to *Blue nude I* (p. 115), *The frog* was part of the tropical paper garden on the walls of Matisse's studio in the Hôtel Régina in Cimiez (Nice). The title refers to the posture of the female figure, who is bathing. The two pomegranates symbolising eternal life set her in a Pacific paradise. The yellow background has to be understood as glistening sunlight shining towards the viewer, an impression enhanced by the monumental size of this picture. The blue of the figure resembles the phenomena of the perception of converse colour after closing one's eyes in bright light.

The silhouettes render the figure in a reductionist manner, as the head and bust are composed of three disks. The inner outlines of the raised arms also define the contour of her long hair. Though the feet are "missing" the legs appear detailed and precisely outlined, exuding a powerful sensuality. Arms, breast and head show a higher degree of abstraction than the legs. The feet are omitted to emphasise the voluptuous thighs which intensified the immediate sexual offering yet the woman still represents eternal and ideal femininity. Even Matisse rarely achieved such an intensive and inexhaustible impression with such economical means.

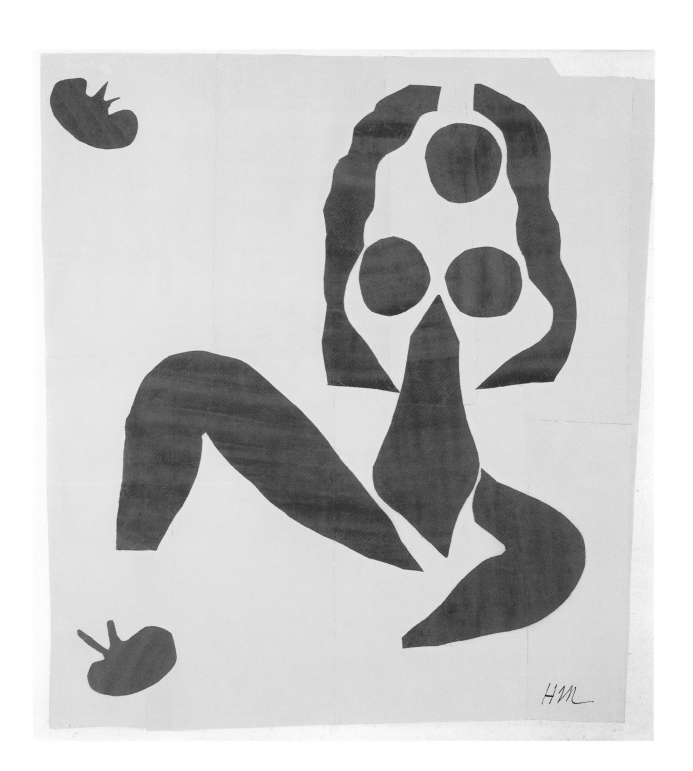

HM

HENRI MATISSE Blue nude, the frog 1952

PAUL KLEE

1879–1940

51
The chapel 1917
Die Kapelle

gouache on paper mounted on cardboard • 29.5 x 15 cm
signed upper left; on cardboard titled, dated, and inscribed "1917/127 Die Kapelle"
Oeuvre catalogue Paul Klee 1917/127

Paul Klee was a gifted draftsman and colourist as well as violinist. Thus his works are constructed in a similar method to musical scores. They originate with elements rather than a composition. Line sketches are performed. Colour tones enter. Tone values are displayed. Nevertheless, an "abstract" piece of music leads to meaningful conceptions which the listener perceives as concrete images and anecdotal situations (like programme music). A generally known sound such as a post horn in a Haydn composition, the murmuring rhythm of a river in Schubert, a magical harp in Wagner or the trill of a treble flute in a piece by Richard Strauss could convert an orchestral composition into a musical narrative to please the bourgeois audience of the turn-of-the-century.

When Paul Klee used concrete signs such as the circular discs for sun or full moon, crescent shapes for moon, hexagram for star or other decipherable images in his abstract compositions, his works would begin to "talk" to the audience. At times the titles of the paintings assist the viewer, just as titles of musical pieces aid the concert-goer. Paul Klee became aware of this on the occasion of his first successful exhibition in February 1917.

The title *The chapel* hints that this gouache composition of 1917 is a fairytale. Perhaps it is a poetic, innocent representation of an enchanted mountainous landscape with an isolated forest chapel. The letter "F" seems to hint at the chapel or a place name. However, Klee's artistic achievement was much more serious, refined and rational.

The image remains coherent even if this gouache is turned sideways or upside down.

A pencil drawing in the collection of his son Felix Klee, later titled *Architecture with stars, sun, and moon* (Architektur mit Sternen, Sonne und Mond), reveals the structural forms of *The chapel*. This is an interpretation based on perceptual psychology which causes one to see the light and dark facets as a pseudo-perspective of a house of cards. Similar to signals and signs, this pseudo-stereometry originates in Picasso's Cubism, while the transparent colouring was inspired by Delaunay's Orphism. Klee's achievement was to remove some of the difficulties in the appreciation of modern art by merging abstract forms into concrete, narrative images, pretending to reveal a childish innocence or fantasy world.

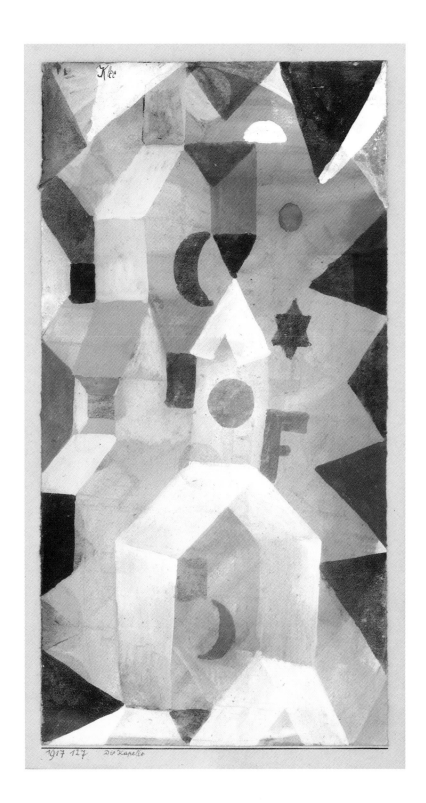

Paul Klee

52
Tropical twilight 1921
Tropische Dämmerung

tempera on paper • 33.5 x 23 cm
signed lower right
Oeuvre catalogue Paul Klee: 1921/128 (G)

An analysis of a Klee work should start from the centre of the composition. For Klee the rectangular canvas was an undetermined surface except for the four edges, and the intersection of the axes or diagonals. Only the successive addition of pictorial symbols will determine the top and bottom. Therefore viewers are able to experience the three-dimensional characters and horizon of the image according to their reality. It is this concept which renders his art so modern.

In the preceding work, *The chapel* (p. 119), a circular disc in the centre of the composition functions as force of gravity. It provides equilibrium to the other forms. In *Tropical twilight* a star with eight spokes is in the centre of the canvas and it determines the inventory of the remaining sign images.

The image is completed by what Klee would call "memories", memories of a nocturnal garden below a "tropical" sky, where hypertropical foliage and buds shoot up against the circular disc of a hazy sun in the upper third of the canvas. The geometric patterns that evoke a fence and a building overgrown by plants counteract the abundance of botanical forms. This work belongs to the period during which Klee the draftsman and colourist became a painter.

Paul Klee

53
Just before the lightning flash 1923
Vor dem Blitz

watercolour • 28 x 31.5 cm
signed upper left, dated lower left and numbered "1923 150"
Oeuvre catalogue Paul Klee 1923/150

This composition was painted during Klee's early years as a teacher at the Bauhaus. At this time he was working with very strict rules which he had set for himself. This piece includes two elements, the modulated grid and the arrow which appear again and again in this phase of his work.

The field is divided by a grid which is graduated from smaller intervals at the edge to broader squares in the centre. The tonality of the work heightens towards the middle of the grid.

Combined with the linear gradation, this lightening gives a feeling of opening out and lifting gloom. There is also a spatial advancement which suggests that the surface bulges out towards the viewer.

In this central spotlit stage a dramatic scenario is enacted. A lighter band snakes down from the top edge to confront a similar band rising from below. These lighter bands enfold the dark forms of two opposing arrows. The light bands seem like an illumination produced by the dynamic forces of the arrows, and at the same time, they serve to distinguish the arrows from the field of colour.

Above the top arrow a weighty oval hovers about to discharge its stored power. Klee often invokes cosmic forces, in this case the drama of an impending storm. There is also a hint of creation carried within the black oval which is consistent with his belief that the history of the cosmos is perceptible in each of its parts. **T.B.**

1923 750 vor dem Blitz

Paul Klee

5 4
Possessed girl 1924
Besessenes Mädchen

oil and watercolour on paper mounted on cardboard • 43.2 x 29 cm
signed lower left; on cardboard dated lower left and inscribed "1924/250/S Cl"
Oeuvre catalogue Paul Klee 1924/250

Paul Klee's manner of painting originates from drawn, constructed strokes and transparent, luminous colouring. Although this "possessed girl" exhibits an overall grotesque physiognomy, nothing seems more delicate, sensitive and authentic than the contours of her eyes, the spread of her nose, the corners of her mouth, or the coloured texture above the décolleté. The rendition of her features is reminiscent of *Absorption: portrait of an expressionist* (Versunkenheit: Bildnis eines *Expressionisten*) of 1919, a lithograph with watercolour.

Although her vulgar make-up sharply contrasts with the delicate lines and colouration, it is an indispensable part of the representation.

This work has elements of portraiture and caricature. The figure may have been inspired by theatre, very likely an opera. In this case the subject would represent an actress or singer, who surrenders herself to the character of her role. In an unfavourable spotlight she has assumed a grotesque look. The sonorous voice produced through lattice-like teeth is expressed in the graded colour tones of her face. The figure *Possessed girl* is known from several drawings, small-size paintings and one lithograph including *Fiordiligi*, 1922, *The singer Las Fiordiligi*, 1923, and *The singer of opéra comique*, 1925 and 1927. Apparently these are studies of roles in Mozart's *Così fan tutte*. Klee knew its text and scores well. He felt they were imperfectly treated in performances. Once again, this work attests to the pervasive musical influence in Klee's work.

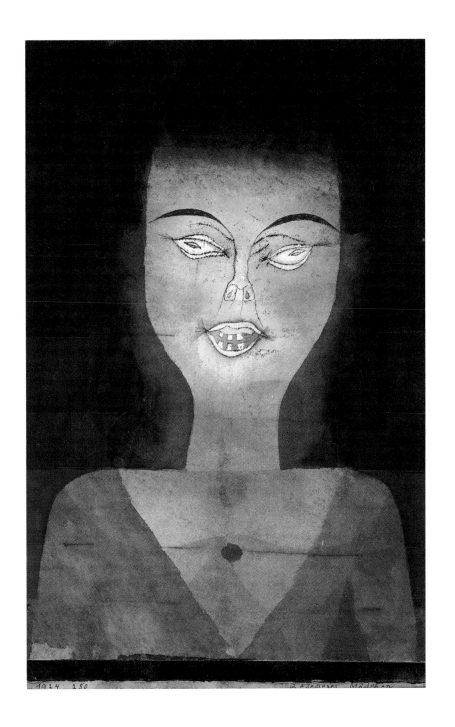

Paul Klee

55
Was fehlt ihm 1930

ink on paper on cardboard • 55.5 x 34 cm
on cardboard titled and dated lower centre and numbered AE8
Oeuvre catalogue Paul Klee

Kandinsky established the formal principles of drawing which Klee developed and adhered to in his work. As a close friend and colleague of Kandinsky during his ten years at the Bauhaus, Klee learned a great deal from him. However, Klee was a very unusual character and brought his own idiosyncratic vision to the application of these rules.

What were design principles for Kandinsky became a metaphor of the cosmic structure for Klee. The artist faces a blank page and then the pen touches the surface making the first dot or point. The beginning is the singularity or point waiting in undifferentiated space. The point moves and describes a line, the line shifts to one side thereby describing a plane. When a plane is displaced it contains a volume. For Klee the point is analogous to the moment of creation. In his book, *The Thinking Eye*, Klee wrote about drawing as taking a point for a walk. He often started with a point somewhere near the centre of a page and moved it in a continuous line which was both an enactment of the creative process and a net which captured an aspect of appearance or qualities of nature.

In his artistic life Klee experimented with a number of modernist styles including Der Blaue Reiter, Bauhaus and Constructivism. This work is an example of his tendency towards Surrealism. Taking a line for a walk implies a degree of chance and thus a degree of freedom for unconscious intervention. However, unlike the Surrealists Klee holds back from automatism by adherence to his basic design principles. This drawing comes very close to automatism, yet the line which never intersects itself seems to have discovered a menacing presence. U.P.

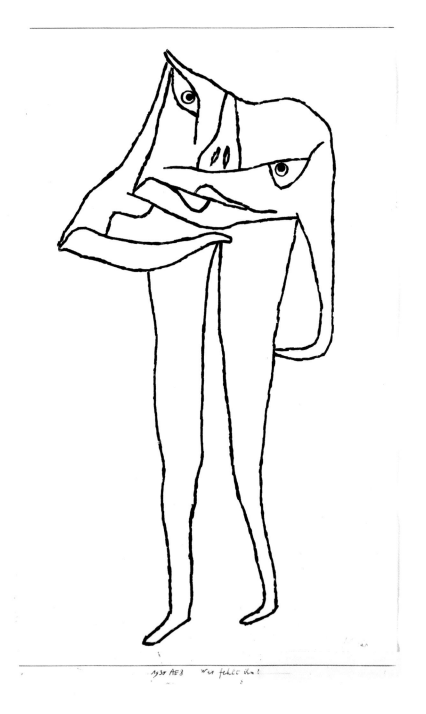

1930 AE8 Was fehlt ihm?

Paul Klee

56
Rising star 1931
Aufgehender Stern

oil on canvas • 63 x 50 cm
signed upper right
Oeuvre catalogue Paul Klee: 1931/230/V 10

Paul Klee was already rather famous among his peers and knowledgeable dealers and collectors in the late 1920s. For a decade he had worked at the "Bauhaus" in Weimar and Dessau, but in 1930 the National Socialists drove him away. He returned to Switzerland where he spent his last seven years in exile in Berne. *Rising star* demonstrates the full range of Klee's extraordinary inventiveness.

Humour is the source of the popularity of

Klee's work, yet we can only do it justice if we consider his process of creation. As in this picture Klee's art is based on the synthetic work process exhibited in his earlier pieces. Here he combines three levels from his earlier works. Resorting to musical terminology, these are the surface harmonisation of juxtaposed tones, the dotted orchestration of chromatic chords and the bold, simple melody of underlying motifs. The structure of the elements results in a harmonic melody, accented by

overlaid coloured rectangles. The tip of a rising zigzag line is crowned by a star of dots, the *Rising star*.

There are ample elements for interpretation's sake. They include elements of landscape, heavenly spheres, and hidden in the background, there is a face the size of the painting with rectangular "eyes," etc. This imagined objectivity is reflected in his words, "Art is a metaphor of creation."

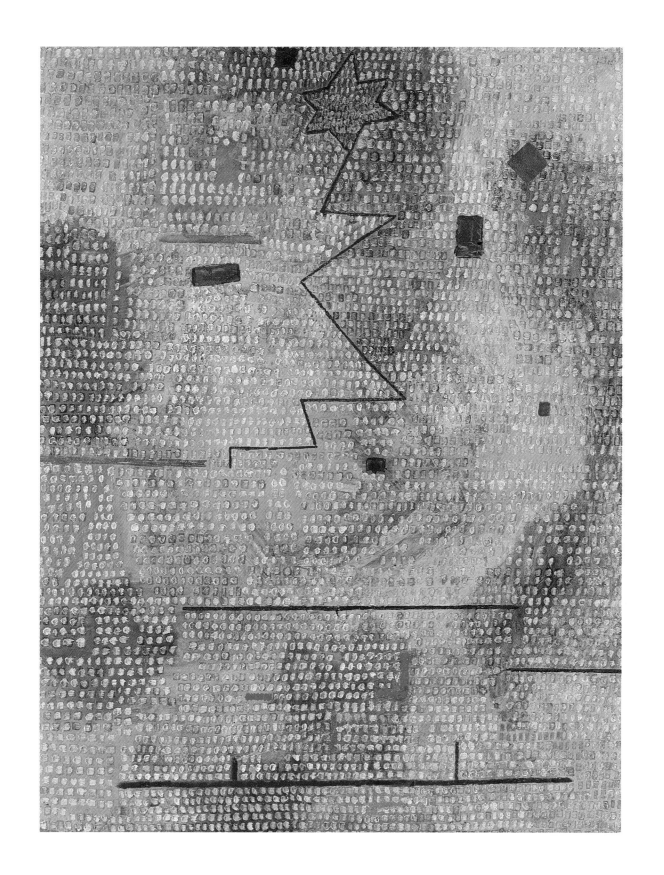

Paul Klee

57
After the flood 1936
Nach der Über-Schwemmung

gouache and watercolour on paper mounted on cardboard • 47.5 x 63 cm
signed upper left; on cardboard titled, signed and inscribed 1936 7
Oeuvre catalogue Paul Klee: 1936/7 (7)

In 1936 Paul Klee was diagnosed as having scleroderma, a terminal disease that is manifested on the skin. He had been suffering with the illness since the previous year. Klee's inventory usually lists several hundred works for a year and his oeuvre totals 9000. For 1936 he notes just twenty-five paintings including this large gouache on paper wherein the pictorial organisation is broken up, testifying to the tragic development of his life.

The change in Klee's style during his exile in Berne is not only an expression of his critical situation, but also of his radical new concept of artistic creation. His prior works were characterised by controlled construction, playful composition and an alternative world to nature. His work is now more and more influenced by historical elements and his personal suffering. He creates allegories of disintegration and impulsive disintegration. The once transcendent painter/creator became a medium for his tragic emotions.

In Egypt during the winter of 1927/28 he observed the dramatic impact of natural forces in the flooding of the Nile. The insights and feelings from this voyage were incorporated into his late work. His colourful early works had been similarly inspired by his voyage to Tunisia in 1914 ("abstract with memories"), but with opposite results.

After the flood interprets his personal catastrophe as a natural occurrence. The high water recedes, revealing patches of dried earth and puddles. Along the shore which is identical with the horizontal picture axis, lie broken, straight boughs topped by branches. The rich colouration expresses Klee's strength to continue with his work.

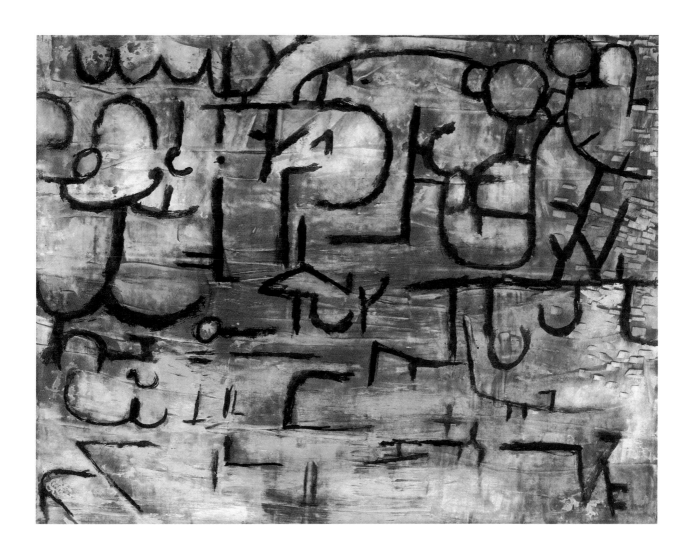

Paul Klee

58
Boats in the flood 1937
Boote in der Überflutung

coloured paste on brown paper on cardboard • 49.5 x 32.5 cm

signed lower left; inscribed on cardboard "1937. V2"

Oeuvre catalogue Paul Klee: 1937/222/V2

This brush drawing verifies the interpretation of the following painting *Signs in yellow* (p. 135) as a landscape. Both of these works from 1937, illustrate natural disasters. In this work it is a flood and *Signs in yellow* refers to scorching heat. Here two thirds of the sand-coloured paper surface appears to be covered by water. Two boats with rowers and coxswain float near the top. Behind (above) them the water level reaches to the edge of the picture. The horizon is no longer visible. Objects which are indicated by curvilinear and tree-like forms appear to be sinking and the force of the water is expressed in the blue colouring of all elements.

In his late oeuvre Klee developed a sign language resembling individual hieroglyphs. These signs can be "read" but also represent a code. In Klee's early works the structure of the picture came before the subject. This work appears more spontaneous but it is impossible to detect which came first. The narrative reflects Klee's destiny and the political situation in Europe.

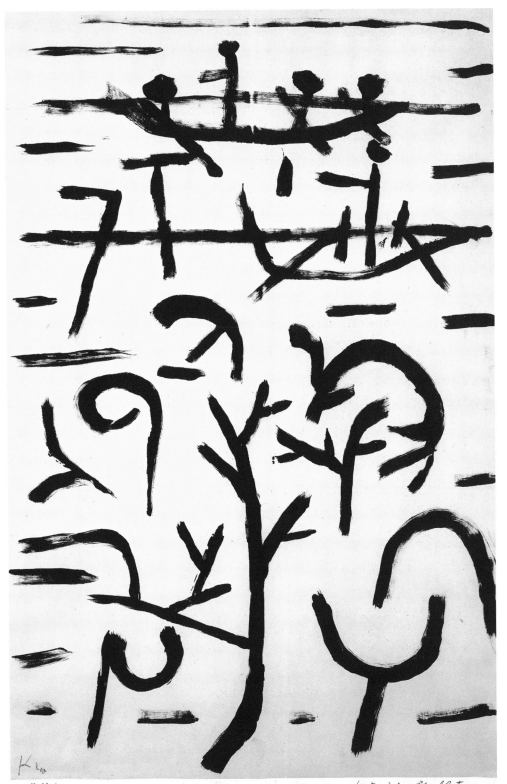

1937.V2.

boote in der überflutung

Paul Klee

59
Signs in yellow 1937
Zeichen in Gelb

pastel on cotton mounted on burlap • 83.5 x 50.3 cm
signed upper left;reverse titled, dated and inscribed "1937 U10"
Oeuvre catalogue Paul Klee: 1937/210/U 10

The year 1937 was particularly dark for modern art in Germany. In July the Nazi's opened the exhibition "Degenerate Art" in Munich. From then on this art was to be forbidden. This show included seventeen works by Paul Klee and an additional 102 were removed from public display. Klee's defiant response created a new impetus in his painting. For the remaining years of his life he entered an increasing number of works into his inventory, each displaying greater intensity. This work remained the last conveyor of happiness for the dying Klee.

But all his works speak of the approaching personal and general catastrophe. Nearly all start at the four edges, lacking top, bottom and horizon (apart from the captions and the mounting) and they could stand on each edge. The open centre contains two black angles and dots. For once, Klee's title which is usually deduced from the finished work, contains no clue for the interpretation. According to various other pictures with more explicit titles, this painting apparently represents a landscape without horizon and limits. If viewed from above, the forms and glowing colours are suggestive of fields with burnt black trees, perhaps an "abstract memory" of a voyage to Egypt.

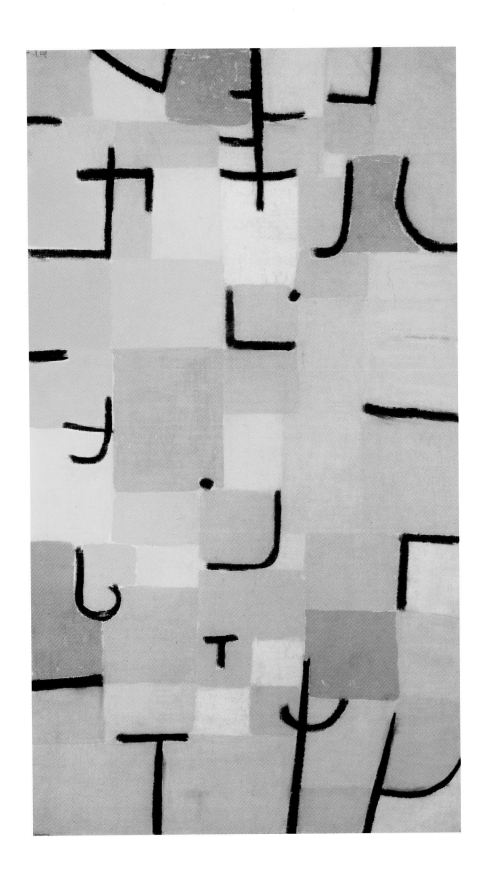

Paul Klee

60
Halme 1938

coloured paste on paper • 50 x 35 cm

signed lower right

Oeuvre catalogue Paul Klee 1938, 6 (6)

Later in Klee's life, he abandoned the rigorous adherence to set rules which sometimes held back the expressiveness in the work of his earlier years. At the same time his figuration became more obscure and often gave way to abstract shapes set against colour fields which are broken with rough and sometimes discordant hues.

This work is one of many in which the abstract elements take the form of letters and hieroglyphs. We can sometimes recognise these but mostly they remain obscure. They suggest the idea of language rather than spelling out a text. The letter 'I' is often used. It is a powerful symbol of singularity in any language even though it does not translate directly. Near the centre of this composition we find a letter 'I'. Maybe this is the stem or straw to which the title refers.

Although the figure may seem to have vanished from the painting, we have a haunting sense that the work is looking back at us. There are hidden eyes everywhere. Just to the right of the central figure 'I' is a hieroglyph which might be a nose and an eye. It seems the figure will not disappear. Klee's imagery attempts to find basic elements which, through their dynamic juxtaposition, reflect the underlying principles of nature. Hence we should expect to find the seed of all creation in each of its components. Contemporary analogies for this can be found in the encoding of life in DNA and the possibility of a fragment of a hologram which can yield an image of its original whole. U.P.

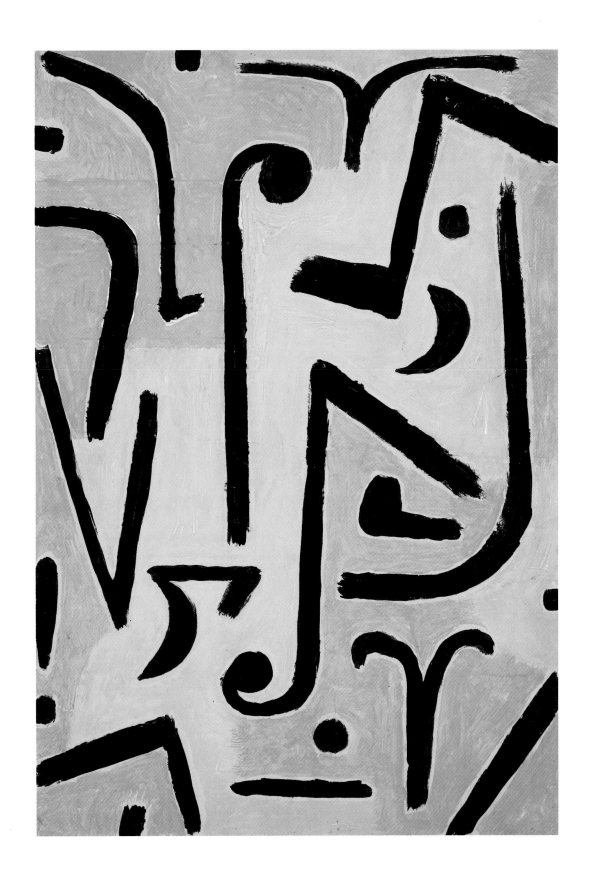

Paul Klee

61
A gate 1939
Ein Tor (T O R)

tempera on black primed Ingres paper mounted on cardboard • 31.8 x 14 cm

signed lower right; on cardboard titled and dated lower left and inscribed "1939 XXII ein TOR"

Oeuvre catalogue Paul Klee: 1939/XXII

At first this work seems to be a rendering of an architectural fantasy drawn in black on a milky blue background. However, the artistic procedure must be considered to understand the content of this work. First Klee primed the paper with a black rectangle which creates an extreme artistic impact. This device was used by Kasimir Malevich through Ad Reinhardt, but it was incongruous with Klee's figurative and narrative art. By overpainting the rectangle with opaque blue and white tempera he transformed it into a vision of a celestial Jerusalem.

The black contours of the gate and moon which are not overpainted, reverse the relationship between "form" and "surface". The latter provides the outline, the former the spatial and illuminated background. This gate architecture may be interpreted as a dream castle for Klee to inhabit while approaching death. A wide path leading up to an open gate means entrance and passage to "the other side".

This interpretation is further enhanced and subverted by the title. The German word for gate, repeated in the title with single letters, is ambiguous. It also means "fool". The single letters T-O-R also imply a third idea which is manifest in the typographical shape of the pillar, moon and path. This is reminiscent of the small landscape *Villa R.* from 1919 (Kunstmuseum in Basel). Here, twenty years later, the anecdotal and structural aspects of *Villa R.* are replaced by a more enigmatic statement.

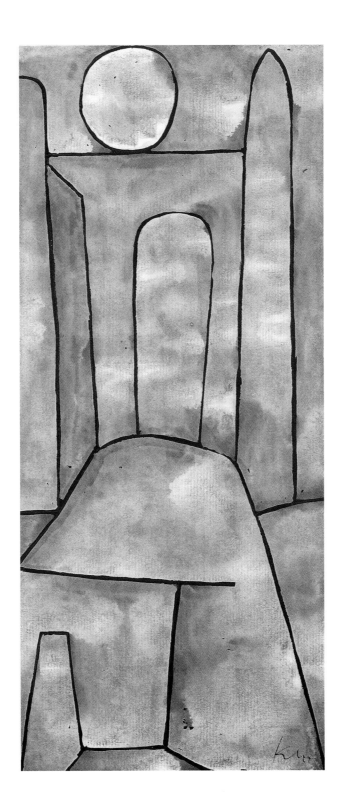

Paul Klee

62
After glow 1939
Glüht Nach

watercolour on paper on cardboard • 29.5 x 21 cm
signed lower right; on cardboard dated and titled lower centre and numbered "YY5"

This painting was made a year before Klee's death. He was enfeebled by a persistent illness and was sometimes prone to despair. The looser compositional techniques he adopted late in life and the use of tougher colour, clearly evident in this work, allowed for a more expressive character in *After glow*. However, for Klee wit was always an element of his art, even in his most harrowing images.

In this painting the hieroglyphs have taken the form of an apparently childish stick-figure. The figure may be thought of as playful, yet the colour is far from cheerful. To the left of the composition a letter 'K' can be distinguished. Klee often included this letter 'K' not necessarily as a signature but, possibly suggesting the character 'K' from Kafka's novels which denoted the protagonist.

The head of the figure is twisted sideways and in the top left corner is a group of signs which might be read as a pair of eyes and the sign of a down-turned mouth. The colour which stains the figure is a vivid pink which is made more violent by the contrasting field. The effect of this discordance and the fragmentation of the body could be seen as an image of death. The title, *Glüht Nach* could be read as still glowing or after glow, in which case this may not be the final death but the 'little death' of love. T.B.

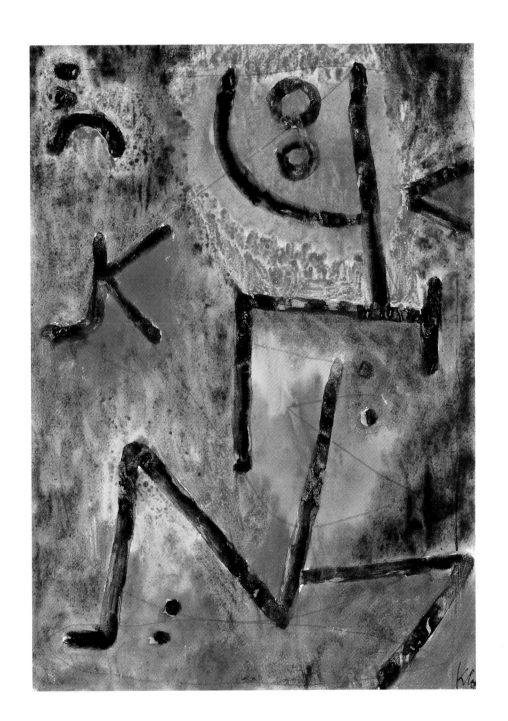

Paul Klee

63
O! these rumours! 1939
O! die Gerüchte!

tempera and oil on burlap • 75.5 x 55 cm
signed upper right; reverse signed, titled and dated on stretcher and inscribed "1939. CD 15"
Oeuvre catalogue Paul Klee: 1939/1015/CD 15

The title alludes to the various political and personal news that Klee garnered from newspapers or letters from friends. Assuming the role of contemporary artist-chronicler he made 1253 paintings and drawings alone in 1939. Images of "people" were more numerous than ever before. These "stick-figures" symbolise the suffering victims of contemporary and future world events.

The (female?) figure whose gesture expresses her distress is possibly the victim of a flood of rumours. She walks sternly towards the right. In general, and especially for Klee, the right is the future. But there is no escaping the rumours overhead (S-shaped ears to the left of her head). She is accompanied by a swarm of lower quadrupeds. A stick touching the left side of her body symbolises pursuit and assault. Disbelief is expressed in blank but wide-open eyes. Hues of yellow invest the spiral in her belly and her breast-like form with warmth. These elements which are located on the right (future) perhaps indicate burgeoning life.

On the right edge a bent, split figure with a yellow head moves from a blue zone towards the woman. Perhaps it is a quadruped, lying upside down because it pushed against the border of the picture and living space. It could be a human figure bowing to destiny. A sombre circle below the small figure on the right recalls an eclipse. Another painting from 1940 with similar "stick-figures" is titled *This star teaches submission* ("Dieser Stern lehrt Beugen").

142

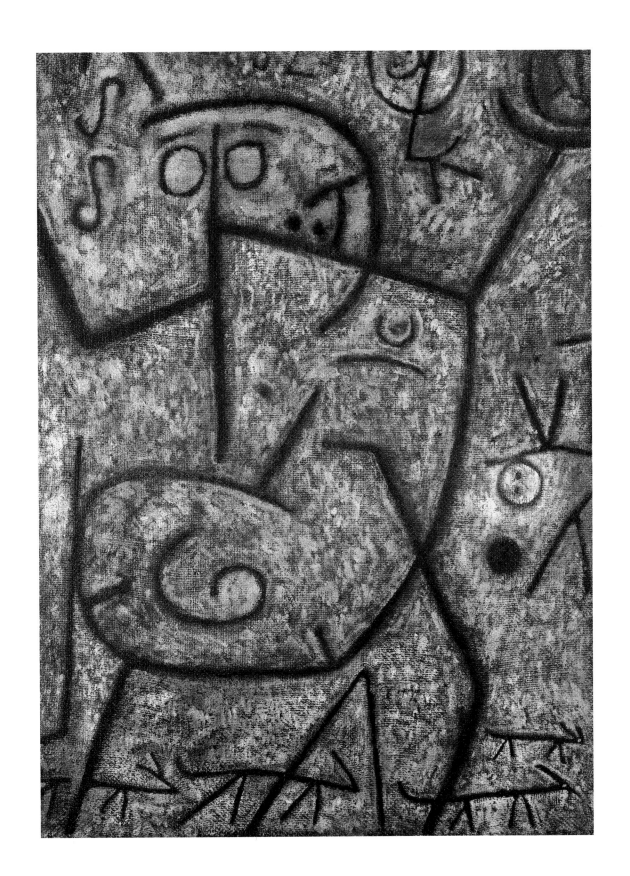

PAUL KLEE O! these rumours! 1939

64
Captive 1940
Gefangen

coloured paste on burlap mounted on canvas • 55 x 50 cm
Catalogue Grohmann, no. 469 • not listed in Klee's Oeuvre catalogue

Captive is one of Klee's last works. He was too ill to enter any more in his oeuvre catalogue. Painted on rough, nearly square burlap, it resembles an emblematic flag with which the exiled, impoverished and fatally ill Klee marks his last stand. The German title meaning "captive", "caught" or "imprisoned" implies a reading of the lines as a complex of "prison bars". These express a confinement from which escape is impossible.

A supine "S" is wrapped in a warm pink. It is perhaps the heart of the figure who keeps one eye open, looking out. The other, U-shaped eye is closed, looking in. The white glimmer of a Milky Way appears through the night-blue background. "It is no accident that I have entered on the tragic path. Plenty of sheets of drawings have pointed the way and said, 'the time has come,'" Klee wrote with poignant finality in 1940.

Ernst Beyeler expressed his special relationship with this painting by assigning it his own title. In his 1973 catalogue of Klee's works, it is entitled "This world—next world" ("Diesseits —Jenseits") which conjures thoughts of standing at the threshold of death with the blue space beyond the bars promising another life.

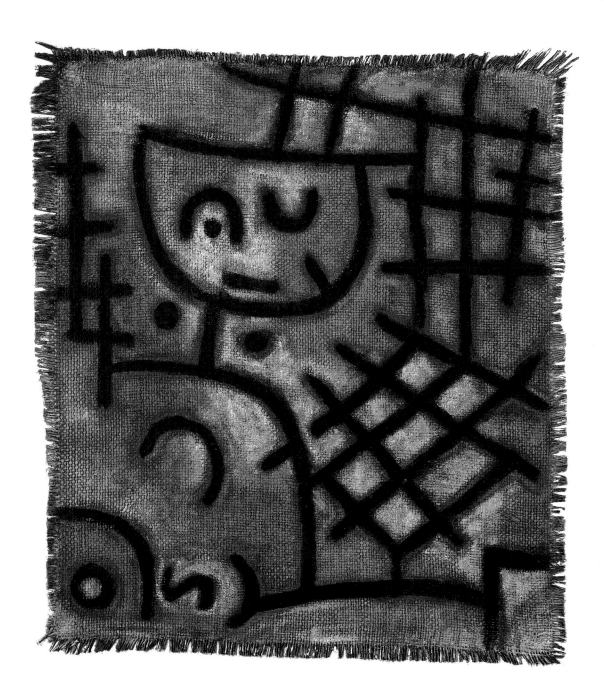

Paul Klee

146

6 5
Muddle fish 1940
Schlamm-Assel-Fisch

coloured paste and crayon on paper mounted on cardboard • 34 x 53.5 cm
signed lower right; on cardboard titled, dated and inscribed 1940 G3
Oeuvre catalogue Paul Klee: 323/G 3

Klee has a strong predilection for ambiguous titles (see *The gate* p. 139). "Schlamm-Assel-Fisch" is a combination of "Schlamm", German for "mud" and "Assel" which means isopod, a type of crustacean. But one may also read it as the German word "Schlamassel" meaning an unfortunate and disagreeable situation. This derived from the Yiddish word which combines German" schlimm" (bad) with the Hebrew "mazel" (luck). The subject is evidently a fish skeleton (with a triangular isopod?) stuck in green-blue mud. Therefore it is a "muddled" situation, a 'Schlamassel". The tragic content echoes Klee's personal situation, his terminal disease, and also the political events of 1939.

In his late works Klee united painting and drawing into hieroglyphics. The sign-fish is certainly not a reference to the Christian symbol. It has perished and is firmly embedded in mud, precluding any possibility of resurrection.

The framing black dots painted on the paper simulate the nails used to attach canvas to a stretcher.

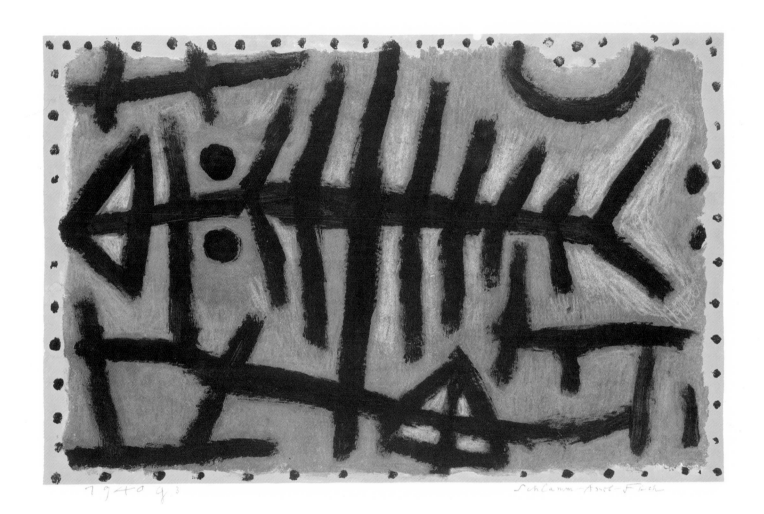

7940 93 Schlamm-Assel-Fisch

Paul Klee

6 6
MUMOM sinks drunken into a chair 1940
MUMOM sinkt trunken in den Sessel

black paste on paper mounted on cardboard • 29.5 x 21 cm
signed upper right; on cardboard dated, titled and inscribed "1940 H1"
Oeuvre catalogue Paul Klee 1940, 301 (H1)

Paul Klee entered his works in his oeuvre catalogue until 10 May 1940. That was the day he left for a hospital in Ticino, southern Switzerland, where he died on June 29. He listed year and month and grouped those works (by capital letters) executed in the same technique and week. In 1939 the alphabetic groups went twice from A to Z, once from AA to ZZ and again from A up to P. In January 1940 Klee started with Z and by the end of April arrived at F. "1940 H" marks drawings in black paste on paper with the trademark "Biber", which were executed during the first half of April. *MUMOM sinks drunken into a chair* was the first of this group. It is listed as "H 1".

Klee mounted this drawing on cardboard with a few dots of glue and inscribed it underneath a horizontal line, as he did with all his other works on paper. This time-consuming mounting and registration must have been important to him considering his enormous production during the last two years of his life. He created several hundred paintings and more than one thousand drawings. This effort has to be evaluated in the context of his fatal disease as a contribution to the survival and preservation of creativity.

His late works are characterised by the spontaneous inventions of expressive stick-figures. We have no clue to the name "MUMOM" given to the drunken figure falling into a chair, but we see the incomparable pungent force of Klee's terse brushstroke. Here is a person wasted away to a skeleton, squeezed diagonally between a gesture of cheers (vertical) and the chair. The dots above the head indicate intoxication. The figure succumbs to death which is referred to by the black eyes that are like holes in a skull.

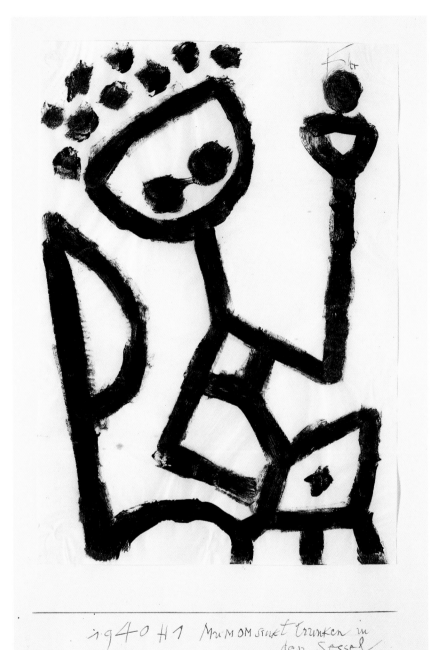

1940 H1 MuMOM sinkt trunken in
den Sessel

MAX ERNST
1891–1976

67
Snow flowers 1929
Fleurs de neige

oil on canvas • 130 x 130 cm
signed lower right
Catalogue Spies-Metken, vol. 2, no. 1380

While living in Cologne, Max Ernst participated in various Dada-manifestations. These took place in several German cities. In 1920 the Parisian Dada artists asked him to participate in their exhibition, and from 1922 he lived in Paris. There he became friends with the poet Paul Éluard. Ernst contributed a multitude of new technical tools to Surrealist painting (collages made of wood engravings, assemblages, frottages, etc).

A Surrealist history of nature, which was rooted in his German Romantic and ironic-poetic concept of the world, was a typical subject for Ernst in the 1920s. Between 1927 and 1929 he worked on a series of "flower-landscapes" with large, colourful blossoms on dark backgrounds. These backgrounds can be seen as velvet-blue horizons, nocturnal skies or depths of water. Botany mingles with zoology and geology as the blossoms may be seashells or fossils. Other paintings in this series are named *Shell flowers* and *Landscape of seashells*.

Snow flowers is the largest, most ornate painting in the series and the only one on a square canvas. Its subject, the "snow flower" is an invention of Max Ernst and refers to the patterns drawn by frost on a window.

The pigments were applied in diaphanously thin layers, giving the flowers an iridescent luminosity which is intensified by the black and moss-green of the background. The zigzag texture of the flowers were drawn with a comb, whereas the stems have the grainy texture of bark.

An impression of prehistoric blossoms in an icy atmosphere is heightened by the wintry moon. The small green square with a family of birds (lower right) is the personal emblem of the artist.

Max Ernst

68
Bird head 1934–35
Oiseau-tête

bronze (cast 1956, no. 9) • 53 cm high
Catalogue Spies-Metken, no. 2157

Max Ernst produced his first sculptures in 1934 after spending time with Giacometti at Maloja, Switzerland. He initially experimented with painting and incising stones, but quickly moved on to sculpted works such as *Bird head* of 1934–35. In this work the figure of an anthropomorphised bird, which is a recurring theme in Ernst's paintings and collages, is translated into three dimensions.

The bird figure in Ernst's work appears in different guises, but most frequently as a symbol of the artist himself. The role of the bird as alter-ego is most explicit in the collage and mixed media series *Loplop presents* (Loplop presenté) produced in the early 1930s, in which this figure is depicted displaying art works. Ernst described Loplop as his "private phantom". In *Loplop introduces Loplop*, 1930, the bird-creature presents a painting of another bird, and a figure with an outstretched hand is standing behind both, drawing attention to the bird and its painting.

The form of *Bird head* of 1934–35, closely resembles the figure in the collage drawing *Loplop presents grapes*, 1932, in which the square-bodied bird presents an equally square canvas. However, here the body has become the canvas on which the bird hovers in low relief, its head protruding. Schematised human features have been modelled on its wings and tail creating a mask-like face. The Surrealists shared an interest in psychoanalysis and theories of the unconscious. The oscillation between the forms (bird/head) in this work and the uncertainty as to which takes precedence, suggests Freud's theories of displacement in dreams, in which one object masks another more threatening object.

Freud also identified dreams of birds and flying as erotic in nature. This reference is more apparent in Ernst's disturbing collages of 1934 in which bird-headed men and women appear, often engaged in a sexually-charged struggle. The bird-creature was associated with Ernst by his Surrealist contemporaries, and the poet Éluard characterised Ernst as: "Swallowed up by feathers and left to the seas, he has translated his shadow into flight, into the flight of the birds of freedom". W.T.

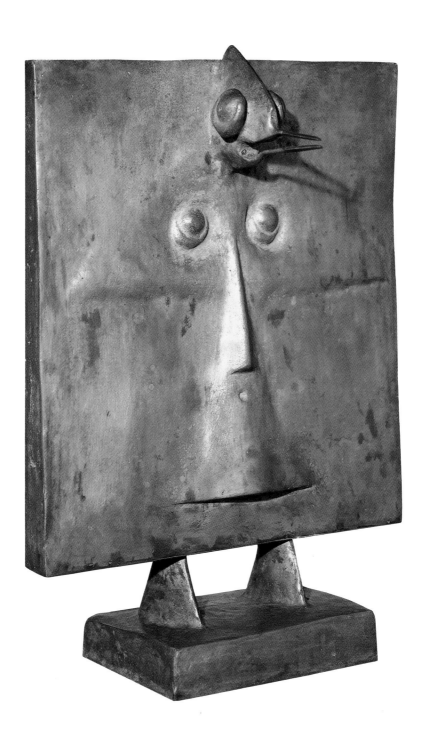

Max Ernst

69
Humboldt current 1951/52

oil on canvas • 35 x 60 cm

signed lower right; verso dedication: "To Peggy for her 12th wedding/ for her 12th of July/ affectionately/ from/ Max and Ben"

[Margaret [Peggy] and Ben Norris, Honolulu]

Catalogue Spies-Metken, vol. 4, no. 2969

Max Ernst barely escaped from an internment camp in France before entering New York in July 1941. Travelling via Lisbon he arrived together with Peggy Guggenheim. He lived in the United States from 1941 to 1953, where he continued to create Surrealist works relating to natural history and to invent techniques and themes. His American works reflect the new surroundings in his use of novel materials and his adoption of a farcical animated world view.

He spent the summer of 1952 in Honolulu as guest lecturer at the University of Hawaii. During this stay he made a series of frottages by rubbing pencil over wood. The artist interpreted the resultant veining as sea, to which he adds waves, clouds, fish, birds or sun disks. Two small format paintings of this series, *Gulf stream* and *Humboldt current*, are both examples of Ernst's chimerical "natural history." In 1954, shortly after his return to Paris, the Beyeler Gallery organised a retrospective, but not a single work was sold.

His interpretation of the Humboldt current in the Pacific as a frosty white bank moving through cool blue water is a correct one as is his rendition of the warm Atlantic gulf stream in ochre and green in the painting *Gulf stream*. *Humboldt current* represents a cross-section showing the current beneath the water surface. A frost-white, full moon ascends from the water into a murky, clouded sky. Its silver reflection flashing on the current. There is total silence. This rather romantic image is intensified by the preponderant blue which was always the colour of German Romanticism for Ernst. However, it is the distinct wood veining of the horizontal waves and dense clouds which is the original point of this scene.

Ernst's Pacific impressions have little in common with Matisse's *White algae on a red and green background* (p. 111). He is far too preoccupied with material and the inner image to entertain the sensuality of a Matisse. His interest is aroused by the spiritual rather than the natural.

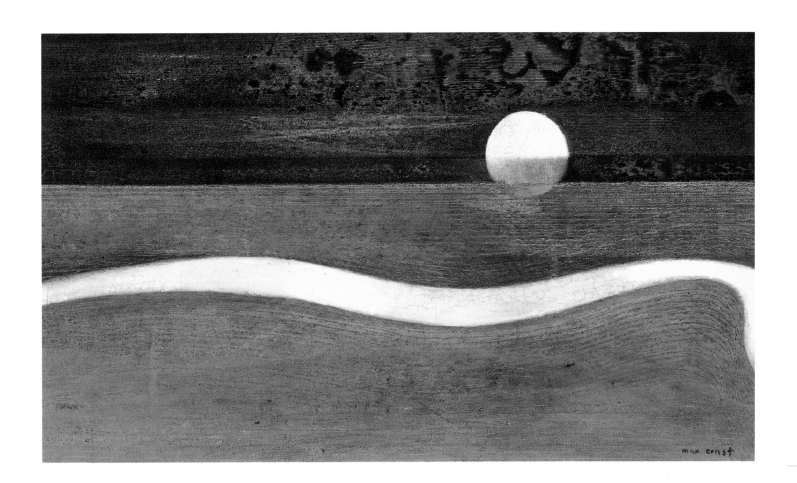

MAX ERNST Humboldt current 1951/52

Max Ernst

70
Birth of a galaxy 1969
Naissance d'une galaxie

oil on canvas • 92 x 73 cm
signed lower right; reverse titled, signed and dated

On 20 July 1969 Neil Armstrong and Edwin Aldrin set foot on the moon. This event was celebrated by the Beyeler Gallery with a special exhibition and luxurious catalogue displaying relevant sculptures and paintings by forty-six modern and contemporary artists. Included were three works by Max Ernst (from 1928, 1938 and 1958) that depicted the moon in the romantic manner of *Humboldt current*. Though *Birth of a galaxy* which was made during that year would have been a marvellous contribution to the exhibition, Beyeler could not acquire the painting until two years later. *Birth of a galaxy* was reproduced on the cover of the catalogue of the *From Venus to Venus* exhibition at the Beyeler Gallery in the summer of 1972. The exhibition celebrated the voyage of the Russian spaceship "Venus 8" on 27 March 1972.

This spectacular picture discloses a fundamental principle underlying Ernst's art. He wished to convey an image, not a painting and even in his manifold works, an overpowering image always holds ascendancy. The transformation of diverse materials and techniques into an image of something totally different is an essential characteristic of Ernst's work and Surrealism in general. Ernst's major contribution to Surrealism was the "illustrations" of a kind of fantasy "science".

This ostensibly trustworthy document of space travel, *Birth of a galaxy*, as well as the large painting *Children playing astronauts* (Enfants jouants aux astronautes) were painted in 1969, the same year Ernst published the illustrated book *Journal d'un astronaute millénaire*.

MAX ERNST Birth of a galaxy 1969

JOAN MIRÓ

1893–1983

7 1

Painting (the Fratellini brothers) 1927
Peinture (personnage: les frères Fratellini)

oil on canvas • 130 x 97.5 cm
signed and dated lower centre; reverse signed and dated
Catalogue Dupin, no. 190

Miró first travelled to Paris from Barcelona in 1920. Over the next few years he established friendships and associations with the artists and writers who would form the core of the Surrealist group. In 1925 he exhibited in the first Surrealist exhibition *La peinture surréaliste*. It was during these years that Miró developed the private language of symbols and motifs that appears in such works as *Painting (the Fratellini brothers)*, 1927.

This painting is one of a series of works from this period which are dominated by a flat blue or brown background with shallow space and a floating white form. In this painting the white form seems to delineate the body of a clown with an attenuated neck. At the end of the neck is an outline, an inversion of the body shape, which suggests a head. Attached to this are a large clownish nose, the circle of an eye and another attenuated form. The whole figure floats against the ambiguous space of the strong blue ground.

Circus motifs were popular with Miró, as with other Surrealists and painters of this period and the Fratellini brothers were a famous trio of clowns who performed at the Cirque Medrano in Montmartre. Miró seems to have been inspired by the clowns' outlandish make-up and performances, in themselves a form of social inversion which had affinities with the Surrealist interest in dreams and the unconscious.

The reading of Miró's abstracted visual language in this painting as depicting the figure of a clown is of course dependent on the title of the work, and while Miró described this language as directly referring to specific forms it does remain enigmatic. The seemingly random shapes in these works also show his interest in automatism, while not necessarily being automatic in execution as Miró often prepared detailed working drawings for his paintings. The element of chance and ambiguity in the process of creating a work could be found in the accidents that occurred in the drawings or in the process of painting, or indeed in the titling of the finished painting. Miró wrote "From a thing... I find a world. And when I give the whole a title, it becomes fully alive for the first time. I find my title during the progress of a work, by putting one thing next to another."

W.T.

Joan Miró

72

Composition (small universe) 1933
Composition (petit univers)

gouache on cardboard • 39.7 x 31.5 cm
signed and dated lower right

This small painting of an acrobatic circus performance is set in a landscape which is delineated by red, blue and yellow signifying earth, water and air. The primary colours of the prism are the leading actors in this painted narrative. Black and white symbolise gravity and centrifugal force keeping this miniature universe in motion. Sea and land animals leap into the air while sun, moon and stars swirl around like the balls of a juggler.

Surrealists often appropriated well known pictures and sculptures which were preferred by the bourgeoisie. And this work by Miró is no exception. This pictorial narrative which is so characteristic for Miró's Surrealist period is not his personal invention. Miró's *Dutch interior* (Interieur hollandais, 1928) and *Portrait of Mistress Mills of 1750*, 1929, in the permanent collection of Museum of Modern Art, New York, demonstrate how he transformed earlier genre paintings. *Dutch interior* refers to a work done in 1661 by Hendrick Maartensz Rokes Sorgh (1611–1670). *Portrait of Mistress Mills of 1750* incorporates a portrait by George Engleheart (1752–1829)—or rather an aquatint engraving after the original by T.R. Smith—into a Surrealist composition. In this *Composition (small universe)* the artist paraphrases *Najades at play* (Spiel der Najaden, 1886, Kunstmuseum, Basel) by Arnold Boecklin (1827–1901). Yet Miró's oeuvre has a very special character. The cliff in Boecklin's painting becomes an anvil-shaped springboard.

In 1944, more than a decade later, he transposed this form into the three-dimensional sculpture *Solar bird*. Then in 1966 he referred to it in a large bronze. In this picture the heavy black base crosses the horizon of the sea leading into a white centre that splits into a blue and red stub in front of the yellow sky. The blue stub on the left is turned into the good-humoured physiognomy of a walrus as indicated by eyes and moustache hair. It moves beyond water and land towards the sphere of jumping, flying, floating and falling acrobats. Beneath the red part, and to the right, a green cricket jumps into the air. The tunafish, which is tinted red with a brilliant white tail-fin and head, makes the highest jump.

The female figure shows her bewilderment. She rises like a fog in the landscape or a genie from a bottle as in the tale from *1,001 Arabian Nights*. This bewildered fairy introduces an erotic element which is also introduced by the phallic shape of the fish. The blue footprint indicates that the first approach has been made. "The crucial point" in Boecklin's painting is located in the centre of this composition. This is where the Najades play for the erotic curiosity of the viewer. Yet in Miró's composition sexuality is portrayed poetically, as the inspiration for the movement of the small universe including animals and man.

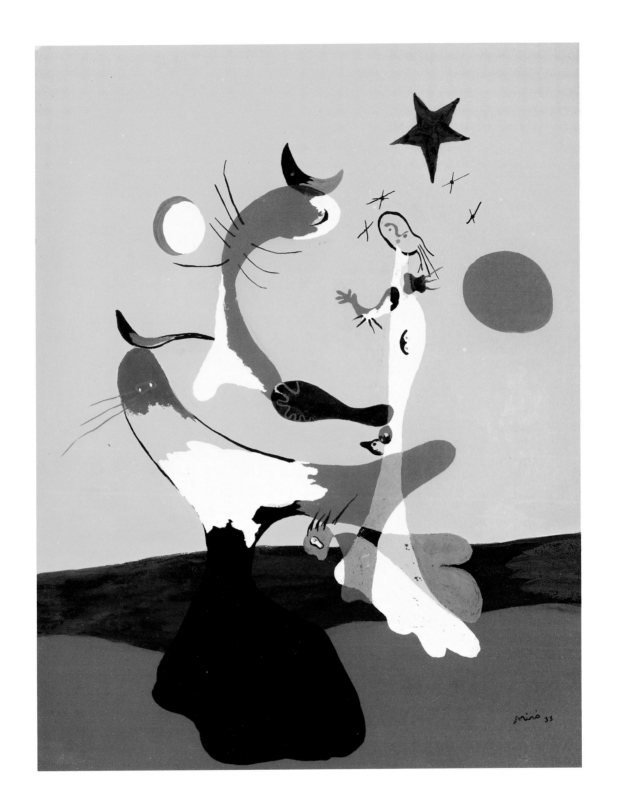

Joan Miró

73
Spanish dancer 1945
Danseuse espagnole

oil on canvas • 146 x 114 cm
reverse signed, dated and titled
Catalogue Dupin, no. 660

In the late 1930s, some of Miró's works such as *Still life with old shoe*, 1938, reflected his political sympathies. With the outbreak of the Second World War and Franco's victory in Spain, Miró turned to neutral subjects. He later described it, "At Varengville-sur-Mer, in 1939, a new stage in my work began, which had its source in music and nature. It was about the time that the war broke out. I felt a deep desire to escape."

The Spanish dancer which first appeared in Miró's oeuvre in the 1920s, is the the subject of this work. This painting is from a 1944/45 series which combine solid colour areas and graphic lines. The figure in these works are usually women. They are dancing or shown with birds, stars or music. *The Spanish dancer*

has a highly schematised figure which is predominantly linear. Colour blocks within the composition respond to the lines of the figure. They "float, collide, and unite" across the painting, but are either contained within the lines of the figure or are connected to its lines, changing colour as they cross them. Towards the top of the composition is a single star.

The figure stands on a strong black foreground which meets a background of raw canvas scraped across with blue/grey paint. The space of the foreground is shallow, but it serves to anchor the figure. In other related works such as *Women dreaming of escape*, 1945, the figures appear in a flat undifferentiated space. The depicted space in this work is ambiguous. Apart from the colour areas, the figure of the

dancer is transparent with the blue/grey ground also forming the substance of its body.

The colour areas also depict the attributes through which Miró symbolised 'women'. There are three floating eye forms, two on its 'head' and one on an 'arm'. Their shape is similar to the form which he uses to indicate a vagina. To the left of the vagina are three clawlike forms representing pubic hairs. The schematised breasts are linear rather than coloured, appearing on the figures 'chest', but other breast-like forms can also be founds in the composition. A fetishistic repetition and substitution of symbol or object for the object of desire occurred in much Surrealist art, in part as a response to Freud's theories of substitution and sexual desire. W.T.

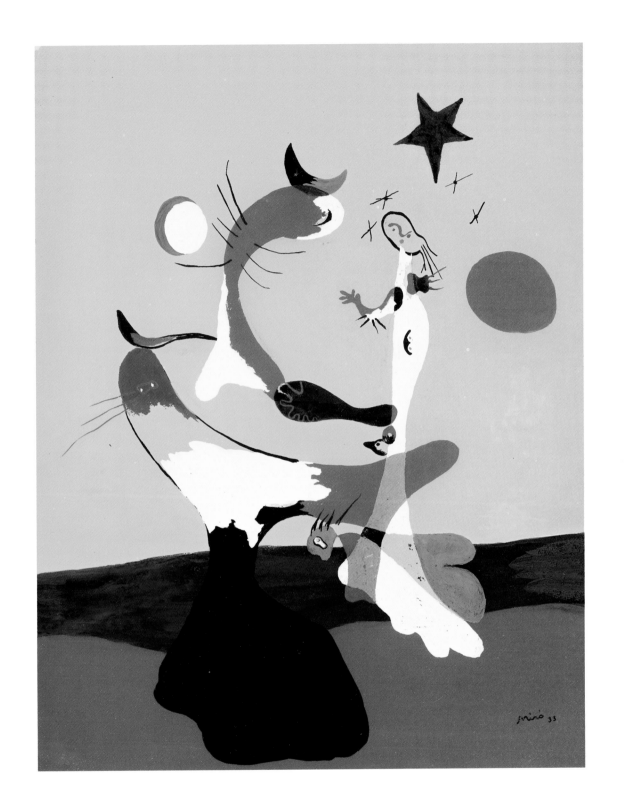

JOAN MIRÓ Composition (small universe) 1933

Joan Miró

73
Spanish dancer 1945
Danseuse espagnole

oil on canvas • 146 x 114 cm
reverse signed, dated and titled
Catalogue Dupin, no. 660

In the late 1930s, some of Miro's works such as *Still life with old shoe*, 1938, reflected his political sympathies. With the outbreak of the Second World War and Franco's victory in Spain, Miró turned to neutral subjects. He later described it, "At Varengville-sur-Mer, in 1939, a new stage in my work began, which had its source in music and nature. It was about the time that the war broke out. I felt a deep desire to escape."

The Spanish dancer which first appeared in Miró's oeuvre in the 1920s, is the the subject of this work. This painting is from a 1944/45 series which combine solid colour areas and graphic lines. The figure in these works are usually women. They are dancing or shown with birds, stars or music. *The Spanish dancer*

has a highly schematised figure which is predominantly linear. Colour blocks within the composition respond to the lines of the figure. They "float, collide, and unite" across the painting, but are either contained within the lines of the figure or are connected to its lines, changing colour as they cross them. Towards the top of the composition is a single star.

The figure stands on a strong black foreground which meets a background of raw canvas scraped across with blue/grey paint. The space of the foreground is shallow, but it serves to anchor the figure. In other related works such as *Women dreaming of escape*, 1945, the figures appear in a flat undifferentiated space. The depicted space in this work is ambiguous. Apart from the colour areas, the figure of the

dancer is transparent with the blue/grey ground also forming the substance of its body.

The colour areas also depict the attributes through which Miró symbolised 'women'. There are three floating eye forms, two on its 'head' and one on an 'arm'. Their shape is similar to the form which he uses to indicate a vagina. To the left of the vagina are three clawlike forms representing pubic hairs. The schematised breasts are linear rather than coloured, appearing on the figures 'chest', but other breast-like forms can also be founds in the composition. A fetishistic repetition and substitution of symbol or object for the object of desire occurred in much Surrealist art, in part as a response to Freud's theories of substitution and sexual desire. W.T.

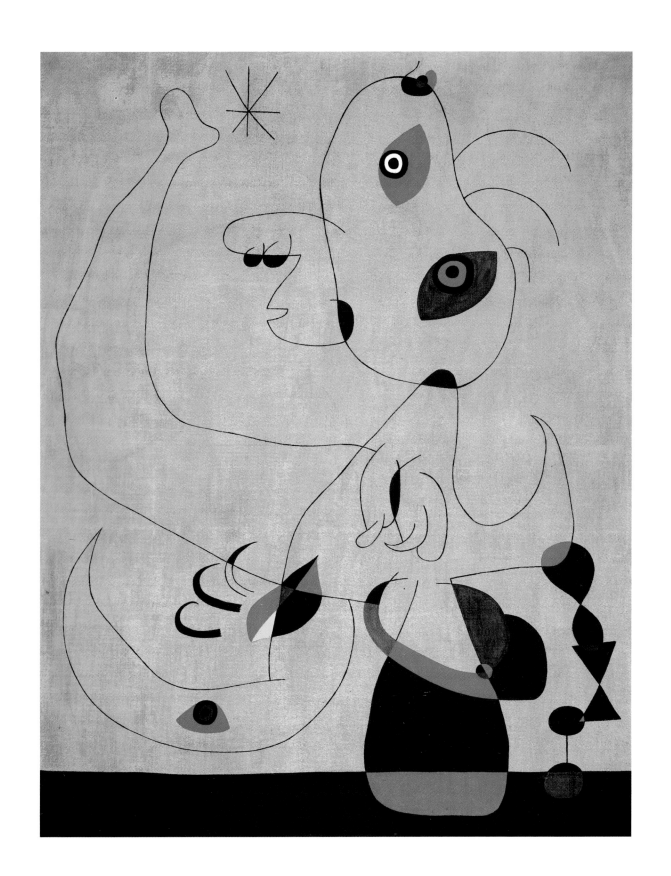

Joan Miró

74

Sun's amorous embrace 1952

L'etreinte du soleil à l'amoureuse

oil on canvas • 22 x 16 cm

signed lower right; reverse dated

Catalogue Dupin, no. 798

In the painting *Composition (small universe)* (p. 161) of 1930, Miró had anticipated the form of a sculpture that he did not execute until 1944. Conversely, one of the figures in this miniature picture is derived from a sculpture, *Woman*, 1950. This use of motifs found in previous works facilitates the decoding of the pictorial narratives.

The figure to the right is a rather chubby female keeping her upper body straight. Her legs are crossed and short stumps depict her arms and breasts. She equally accepts and rejects the erotic advances of the sun which is referred to in the picture's title. The embrace is graphically expressed in the overlapping forms attached to the yellow setting sun and the woman. Touching rouses the excitement of both partners to a degree where the colourless female body turns red (triangular shape on her right breast) and the sun is overshadowed by blue.

The red, blue, black colour combination is reflected in the pattern of the carpet or bed-cover in the foreground. In the upper picture plane the black full moon and the green crescent of a waxing moon merge into a mutual red ellipse. This may represent of the passage of time.

Miró's abstract pictorial poetry is based on sensory perception. Lines, plane and colours formulate a plausible narrative similar to a kaleidoscope of partial memories in dreams that flash into a sensuous experience. The power inherent in Miró's late paintings manifests itself in the way that he uses the geometric and colour elements of abstract painting, like those in Mondrian's painting. But Miró uses these devices to narrate the impish stories that are so characteristic of his work.

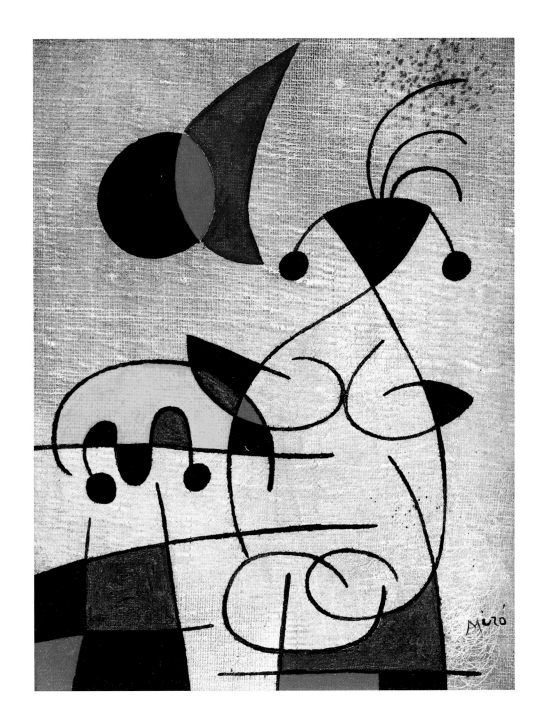

JEAN DUBUFFET
1901–1985

75

[Francis] Ponge as will-o'-the-wisp 1947
Ponge feu follet noir

oil on canvas • 130 x 97 cm
reverse originally signed, titled and dated "23 juin 1947"
Catalogue Loreau, vol. 3, no. 130

In the decade after the Second World War the recovery of the cultural life in Paris from the German occupation manifested itself in intensified creativity in the arts, theatre and philosophy. It was in this atmosphere that Jean Dubuffet changed from tradesman to painter at the age of forty-one. He rejected the accepted aesthetic values and considered amateurish productions such as anonymous sidewalk paintings, graffiti, and pictures made by children and the insane as serious artistic achievements. Though these works had inspired photographers, Surrealist painters and poets in the 1920s and 1930s, it was Dubuffet, who in writing and painting declared this form of spontaneous art equal to and more original than professional painting. He called it "art brut". In 1947 Dubuffet sold his wine store and produced the paintings of his first important period. These were based on the formal characteristics of "art brut", which he had begun to collect. The Beyeler Collection owns four of these early paintings and two from later periods and the gallery was instrumental in propagating Dubuffet's work through exhibitions and publications.

Dubuffet portrayed the poet Francis Ponge the year that his book *Dix-Courts de la Méthode* was published. The title of Ponge's book is an allusion to Descartes' *Discours de la Méthode*. Ponge's statement "man is the future of man" could have been the motto of Dubuffet's collection of "art brut" documents. His portrayal of Ponge as "will-o'-the-wisp" belongs to a series Dubuffet painted in the same style between 1946 and 1947. This series *More beautiful than they think* (Plus beaux qu'ils croient) included portraits of poets and writers such as Paulhan, Léautaud, Jouhandeau, Artaud, and painters such as Michaux and Chaissac.

It is evident these are not portraits in the conventional sense, nor caricatures, even though a photograph of Francis Ponge shows some similarities with the painting. Ponge had a round head, partly bald with short hair, narrow eyes, wide nose and mouth formed as if he were blowing smoke. This representation reflects these characteristics as if seen by a child. It contains the immediate impressions of a person captured as a curiosity. The physical proportions are subordinated to the experience. But one has to go beyond this comparison with children's drawings, as these elements serve as an anti-cultural, subversive reference point of style for a new foundation of portrait and professional painting.

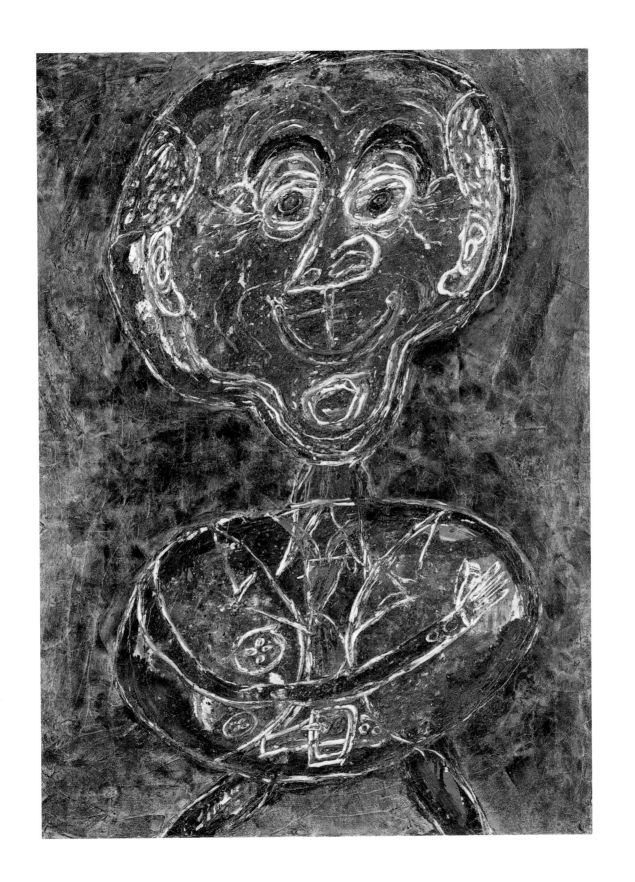

JEAN DUBUFFET [Francis] Ponge as will-o'-the-wisp 1947

Jean Dubuffet

76
Lady's body—butcher's slab 1950
Corps de dame—pièce de boucherie

oil on canvas • 116 x 89 cm
signed and dated lower centre; reverse signed, dated and titled
Catalogue Loreau, vol. 6, no. 110

Dubuffet's post-war paintings combine a radical revision of aesthetic conventions based on "art brut" with a striving for concrete materiality and gesture. This was also postulated in the works of several of his painter friends. But Dubuffet always went "too far," or one step further than the good taste and character of professional painting permitted. Though he did not abandon the traditional, framed picture to be exhibited in galleries and museums, he sequentially subjugated common artistic themes to his anti-cultural treatment. This is exemplified by the works in this catalogue. In *Ponge as will-o'-the-wisp* (p. 167) the theme was a portrait. In *The lost traveller* (p. 171) it was figuration, and in this piece it was the female nude. The painting, *Extremely rich earth* (p. 173) illustrates Dubuffet's work within the landscape tradition.

Jean Dubuffet accomplishes powerful pictorial imagery in his *Lady's body* (Corps de dame) series. While the female nude is eternally connected with eroticism, this portrayal of a woman's body expresses the blatant, drastic sexual impulse. That the artist depicts a "lady" not a "woman", plus the ambiguity of "corps" as "female body" or "institutional body" (such as diplomatic or army) is as much an icono-clastic exposé as the notation "butcher's slab".

The female torso is spread on the canvas like an anatomical specimen for sexual curiosity. There is hardly space for head and limbs. Figure and background share the same materiality, establishing it as a product of primal art, like the prehistoric "Venus" statues. The crude, childish, obscene delineation of a female anatomy by "primitive" outlines appears as if for the first time in millennia "woman" has been depicted in unsparing, impudent brazenness. But this figure cannot obscure the fact that it is depicted by a sophisticated painter.

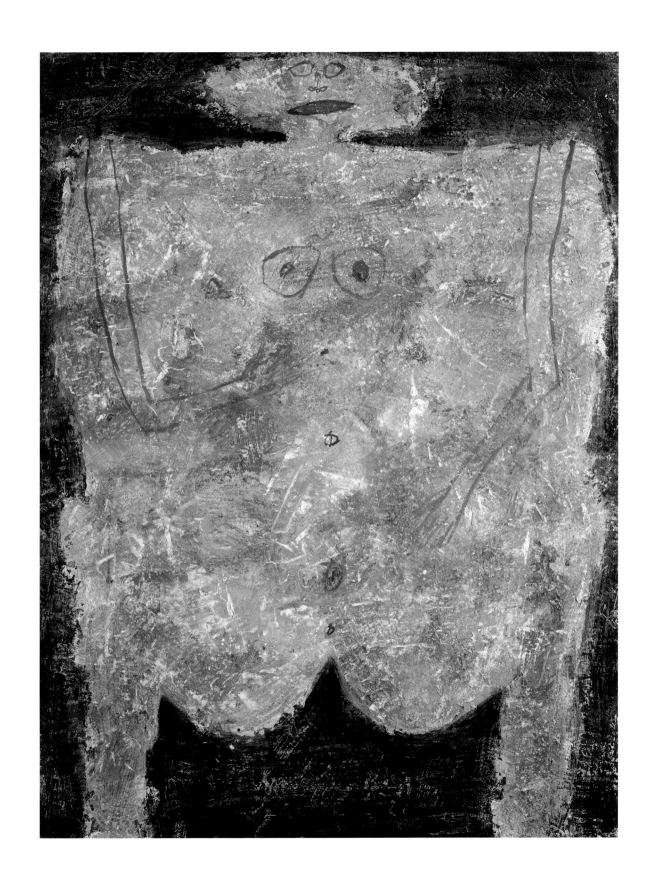

Jean Dubuffet

77
The lost traveller 1950
Le voyageur égaré

oil on canvas • 130 x 195 cm
signed and dated upper left; reverse dated "21 ou 23 janvier 1950"
Catalogue Loreau, vol. 5, no. 178

This large painting shows a well-dressed traveller (in city clothes and hat) who is lost in a suburban environment. But this is not the entire story. The audience is invited on an adventurous journey throughout the canvas. According to Dubuffet's concept of "art brut" as archetypal art, pictorial representation does not originate from the study of natural form. It is not the aesthetic rendition of perceived reality, but is composed of pictorial signs for imaginary content which recount an experience or situation. Dubuffet's style refers equally to the power of children's drawings as to the visual fantasy capable of interpreting scratches on walls or encrusted surfaces and thus of bestowing upon the unformed a sense of form. This style is a manifesto that draws attention to the genuine source, content and value of art.

The round torso of the traveller and the way he holds his arm across his body are formulations of this "primal nature". It is similar to the preceding portrait of Ponge (see p. 167) and is intended to represent an early phase of artistic evolution. This is the "primitive" phase where the figures seem to be made of parts which are glued together. But Dubuffet is anything but a "primitive" or "naive" artist, he merely offers rules of form other than those of "real" painting.

Monochrome hills with streets and paths are behind the traveller. There is an isolated house with red roof (left). Having escaped an enclosed pasture, a horse (right) approaches the traveller who is in a precarious situation. There is no escape proportional to his size. A more ornamental than topographical image of a hilly horizon stretches to the canvas' upper edge. It leaves little space for the sky and setting sun. The more one looks into the painting the more one senses the immediacy of the emotional content as narrated in Dubuffet's style.

JEAN DUBUFFET The lost traveller 1950

Jean Dubuffet

78
Extremely rich earth 1956
Le très riche sol

oil on assemblage of canvas • 156 x 117 cm
signed and dated upper right "décembre 1956"; reverse titled, signed and dated
Catalogue Loreau, vol. 12, no. 97

In the 1950s Jean Dubuffet's work offered quite a few surprises, including assemblages of butterfly wings, sculptures made of cinder, pictures made with sand, collages with dry leaves and lithographs on natural textures. In this way he widened the variety of media and tools within the traditional parameters of art without venturing into new concepts, such as action painting or performance art. Ten years later, Dubuffet's development shows a more decisive change with the invention of his three-dimensional "Hourloupe" world. *Extremely rich earth* of 1956 and *Car on a black road* (p. 179) of 1963 contain the transitions to his later style.

Extremely rich earth combines painting on canvas with assemblage technique, enriching the texture and materiality of the surface. The kaleidoscope of painted and glued forms resembles a geological cross-section, disclosing deposits of civilisation's waste mixed with natural lumps of earth and stones. The dark, narrow band indicating "sky" bestows a nocturnal, sombre atmosphere, brightened by a few colourful objects in the earth. A figure (left) is composed in the same segmented manner as the earth. She seems to sink into the debris and rubble which slowly engulfs and imprisons her, fear written on her face. She represents a part of the fertility of the earth, enhancing and merging with it. Within this mingling of figures and surface Dubuffet reveals his personal world of gnomes. It contains no similarity to "our" world but nevertheless elicits empathy because of the analogues in behaviour.

Jean Dubuffet

79
Bus at Montparnasse station 1961
Autobus Gare Montparnasse

gouache on paper • 67 x 67 cm
signed and dated lower right
Catalogue Loreau, vol. 19, no. 7

"I want my street to be crazy, my broad avenues, shops and buildings to join in a crazy dance, and that is why I deform and denature their contours and colours..."

With the post-war economic boom heralding a newly-invigorated Paris, the city that Dubuffet depicts in his 1961/62 series, *Paris circus* is markedly different from his earlier Parisian street scenes. His 1943/44 series *Views of Paris* contained brightly coloured yet more sombre and less energetic paintings. The deployment of figures and use of space here is more complex. Dubuffet frequently returned to earlier subjects and the difference between these series illustrate his stylistic recapitulations.

Dubuffet is renowned for his versatility—his ability to work in a variety of media ranging from painting to lithography to architectural constructions. His *Paris circus* series is no exception. He moves from producing scenes in an opaque and gritty paste to this gouache showing an extraordinarily light and delicate touch.

This image depicts a small part of this busy metropolis while other works in the series are highly compartmentalised. Their impastoed surfaces are incised with telescoped images of buses, people, restaurants and bustling public spaces which are reminiscent of Jean-Luc Godard's 1960 film, *A bout de souffle*.

The link between this comparatively delicate gouache and Dubuffet's oils is the wild flat pattern generated by his depiction of daily occurrences and ordinary people. The clarity of contour lines and clever compositional devices employed by Dubuffet in this work prefigures the *Hourloupe* series which began the following year.

In *Bus at Montparnasse station* the schematic front-view of his city subjects with rubbery features and lissom figures coupled with the sketchiness of the brush contribute to the vividness of the scene, the "crazy dance". Despite the busy surface, Dubuffet manages to retain the composition's tightness. C.B.B.

Jean Dubuffet

80
Virtual virtue 1963
Vertu virtuelle

oil on canvas • 97 x 130 cm
signed and dated lower left
Catalogue Loreau, vol. 20, no. 152

This work was painted in 1963, the year of Dubuffet's retrospective at the Museum of Modern Art in New York and it comes from the "Hourloupe" cycle in Dubuffet's oeuvre. The word "Hourloupe" was Dubuffet's onomatopoeic invention to suggest a wonderful or grotesque creature or object. It also evokes something threatening with tragic overtones.

The source of this series of works are ballpoint pen telephone doodles and a concomitant desire in Dubuffet to turn away from the physical environment to the unreal. He wrote, "The mystic jubilation of the physical world is over. I am nauseated by it and I want only to work against it. It is the unreal which now fascinates me: I hunger for the non-true, the false life, the anti-world; my work is launched on the path of irreality."

Based on a contrived system of planes and stripes carried out in red and blue on black and white, Dubuffet's work describes a fantastic world. The tightly interlocking cellular forms make it difficult for the viewer to distinguish figure from ground. The repetitive nature of this dense surface does not however yield a monotonous and unfocused field but is endlessly interesting by virtue of the inventive self-generating quality of this design.

In spite of the flatness of the surface, it is not surprising that Dubuffet translated these Hourloupe devices at a later stage into three-dimensional pieces. As the series progressed the schematised patterns became increasingly simplified and gradations of colour disappeared. The yellows, greens and browns which are used sparingly in this painting were eclipsed in the more precise later works.

The gritty and encrusted surface which is the hallmark of Dubuffet's work is not as evident in this particular work, but the layered surfaces of the Hourloupe series testify to Dubuffet's fascination with materiality. C.B.B.

JEAN DUBUFFET Virtual virtue 1963

Jean Dubuffet

81
Car on a black road 1963
Automobile à la route noire

oil on canvas • 195 x 150 cm
signed and dated lower right; reverse titled, signed and dated
Catalogue Loreau, vol. 20, no. 176

In Jean Dubuffet's oeuvre the years from 1963 to 1974 represent his "Hourloupe" period. This word was invented by Dubuffet for a gnome-like figure (like Mickey Mouse) of morose nature who is resigned to its fate. The term is also used to describe the figure's environment with three-dimensional furnishings and passable caverns. But "Hourloupe" primarily characterises a succinct style of painting which is an unmistakable trademark. With these three meanings Dubuffet comments on the artificial, uniform, cramped and philistine environment of the modern, technological space age. *Car on a black road* marks the beginning of the search for this style.

"Hourloupe" originated from random forms that Dubuffet drew on notepaper during a telephone conversation in summer 1963. The curved outlines, similar to pieces of a puzzle, add up by a kind of cellular proliferation into a seamless mosaic. These are differentiated by various hatchings, not unlike a black and white map with differing patterns of dots and lines which are used to illustrate election districts, climatic zones or geological properties. The final "Hourloupe" pattern is composed of linked, black outlined cells together with red, blue or white parallel hatching. In this painting the "Hourloupe" style is recognisable in the outlining of the car and its superimposed patterns. The two figures looking through the windowshield seem frightened as they drive with headlights on, lighting a nocturnal black street. The landscape which contains an abundance of leaves and trees (to the right and left of the street) is not yet affected by the "Hourloupe" infestation. In the following years Dubuffet's paintings are increasingly marked by these hatched, coloured cellular forms.

ALBERTO GIACOMETTI

1901–1966

82
Seated woman III 1946
Femme assise

bronze • 76.7 cm high
Cast no. 2/6
signature and numbered; casting stamp "Susse"

Alberto Giacometti's work ranks high in the Beyeler Collection. In 1961 Ernst Beyeler acquired the most comprehensive Giacometti collection at that time from David G. Thompson. Beyeler wanted to keep this collection together in Switzerland, Giacometti's home country. Financing this idea was a risky and daring undertaking until finally a syndicate of art lovers from Basel, Zürich and Winterthur took over. Since 1965 the former Thompson pieces have been owned by The Alberto Giacometti Foundation benefiting several Swiss museums through permanent loans. Before the works were allocated to the Kunstmuseum in Basel and Kunsthaus in Zürich they were exhibited all together in the Beyeler Gallery. Beyeler did not keep any of these works for his private collection.

The Giacometti works in the Beyeler Collection at this time have been selected from various sources. Beyeler's criteria in their selection was how well they fulfilled the intent of the artist. Therefore these are "difficult" works.

In this sculpture, *Seated woman* from 1946, the figure and stool are little more than the wire reinforcement covered with minimal plaster modelling. The delicate phase in the preparation of the cast can be considered a supreme achievement of Giacometti's brother Diego (1902–85) who also patinated all of the bronzes during Alberto's lifetime.

This work is like a sketch. The artist has removed a natural aspect of this figurative work by integrating two legs of the stool with the legs of the woman. This simple theme of a seated woman gains meaning as a mysterious reminiscence of his earlier sculptures, such as *The invisible object* from 1934. For Giacometti the representation of his model is primary. Viewing this figure from the front conveys the artist's confrontation with a human being and we sense the kernel of existence in the head and the eyes. The rest serves as a construction for the head, fixing it in space and rendering a timeless quality in its gaze.

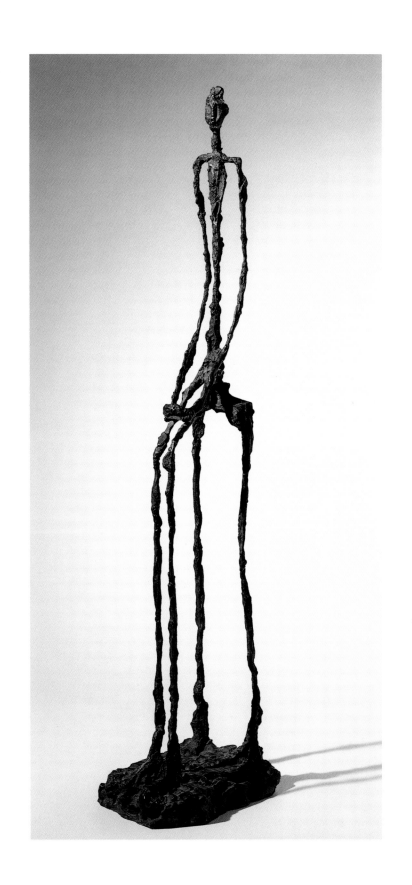

Alberto Giacometti

83

Walking man in the rain 1948
L'homme qui marche sous la pluie

bronze • 47 cm high
Cast no. 1/6
signature and numbered

Giacometti's sculptures from the mid-1920s to the mid-1930s testify to his extraordinary originality and ability. In these post-Cubist and Surrealist sculptures he combines distinct formulation with spiritual meaning. From 1935 to 1945 the artist pursued what many thought an obsession. He searched for a sculptural form of figural representation. He wished to create these pieces—heads, busts and full-length figures in their spatial environment, as he perceived them and not according to sculptural conventions. He saw in his models not just "objects" but persons endowed with the dignity of existence and the sacred aura of cult figures.

Giacometti's first stylistic medium for his concept were small frontal figures on large pedestals. Starting in 1946 the artist believed that his perception was best expressed as attenuated and elongated figures. In 1947 he invented the so-called "Giacometti style" of dematerialised, weightless, elongated figures. His often multi-figural compositions are modern monuments of the human condition wherein women stand like goddesses and men are walking.

Sculptural monuments were topical after the Second World War but Giacometti never received a commission for one. Most of his small compositions were intended as maquettes for large figural groups to be set up in public places. This group of works included *The place* (La place, 1948) containing four walking men and one standing woman, and *Three walking men* (Trois hommes qui marchent, 1948) which had three men on a platform that represented a public place. It was supported by a pedestal.

The rather anecdotal titles such as *Walking man in the rain* and *Man crossing a sunny square* (Homme traversant une place ensoleillée, 1948/9) veil the underlying meaning of the walking motif and the figure's base. The man in this work is as thin as wire. He resembles a pictograph for "walking" which in Giacometti's work was a metaphor for men's tedious activities and fateful movement. The pedestal seems to symbolise a segment of life or perhaps an Egyptian sarcophagus. There are similarities between this work and Egyptian funerary statues which symbolise a passage into the realm of the netherworld.

Giacometti freed sculpture of the pathos still inherent in works like Rodin's *Citizens of Calais*, c. 1884–88. He intended to set up his sculptures in public spaces in such a way that the figures would mingle with the people passing by. (Rodin thought of this concept late in his life but did not live long enough to develop it.)

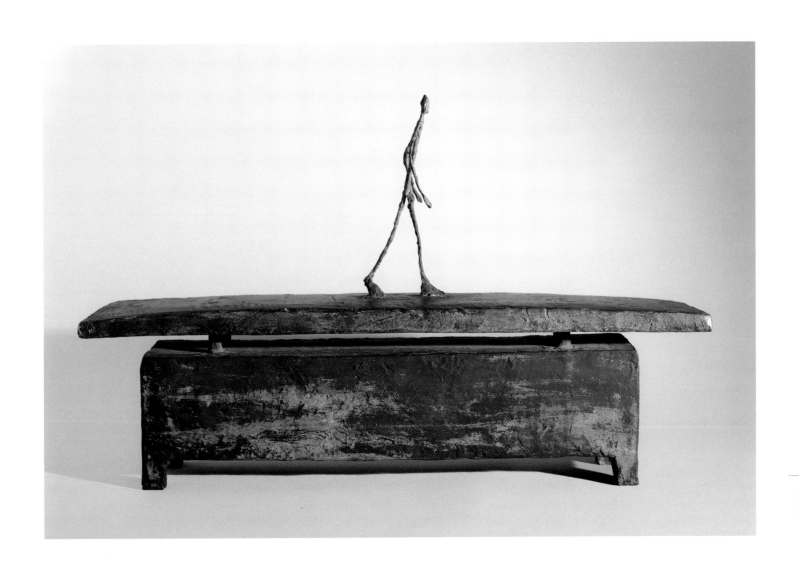

Alberto Giacometti

84
Sculptures 1950

pencil on paper • 63 x 48 cm
signed lower right

Giacometti's distinct sculptural and painting styles evolved essentially from drawing. He recorded with pencil on paper how he perceived the objects and figures and their enveloping space. He understood that both perception and the objects possess this space. One of the essentials of perception is the distance between objects as well as the distance between viewer and objects. Giacometti became fully aware of this phenomena, and in 1945 he developed a significant drawing style that led, in 1946, to his painting style and, in 1947, to the "Giacometti style" of his sculptures.

For his paintings and sculptures Giacometti concentrated on a few specific themes though they vary in form and content. Until his death he sketched everything he saw but primarily his own sculptural work.

This drawing Sculptures, 1950 possibly depicts two sculptures, a side view of a man's bust and a plaster or bronze figure of a walking man on a pedestal. Giacometti's surprising style is also evident in the background treatment. The box-like room behind the figure is sketched in perspective with pale lines that open toward the front and fuse along the edges into the plane. Vertical and horizontal lines frame the image.

The difference between the drawn bust and the figure of the walking man is remarkable. The head looking at the walking figure appears more real than the figure. This is indeed the artist's intention. Giacometti uses the bust as a metaphor for the artist as he looks at one of his creations. Giacometti felt that this motif as a metaphor was generally more valid than that of the walking man. This drawing was made in the same year as The cage (p. 187), a sculpture that includes a standing woman and a male bust mounted on the same platform. The "cage" is on a high stand and contains a tree-like woman and a man who stares at her as if she is a vision.

As far as we know Giacometti never drew rough drafts for his sculptures, therefore Sculptures is neither a sketch for a subsequent work, nor a depiction of his studio. It documents what the artists wants to say through his sculptures.

Alberto Giacometti

85
The cage (first version) 1950
La cage (premier version)

bronze • 91 x 36.5 x 34 cm

Giacometti experimented with Cubism in the late 1920s and with Surrealism in the early 1930s. One of the most celebrated of his Surreal works is *Suspended sphere*, 1930–31. This sculpture took the form of a cage in which a suspended sphere hangs over an erect sickle shape. The viewer is drawn to imagine that if the ball swings it will be sliced open like the eye in Buñuel's film *Le chien Andalou.*

The symbol of the cubic cage surfaces several times in Giacometti's sculpture particularly in his Surrealist period. He was one of the artists most revered by Francis Bacon and it was these objects which influenced Bacon to use a similar structure to enclose his figures in the Pope series. Giacometti later rejected his earlier modernist experiments and concentrated on the single figure or on groups of figures in which the individuals still seem to exist isolated in their own space and time. At times however, he creates enclosures such as the example shown here.

The cage structure allows him to raise the composition from the ground thus denying gravity. In place of the sphere and sickle of *Suspended sphere* we have a female figure who stands on the platform while a disembodied head rises up out of the elevated floor. It is tempting to speculate on this arrangement of two elements as being male and female. The female form holds onto the vertical frame looking out while the head stares through the adjacent "window". They remain locked together in their suspended prison. In another version (*The cage*, 1950–51) the cage is elevated on long legs bringing it to eye level and replacing the need for a plinth.　　T.B.

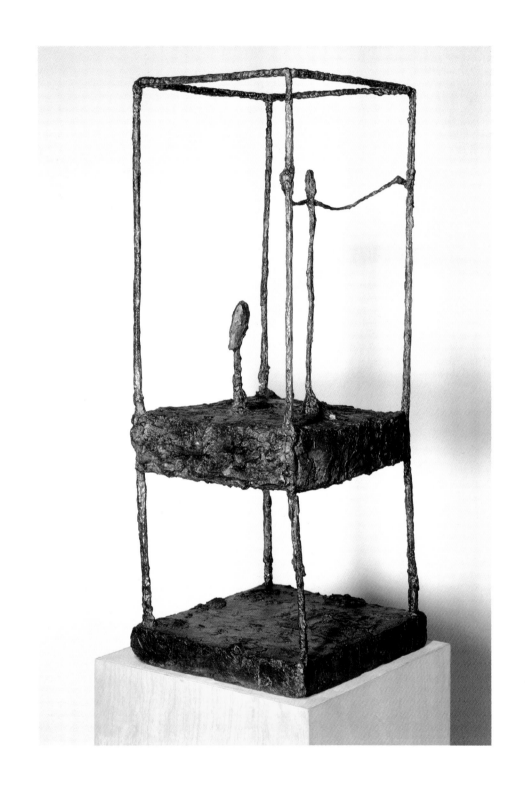

Alberto Giacometti

86
Interior in Stampa 1951
Intérieur à Stampa

pencil on paper • 50 x 32.5 cm
signed and dated lower right

This drawing depicts a small chamber of the kitchen in the old house of the Giacometti family in Stampa, in the Swiss Alps. From the age of ten Alberto had sketched his mother working in the kitchen. Giacometti was a highly accomplished draftsman in his youth, but he abandoned this skill for two decades. After the Second World War he returned to drawing as a means of verifying his perception of objects and space, eventually leading to the "Giacometti style". Beginning in the 1950s the artist produced an extensive oeuvre of drawings comparable in quality to Cézanne's. The popularity of his drawings predates that of his bronzes and paintings.

In a chamber with thick walls stands a plain, wooden table in front of a window. The spatial relationships depend on the darker, closer edge of the table leading over the scale towards the window, the brightest area in the room. In general, the fragmented, light stroke of the pencil adds little to perspective and outlining. This drawing does not render a static room with objects but "reacts" to eyes wandering back and forth, viewing the environment purely as optical rather than tactile.

Giacometti's drawing style evolved from the optical quality of the pencil demonstrated by the crystalline rays of this work. Shading and modelling is never achieved through hatching. The artist used india-rubber for blurring and shading.

Alberto Giacometti

ALBERTO GIACOMETTI Interior in Stampa 1951

Alberto Giacometti

87

The street (street corner of Rue Hippolyte-Maindron and Rue du Moulin Vert) 1952
La rue

oil on canvas • 73 x 54 cm
signed and dated lower right

Even in his youth Alberto's skills surpassed those of his father, Giovanni (1864–1933) who was a prominent post-Impressionist landscape artist in Switzerland. Alberto eventually painted portraits which are comparable in quality to those of Cézanne and the Beyeler Collection holds three superb examples of these. His painting style is as unmistakable as the "Giacometti style" in sculpture. This style was achieved through drawing and the paintings exhibit a strong linear character as exemplified in this work.

This painting contains a rather unreal impression of a Parisian street. There are no people, no life. The dramatic extension of the street into the background emphasises its function as the main theme and its pre-eminence over the buildings. The buildings are viewed from the left sidewalk on the Rue Hippolyte-Maindron, just in front of the corner leading to the right and into the Rue du Moulin Vert. Giacometti's studio was in this part of the Montparnasse and though the buildings serve as perspective, it was the space of the street which is painted in an airy pink, pale yellow and greenish light, that dominated Giacometti's perception.

The picture is enclosed by black lines and dark greyish colours. Giacometti's father occasionally decorated the wooden frames of his pictures with symbolic or ornamental motifs, while this painted frame serves as an integral part of the work. In The street the frame establishes a proportional balance between the spatial depth and the standard measure of the canvas. It also serves to place a topographic subject into a visionary sphere.

Alberto Giacometti '05

ALBERTO GIACOMETTI The street 1952

Alberto Giacometti

88
Woman of Venice VIII 1956
Femme de Venise VIII

bronze • 122.3 cm high
Cast no. 6/6
signature and numbered; casting stamp "Susse"

In autumn of 1955 Giacometti was invited to participate in the French exhibition at the Biennale in Venice. During the spring of 1956 he worked on a standing female figure for this exhibition. He made several versions changing the expression and height repeatedly from 105 to 156 centimetres. He used the same reinforcement and clay. Diego made a plaster cast of each alteration the following morning. Altogether fifteen versions were executed. Ten of these works, forming two groups of four and six figures respectively, were shown in Venice. Later nine figures were cast in bronze and given the title *Women of Venice*

(Femmes de Venice). The version VIII in the Beyeler Collection, which is probably not the eighth chronologically, represents the most hieratic figure.

The writer Jean Genet, who often visited Giacometti in his studio, and published their conversations in 1957 in *L'atelier d'Alberto Giacometti*, gave the most moving interpretation of these statuesque females: "Clearly, each statue is different ... In front of these women I have a feeling of discovery—the time and the night which shaped them so cleverly, eroded them to give them this appearance,

at the same time soft and hard of eternity that goes by. Or maybe them come out of a kiln as residue of a terrible firing—when the flames went out what remained was this. But what kind of flames!"

Especially revealing is the following excerpt:

Genet "You must have a strong stomach to keep one of your statues in your home with you."
Giacometti "Why?"
Genet *I hesitate to answer. My words will expose me to ridicule.* "One of your statues in a room and the room becomes a temple."

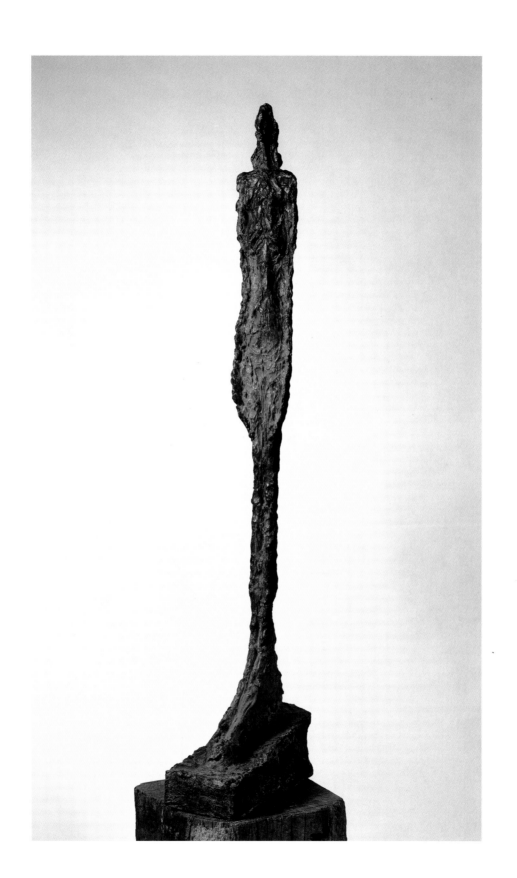

ALBERTO GIACOMETTI *Woman of Venice VIII* 1956

Alberto Giacometti

89
Aika 1959

oil on canvas • 92 x 73 cm
signed and dated lower right

Giacometti's models were usually family members or close friends whose features he knew intimately. This allowed him to transcend the individual and look for a generic expression of existence.

Two portraits of Aika Sapone are known to exist, including this masterpiece which was painted in November 1959. The other (100 x 65 cm) was painted during February 1960 and is in the collection of Dr. Eberhard W. Kornfeld, Berne. In the later portrait, which Giacometti considered unfinished, the model appears less severe.

Aika Sapone was fifteen years old in November 1959 when she came to spend the holidays in Paris. She was with her father, a tailor from Nice who made clothes for Giacometti and other artists. Aika went to Giacometti's studio to sit as model every afternoon from three to five o'clock if the light was bright enough. Every night for three weeks after the painting was 'finished', Giacometti reworked the head. He would then compare it the next day with the model when she returned. Aika finally had to leave to return to school. (This information was included in a letter from Aika Sapone to Valerie Fletcher of October 1987, published in the Giacometti catalogue of the Hirshhorn Museum, Washington, D.C., 1988, ed. no. 87.)

The polarity of art (representation) and reality (model) presents the basic foundation of Giacometti's work. The painting should be far more than merely the depiction of a young girl as indicated by the strict frontal pose and nearly symmetrical structure. The brushstrokes in the background resemble sketched lines and allude to the studio atmosphere. On the left there is a staircase and on the right is a female sculpture. The elements closest to the painter are rendered according to normal rules of perception wherein the knees and hands appear "too big" and the more distant anatomical parts, head and shoulders are "too small". But the head exhibits a powerful presence transforming this work into a "duplicate of reality".

The beginning of Giacometti's last masterful period can be dated as starting in 1958. Except for the figural group intended for the Chase Manhattan Plaza in New York, portraits dominate his late oeuvre. Though the term "portrait" with its usual connotation of a "likeness", can hardly be applied to Giacometti's rendition of women and men. As exemplified in this work, he elevates his models to hieratic figures in sacred surroundings.

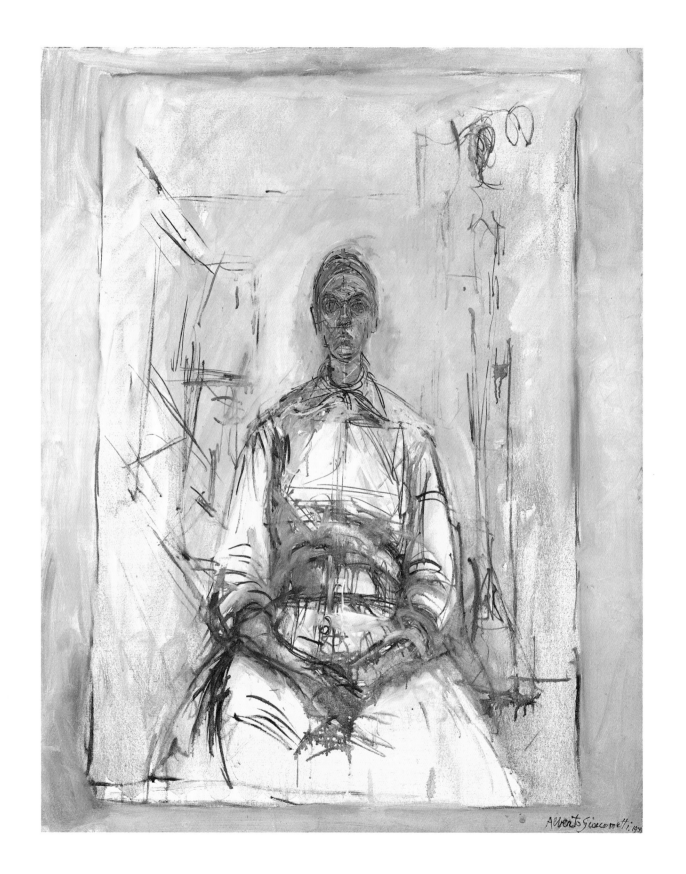

Alberto Giacometti

9 0
Monumental head 1960
Grande tête

bronze • 95 cm high
Cast no. 6/6
signature and numbered; casting stamp "Susse"

In 1958 Giacometti, Alexander Calder and Isamu Noguchi had been commissioned to submit a sculptural project for the plaza in front of the sixty storey building of the Chase Manhattan Bank in New York. Giacometti made miniature figures for experiments on the architectural model of the plaza. The final plaster model for *Monumental head* and *Walking man* can be seen in various photographs taken of his studio in Paris in 1959. The 1960 date given for the sculptures refers to the year of completion for the whole group as well as the individual casts. *Monumental head* and the following two bronzes *Standing woman III* and *Walking man II* (pgs. 199 and 201) are all part of the composition.

The large head on an elongated throat resembles various busts Giacometti made of his brother Diego who often served as Alberto's model. But these heads also show a likeness to the artist himself. When these heads are attached to a body they represent "walking" but in the form of a bust they express "gazing".

Several sculptures from 1950 show a combination of a standing female with a male bust which is proportionally too small. Since the male's eyes are directed just past the female, this grouping seems to refer to a mythological event, not to a man observing a woman. In the ensemble of the Chase Manhattan Plaza project *Monumental head* refers to the artist.

The correlating heights of *Monumental head* and *Cube* from 1935 (95 cm and 94 cm) present an argument for this interpretation. *Cube*, is a stereometric abstract form, originally intended as one element of a sculptural group. It was later described by Giacometti as a head and incised with his self-portrait before it was cast.

In the Chase Manhattan project *Monumental head* assumes the artist as observer of the life-size *Walking man* and visionary seer of the larger than life *Standing woman*. Fusing the base with head and throat turns the sculptural representation into a representation of a sculpture. It is a "Monumental head with base". It is a work of art contained in a work of art, or, is art itself.

Art, along with reality and mythos, imparts meaning. This is an idea that Giacometti may have derived from the colossal marble head of Constantine the Great (c. 330 A.D.). Today this fragment of a gigantic statue (height of head 261 cm; original height of statue surpassed 7 metres) stands on a pedestal in the Capitoline Museum in Rome, where, in 1958, it was seen and sketched by Giacometti. In this case, *Monumental head* bears three dimensions: reality, myth and history. *Walking man* implies the present and *Standing woman* eternity.

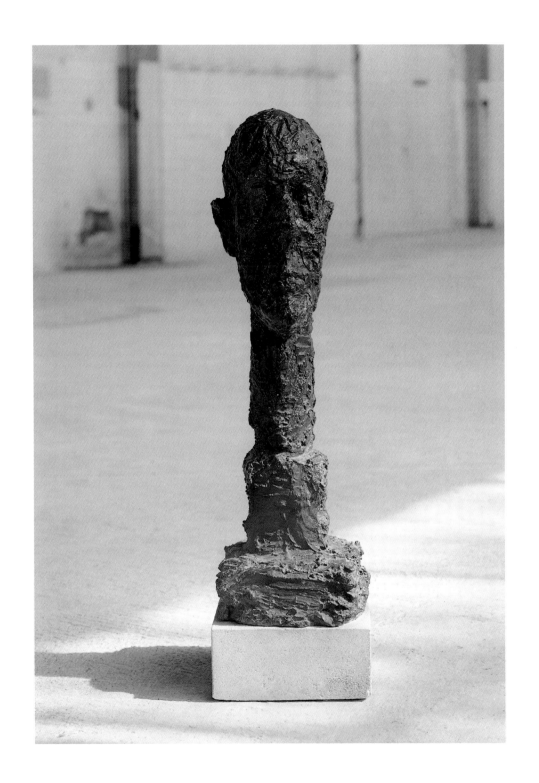

Alberto Giacometti

9 1
Standing woman III 1960
Femme debout III

bronze • 235 cm high
Cast no. 6/6
Signature and numbered

Four versions of a standing woman were created as part of the public monument for the Chase Manhattan Plaza in New York, which was never realised. These versions differ in height (versions: I = 267 cm; II = 278 cm; III = 235 cm; IV = 276 cm). They are all larger than life-size. Alone, or in a grouping, the female represents the spiritual direction and aim for the walking man and acts as his point of reference. Her height and posture express the artist's mythological thoughts. These sculptures are related stylistically to prehistoric and primitive art.

Giacometti had previously titled sculptures in groupings of seven and nine standing women as *The forest* (La forêt) and *Glade* (La clairière), respectively, in order to compare female figures with trees. He also talked about these ideas and formulated them in drawings. His women are cult figures promising the continuity of life, thus giving an overriding significance to men's daily, tedious activities.

When Giacometti visited Chase Manhattan Plaza three months before his death the solution for the seemingly insurmountable architectural problems suddenly appeared obvious. He could make his statement in one single female figure of seven or eight metres in height, dimensions appropriate for a cult statue. But this rudimentary, tree-like depiction of the female body possesses a venerable quality that can be sensed even in the smaller bronzes.

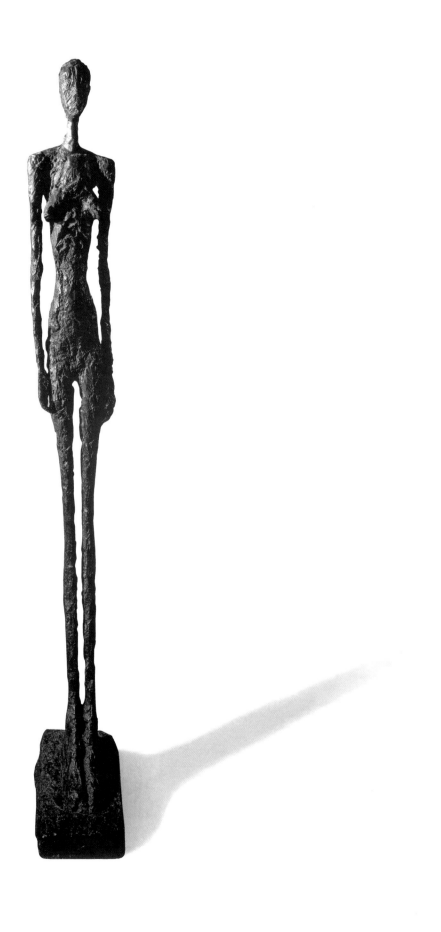

Alberto Giacometti

92
Walking man II 1960
L'homme qui marche II

bronze • 187 cm high
Cast No. 4/6
signature and numbered; casting stamp "Susse"

In 1932 Giacometti had public monuments in mind when he created *Model for a square* (Project pour une place). He had the same goal in 1948 when he made *City square* (La place) and *Three men walking* (Trois hommes qui marchent). *Charriot* (Le chariot), *Square* (La place; 3 standing women and a male head), *The forest* (La forêt; 7 female figures and a head) and *Glade* (La clairière; 9 women on a pedestal) all of 1950, were developed as possible public monuments. Yet this work was never commissioned.

When Giacometti finally received a commission for a monumental group it was never realised. This sculpture formed part of his concept for the Chase Manhattan Plaza in New York (see preceding pgs. 197 through 199).

His project for the plaza near Wall Street comprised one life-size walking man, a larger-than-life standing woman, and a monumental head. The artist intended to fix the two figures on a plinth and install them on the busy plaza, whereas the monumental head should be set on a high pedestal. Even though this concept was not approved Giacometti developed it. Two casts were made of *Walking man*, four each of *Standing woman* and *Monumental head*. It is unknown if he intended to position more than one man and one women on the plaza.

For the Venice Biennale in 1962 Giacometti positioned two walking men, two standing women and the monumental head in such a way that they could be seen both as a group and as single sculptures. At the Foundation

Maeght in Saint Paul-de-Vence these same figures formed a unit, but visitors could walk between each figure in the courtyard.

Walking man II measures 5 centimetres more than version I. Both versions represent an average-sized man crossing a square yet their pose is contrary to the natural movement of walking. Their arms and hands are rendered as stiff and immobile. Their whole appearance, with bent body and head, seems hieroglyphic. The goal of their active, continuous and fateful walking is to encounter the female who represents eternity. This is an encounter Giacometti never considered within reach.

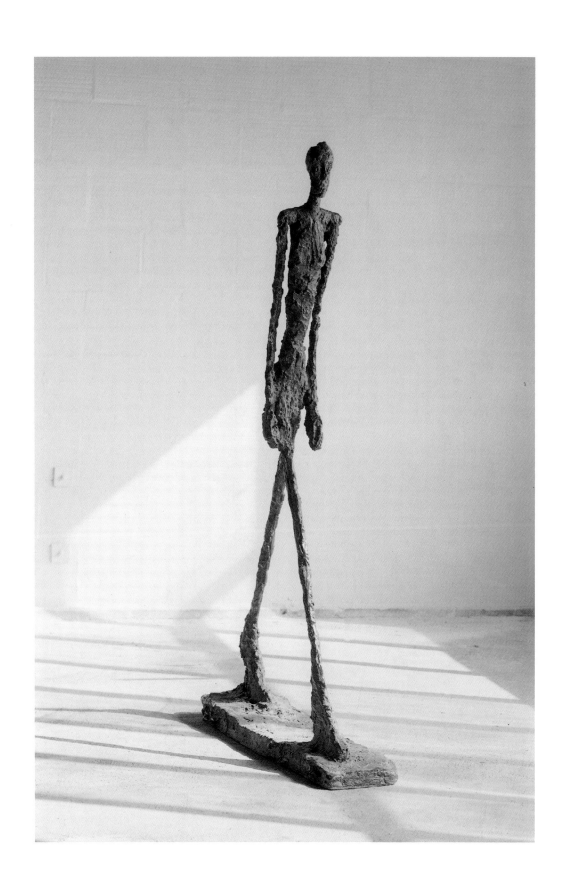

Alberto Giacometti

93
Caroline 1961

oil on canvas • 100 x 81 cm
signed and dated lower right

This young woman from Montparnasse, known in that quarter as "Caroline", occupied a prominent place not only in Giacometti's late works from 1960 to 1965 but also in his private life, and she was present when he died. The artist measured the value of his work and the risks of life against the intensity of her personality and courage. A contemporary witness, Mrs Maeght, reported that the intimacy between Giacometti and Caroline was so strong that at times they would exchange an intense look for half an hour without interruption. The magnificent portraits that the artist and model created together convey some of this intimacy but surpass the private aspect through the hieratic frontal depiction.

These portraits place Giacometti alongside the great masters of European art. Cézanne, when having his wife sit as model for a painting, saw his task in making the living Madame Cézanne into an artistic masterpiece. Giacometti did the reverse. He used his art to reciprocate the individual being, Caroline in a painted image of the model.

This profound claim on reality was accomplished in the mummy portraits from Fayum or Byzantine icons of saints because they were meant not as image but as presence. Though no religious meaning underlies Giacometti's art, the impression is that of "secularised icons" of mankind. Giacometti's art distinguishes itself from European portraiture with its emphasis on features, social situations and artistic intentions because he painted individual subjects with the essence being "to exist". Their eyes stare out of the picture and force us to enter their world. They see and so they exist.

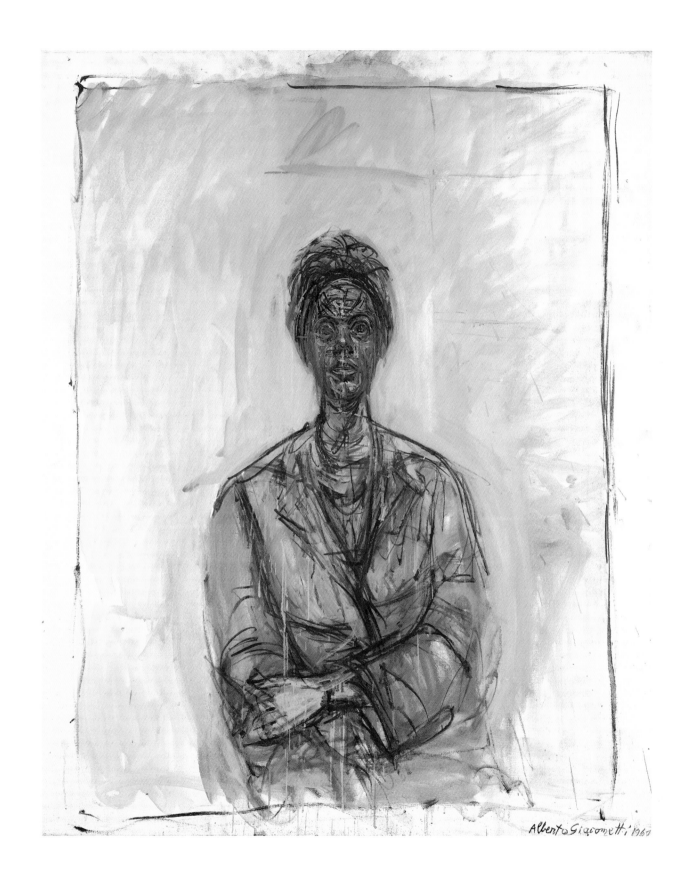

Alberto Giacometti 1961

Alberto Giacometti

94
Isaku Yanaihara 1961

oil on canvas • 100 x 81 cm
signed and dated lower right

In 1954 Isaku Yanaihara, a Japanese professor of philosophy, came to Paris to get to know the exponents of French Existentialism. He had translated Camus's *The Stranger* into Japanese and now intended to write an article about Giacometti. During his visits with Giacometti in November 1955, an intimate friendship developed that became even closer when Yanaihara sat as his model and befriended Giacometti's wife, Annette. Yanaihara prolonged his first stay in Paris, and returned each year until 1961—except in 1958, the

year he published the first Japanese monograph on Giacometti.

Prior to this portrait Giacometti made several paintings and busts of Isaku Yanaihara, revealing the gradual evolution of his masterful late style. Giacometti's intention went beyond capturing the model's personality and physical characteristics. He wanted to represent the actual presence. Linear structure and fluid, open brushstrokes define knees, arms and upper body as if they were the pedestal of

the head. However, the head has a metallic corporeality, the dark and white brushstrokes creating a plasticity comparable to a free-standing sculpture.

The fluid tones surrounding the head insinuate the space behind. This is the image we see when we concentrate and "objectively" look into a mirror and try to be aware of the distance of mirrored space behind us. This painting exudes an intensity unique in the history of European portrait painting.

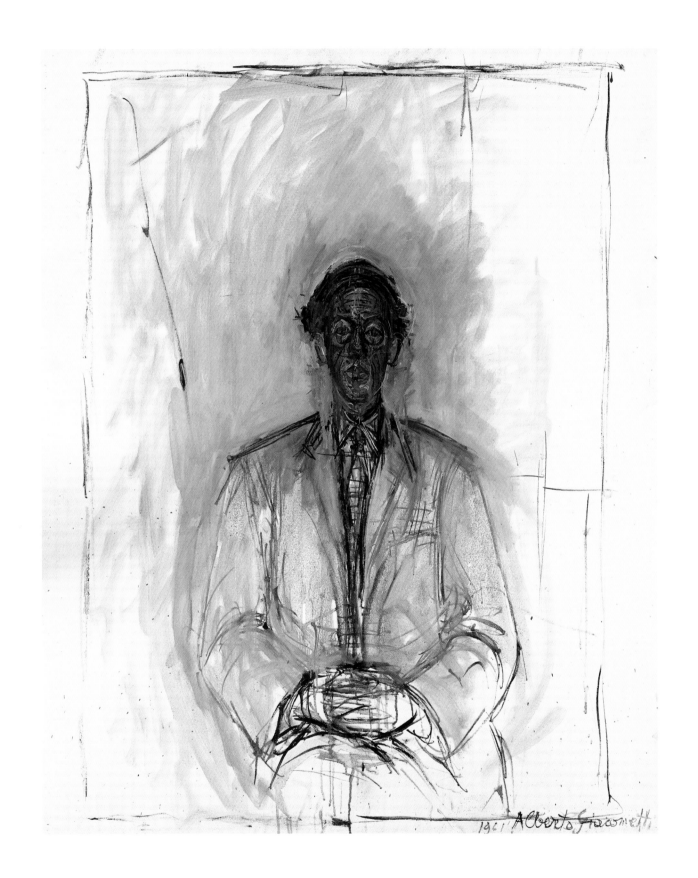

1961 Alberto Giacometti

Alberto Giacometti

9 5
Elie Lotar III (seated) 1965
Elie Lotar III (assis)

bronze • 67 x 29 x 35 cm
Cast no. 8/8
signature and numbered; casting stamp "Susse"

Giacometti strived to render more than similarities to the subject's physiognomy and the spatial perception of a figure in his portraits. Yet he worked from models even during the last two years of his life. Giacometti would continue working on a portrait after the sitter left. The model served primarily as a medium for the expression of something reaching beyond reality.

Elie Lotar was more than fifty years old in 1965. He was the son of a prominent poet in Romania, and went to Paris as a young man after the war where he worked as a photographer on the fringe of the avant-garde of Montparnasse. Now he frequented the night-life of Montparnasse. Giacometti met him in the bar Chez Adrien, where he had also encountered a young woman known as Caroline. Both Caroline and

Lotar became frequent visitors to Giacometti's studio and posed as models and lived off his money. The artist saw in Lotar, a person who did not fulfil the promise of his talents, and who exulted in a existence void of ambitions and illusions. He believed this far closer to reality than success. The aged, bald and alcoholic Elie Lotar's round skull posed a new challenge for the artist. The re-creation of this compact head in its spatial relationship, imbued with a kernel of existence, was Giacometti's last task.

In 1964 and 1965 Giacometti sculpted three busts of *Elie Lotar*. These were differentiated by Roman numbers. Number I depicts the head and shoulders, number II from head to hips and *Elie Lotar III* sitting on a chair, his hands resting on the upper thigh. The head dominated each sculpture. The gaze seem to transcend

the artist or viewer. He sees something beyond or, perhaps more important, inside.

On 5 December 1965 Giacometti had the clay model of *Elie Lotar III* covered with wet cloth to save it from drying out. Terminally ill he travelled to Chur in Switzerland where he died on 11 January 1966 in the presence of his brother Diego. After the funeral Diego returned to Paris, slowly defrosted the frozen cloth over Lotar's bust and made a plaster cast of his brother's last work. Later Diego placed the bronze cast of Lotar on Alberto's grave in Borgonovo near Stampa, Switzerland.

Elie Lotar III profoundly moves us, not because it was Alberto Giacometti's last work, but because this sculpture embodies the realisation and a culmination of Giacometti's artistic ideal.

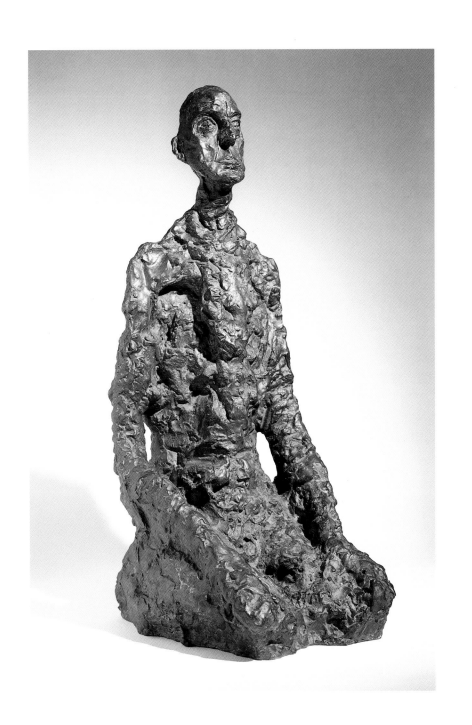

ALBERTO GIACOMETTI Elie Lotar III (seated) 1965

MARK TOBEY

1890–1976

96
Forest cathedral 1955

coloured paste on paper • 52 x 38 cm
signed and dated lower right

Paul Klee noted that Tobey used script-like calligraphy to create images which reflected the vital quality of nature. There are many similarities between Klee and Tobey. Both were individuals, if not loners and both of them spent their last years in Switzerland. The overall rhythms of Tobey's paintings seek to capture qualities of atmosphere and processes of natural landscape or the effects of light. Klee similarly struggled to attune his compositions to the vibrations of nature with his intuitions of simple forms manipulated within his basic rules of composition.

Tobey is often shown in the context of Abstract Expressionism and his work did follow a similar path. He dallied with Surrealism and he visited China and was impressed by Asian calligraphy. However he did not think of his work in the light of abstraction or of expressionism. His luminous grids of colour and linear rhythms capture the specific qualities of particular places and natural conditions. *Forest cathedral* is a particularly good example of this tendency.

The viewer will best enjoy the qualities of these works by allowing the eye to be drawn by the rhythm and tonality of the images. Musical metaphors come readily to mind as they do for Klee and Kandinsky, the two artists whose works Tobey's most closely resemble. T.B.

Mark Tobey

9 7
White journey 1956

coloured paste on paper • 113.5 x 89.5 cm
signed and dated lower right

Mark Tobey was seventy in 1960 when he moved to Basel, where he created his significant late oeuvre. His contact with this quiet, inspired and wealthy city was established by Ernst Beyeler, who provided a final residence and new friends for the peripatetic American. At the World's Fair 1958 in Brussels, Beyeler sensed an affinity with Tobey's paintings and subsequently bought *White journey* of 1956 which was exhibited there. Up to the time of Tobey's death the Beyeler Gallery organised several exhibitions showing his latest works together with earlier paintings. But the important position that Tobey's art occupies in the Beyeler Collection is probably based on a spiritual kinship between the artist and collector.

This affinity becomes especially evident in another Tobey painting in the Beyeler Collection, *Forest cathedral* of 1955 (p. 209). It is a small tempera composition on paper. It links the calm, deep feeling for nature of German Romanticism as expressed in Caspar David Friedrich's (1784 –1840) paintings with Klee's art and sensibilities (see *The chapel*, 1917, p. 119).

Since 1918 Tobey was an adherent to the Baha'i World Faith, which espouses universal oneness, the unity of mankind and the interdependence of nature, science, art and religion. This offers a reference point between Tobey's abstract compositions and Mondrian's Theosophic-cosmic constructions in this collection.

Tobey brought to his versatile artistic career his diverse experiences of North America— from the idyllic life along the Mississippi to the confetti parades on Broadway. Along with this he brought a knowledge of the Orient and an assimilation into European life and culture.

The artist told Beyeler at their first meeting that *White journey* was inspired by a journey through the American continent. Perhaps he saw snow-covered regions, but the meaning of white is here neither snow nor winter. Tobey's white symbolises the culmination of meditation, the result of contemplation, the dematerialisation of things and the rise of the world of senses in a luminous spirituality. The "white journey" is a pilgrimage from detail to general, from fringe to centre, and from quantifiable surface to the infinity of space.

Mark Tobey

98
Night flight 1958

coloured paste on paper on cardboard • 27 x 19 cm
signed and dated lower right

This is an excellent example of calligraphic painting by Mark Tobey. The layered grids of energetic marks produce an overall field of energy which defies focus on any particular detail. The dark field behind the energetic grids of light becomes a space of contemplation which inspires an inward-looking state of mind as much as it invokes an outward space of darkness and light.

It is typical of Tobey that the title is a direct reference to a view of the world. Most abstract painters began making their titles arbitrary or hermetic and in time the titles were replaced by numbers and the unhelpful, "untitled". However for Tobey the works are never abstract. This image strongly suggests the view of a city seen from the air at night. It might also be the after-image left on our retina when we have blinked away the sudden shock of a bright light in the night sky.

The images are not only internal and external. They also suggest the eternal. They form a field of energy which continues beyond the pictorial field, apparently forever.

'This combination imbues many of Tobey's pictures with a luminous quality, an intimation of good fortune. The viewer is invited to venture along the paths of such experience'.

Gottfried Boehm, from *Mark Tobey—A Centennial Exhibition*, Beyeler Gallery T.B.

MARK TOBEY Night flight 1958

EDUARDO CHILLIDA

born 1924

99
From the horizon 1956
Del horizonte

wrought iron • 66.5 x 22 x 32 cm
monogram

The Spanish artist Chillida was committed to the Basque cause and he brings this dedication into his sculptural works. Chillida became acquainted with the issues and developments in post-war art while he was in Paris around 1950. During the 1950s he was already recognised in Europe and America not only for his art but for his political involvement.

From the horizon, together with other wrought iron sculptures from the same period, speak of wind, air, echoes, "silent music", iron, fire and "dream anvils". Chillida's art is a product of his keen awareness and perception of natural phenomena and his affinity to the Basque homeland.

The most important theme in his sculpture is the manifestation of space in which geometric structure or constructivist design alone does not suffice. Space is a limitless area of existence reaching out in all directions. The two vertical stakes thrust their points in space like birds placing their beaks in the wind. These stakes, together with the iron plate inform us of a "front", "between", and "back", while the connecting iron stump in the centre signifies "right" and "left". These circumscribe the innermost core of the spatial area of existence. The analogy to the human spatial existence, makes this abstract sculpture almost a militant expression of sensitive but vigorous humanity.

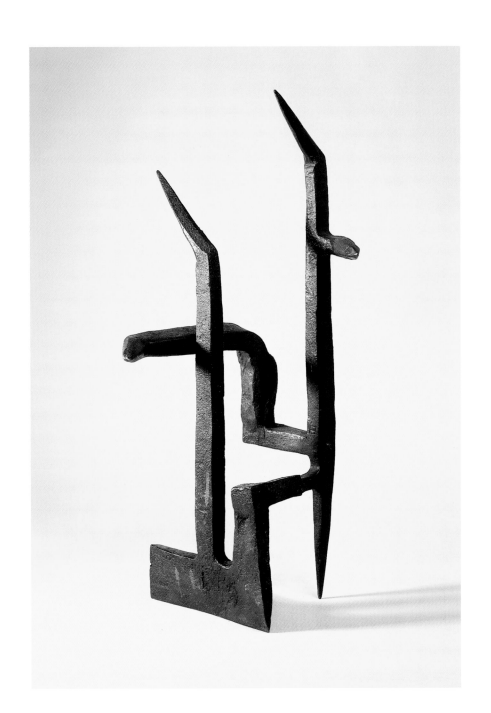

FRANCIS BACON

1909–1992

100

Study for portrait of Henrietta Moraes on red ground 1964

oil on canvas • 198 x 147.5 cm

reverse dated and titled "Study for Portrait of Henrietta Moraes"

This painting is one of a number of figural compositions made around 1964 which set the figure on a striped mattress against violently coloured fields. In the early sixties Bacon had returned to the use of strong colour after a period of grisaille paintings in the early fifties. His regular travels in Morocco between 1955 and 1961 may have had a part to play in this process. His great triptych *Three studies for a crucifixion*, 1962, marked the beginning of this series of works. The sculpted form of the figure in this composition is shown on a heraldic field of vivid red, similar to the field of blood which seems to surround the crucifixion images. It is a masterly reconciliation of flat colour and the volume of an isolated figure.

Henrietta Moraes was one of Bacon's intimate circle of friends who drank with him at the Colony Club in London's Soho district. Bacon nearly always painted those close to him and they did not seem to mind the violence that he did to their images. He was a generous friend and a stinging adversary. No doubt it was preferable to be gouged by his brush than to be lashed by his tongue. He painted Henrietta often. A year earlier he had shown her on the same bed with a hypodermic needle in her arm. She claims to have known nothing about drugs at that time. Bacon simply explained the appearance of the needle as a device to nail the figure down in the composition. He had no interest in its narrative possibilities. T.B.

216

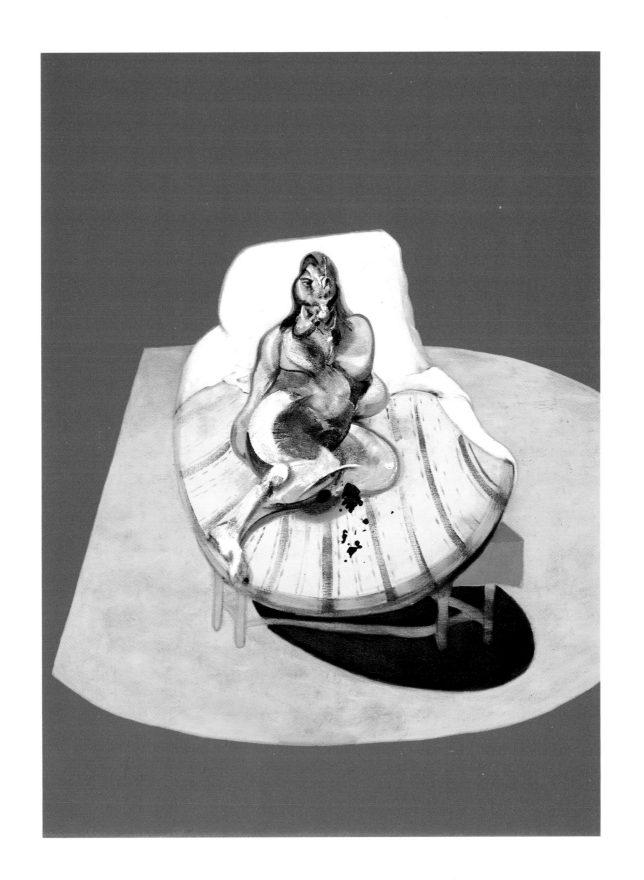

Francis Bacon

101

Portrait of George Dyer riding a bicycle 1966

oil on canvas • 198 x 147.5 cm
reverse dated and titled

Francis Bacon was born in Dublin of British parents in 1909, three years after Samuel Beckett, and a generation after James Joyce, born in 1882. These three artists possess a mutual courage in portraying the human physical existence without aesthetic or social camouflage. They dispassionately examine their subjects like pathologists performing an autopsy. This is the source of the extraordinary power of their works.

George Dyer appears in many of Bacon's paintings. When they became friends in 1964 both were at an advanced age and corresponding physical condition. After Dyer's death in

1971 Bacon visualised the personality and incarnation of his friend in several pictures and the series of black triptychs from 1972–74. As a painter of people Bacon portrays the opposite of what Giacometti expresses in the non-corporeal, weightless apparition of his figures. Bacon depicts specific individuals in his works. Here Dyer is recognisable by the profile with bent nose and edged chin. But Bacon's expressive style renders a condition which transcends the individual.

This "surgical" expression of the subject derives from diverse sources including the paintings of van Gogh, the cinema imagery of

Eisenstein and Buñuel, the chronophotography of Muybridge and Murrey and illustrations of wild animals. It is conveyed in the way that Bacon "manipulates the paint" with a cloth or his fingers or brush, as if he adds a glutinous mass of plasma over the existing composition. The *Portrait of George Dyer riding a bicycle* may have been initiated by a souvenir photograph, but the act of painting transforms the sportsman/subject into a medical specimen of vulnerable physical existence. Bacon expressed it well, "The greatest art always returns you to the vulnerability of the human situation."

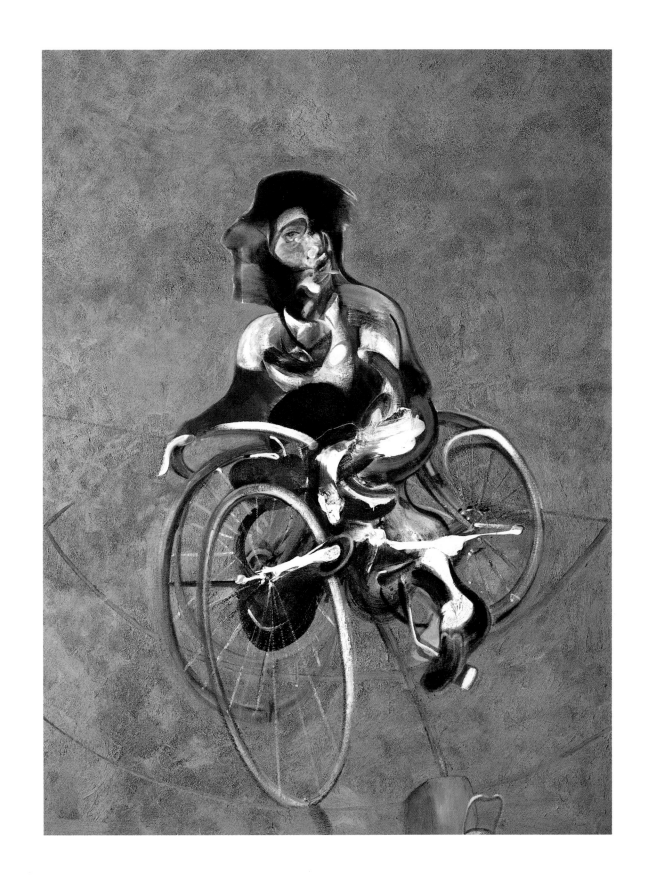

Francis Bacon

102
Lying figure 1969

oil on canvas • 198 x 147.5 cm
reverse signed, dated and titled

The image of a naked man lying on his back is immediately evident in the centre of this composition. He appears tormented, convulsive, with his legs up against a pillow. A wonderful piece of delicate colouring in pink, white and olive green creates a blatant representation of his corpulency. Yet all this seems subdued in comparison with the delirious, screaming head. This expression of torment transcends physical and spiritual suffering. The hypodermic needle in his right arm could be interpreted as a drug injection, but the artist points to a deeper meaning, "I put in the syringe because I want a nailing of the flesh onto the bed." Thereby the tortured man is a modern version of the suffering man nailed to the cross.

In an interview with writer David Sylvester, published in 1975, Bacon said that he thought of "...a hypodermic syringe as a form of nailing the image more strongly into reality or appearance. I don't put in the syringe because of the drug that's being injected but because it's less stupid than putting a nail through the arm, which would be even more melodramatic." The initial perception of the individual spectacle is diverted by the syringe to convey a sense of a vicarious perception of a generalised suffering which transcends the individual.

The scene is set in an environment of vulgar, modern designer furnishings such as the convertible sofa-bed. The furniture symbolises the emptiness in daily life, void of adventure. It depicts the alienation between nature and an environment of artificial light. But the significance lies in the mode of painting. The suffering body appears to have been created in a violent act of painting that "sets an accent" in the flat colouration of the interior. The circle of yellow light sharply contrasts with the blue furniture covering. The third primary colour, red, is on the wall to the left.

Typically in Bacon's work, the compositional idea derives from other imagery. In the 1987 Beyeler Gallery exhibition catalogue, *Francis Bacon. Retrospective*, German art historian Werner Schmalenbach outlines a connection between this work and Marcel Duchamp's *Chocolate mill* (Broyeuse de chocolat) of 1913. Duchamp's work deeply interested Bacon.

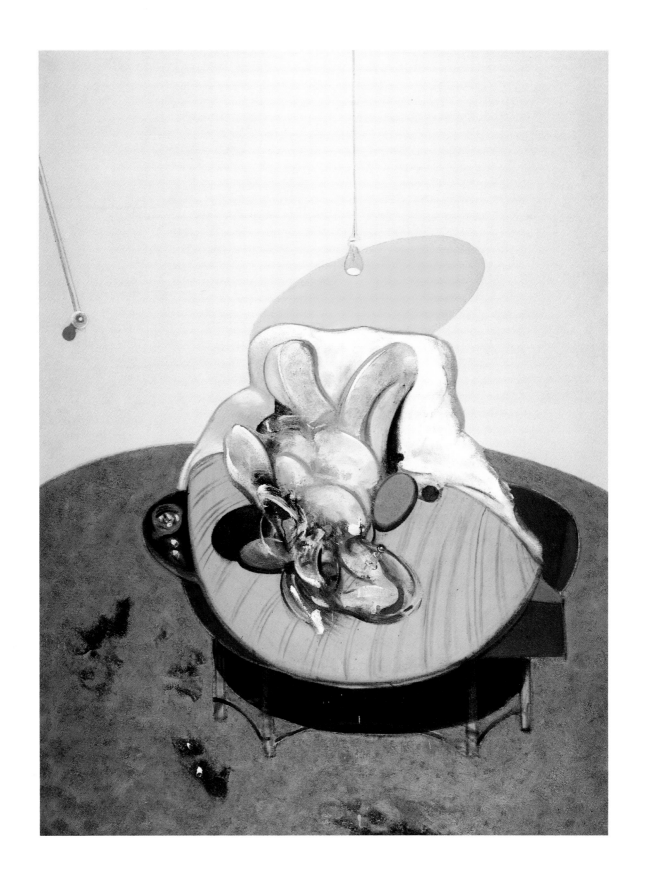

Francis Bacon

103
Sand dune 1983

oil and pastel on canvas • 198 x 147.5 cm
reverse signed, dated and titled

Francis Bacon's paintings are difficult in more than one respect. They are often unpleasant and their subjects are abstruse. They contain imagery of human vulnerability depicted by a wounded man. Bacon cites forms from movies and art history. The actual theme is rendered in a style so different and intense, that everything else appears like a stage setting on which Artaud's "théâtre de la cruauté" is played. They combine violent planar colouration with an extremely simple linear perspective with intersections which border on the sensational. The source of Bacon's art is his relentless search for the extremes of life and, his mastery of painting is the artistic justification.

Sand dune of 1983 summarises the preceding oeuvre of the seventy-four year-old artist in a visionary pictorial event. The title indicates a shore in wind and water. The blue of the stage-like background is reminiscent of sky. The small blue disk in the foreground refers to a water patch, the remains of an ebb tide. Phenomena of nature intrude in the "human" interior. But the structure and mode of painting transform the figural element into a creature stranded on a sand dune. It seems to refer to a human torso displayed like a piece of meat. The painted body lies in a artificial construction with surrealistic optical and material sensuality. But one cannot dismiss it as a dream image because real and physical suffering is potently expressed by the painted scars.

ANDY WARHOL

1928–1987

104
Joseph Beuys 1980

acrylic and silkscreen ink with diamond dust on primed canvas • 101.5 x 101.5 cm
reverse signed upper right and dated

Andy Warhol made a habit of associating with superstars, usually film stars or the glitterati of American high society, making them the subject of his art. Beuys was probably the most heroic figure in the art world in 1980 but he was a very different figure from Warhol's usual set. Beuys was surrounded by the mystique of the artist as shaman. He was venerated by a generation of European artists for his radical role in the Dusseldorf Academy and for his active participation in the environmental movement. He associated openly with members of the extreme left and preached that everyone had the responsibility to be an artist because art should be about shaping and healing the world.

Warhol was also a charismatic figure but his milieu was the demi-monde of sixties New York youth culture. He associated with Pop, with drag, with street culture and he advocated excess. In some ways the two men could be seen as direct opposites and yet when they met, there was an immediate connection. Beuys was most impressed by Warhol's disregard for convention and for the way he worked with a group of collaborators which he called *The Factory*. Fragmenting the institutions of art and engaging in communal activities was central to Beuys' project. Invoking the convergence of art and life was also common ground.

It would seem that the respect was reciprocated because this portrait of Beuys by Warhol is very different from most of the late paintings.

In truth very few of the late works were painted by Warhol himself, but came from the factory which was indeed a production line by that time. Many of the paintings employed crude colours with arbitrary overlaps as a parody of 1950s movie magazines with their displaced colour registrations. This portrait however is surprisingly romantic and hardly distorted at all. The only irony or excess came from the application of diamond dust to give the star his glitter. T.B.

List of works

Claude Monet

1
The Rouen cathedral: the portal (morning) 1894
La cathédrale de Rouen: le portail (effet du matin)
oil on canvas
106.5 x 73.5 cm
signed and dated lower left

Georges Seurat

2
Reclining man (study for *Bathing at Asnières*) 1883–84
L'homme couché, (étude pour Une baignade, Asnières)
conté-crayon on Ingres paper "Michallet"
24 x 31 cm

Paul Cézanne

3
Path leading from Mas Jolie to the Black Castle c. 1895–1900
Chemin du Mas Jolie au Château Noir
oil on canvas
79.5 x 64.5 cm

4
Seven bathers c. 1900
Sept baigneurs
oil on canvas
37.5 x 45.5 cm

5
Still life with cut watermelon c. 1900
Nature morte avec pastèque entamée
pencil and watercolour on paper
verso: unfinished watercolour sketch
31.5 x 47.5 cm

6
Road with trees on a slope c. 1904
Route avec arbres sur une pente
pencil and watercolour on paper
46.7 x 30.5 cm

Pablo Picasso

7
Woman (period of Demoiselles d'Avignon) 1907
Femme (époque des Demoiselles d'Avignon)
oil on canvas
119 x 93 cm
signed upper left

8
The mandolin player 1911
Mandoliniste
oil on canvas
97 x 70 cm
reverse signed

9
Head of a man (head with moustache) 1910 or 1912
Tête d'homme (tête moustachue)
charcoal on paper
64 x 48 cm
reverse signed and titled

10
Bottle on a table 1912
Bouteille sur une table
charcoal and cut-out newspaper on paper
60 x 45.5 cm
reverse signed upper left

11
Head of a woman 1921
Tête de femme
pastel on paper
63.5 x 48 cm
signed lower right

12
The wine bottle 1926
La bouteille de vin
oil on canvas
98.5 x 131 cm
signed and dated lower left

13
Musical instruments on a table 1926
Instruments de musique sur une table
oil on canvas
168 x 205 cm
signed lower left

14
Figure (seated woman) 1930
Figure (femme assise)
oil on wood
66 x 49 cm
signed and dated upper left

15
The rescue 1932
Le sauvetage
oil on canvas
130 x 97 cm
signed upper right and dated reverse

16
Sculpture of a head 1932
Sculpture d'une tête
charcoal on canvas
92 x 73 cm
signed lower right

17
Seated woman 1938
Femme assise
ink, gouache, and coloured chalk on paper
76.5 x 55 cm
signed lower right and dated "27.4.38"

18
Woman sitting in an armchair 1938
Femme assise dans une chaise
china ink on paper
65 x 50 cm
signed lower left, and dated "4.7.38"

19
Woman with a crown of flowers 1939
Femme à la couronne de fleurs
oil on canvas
54 x 32.5 cm
signed lower left and dated upper left

20
Head of a woman (Dora Maar) 1941
Tête de femme (Dora Maar)
bronze
80 x 40 x 55 cm
one of four unnumbered casts
casting stamp "Susse"

21
Painter and model 1953
Peintre et modèle
ink on paper
26 x 21 cm
signed upper left, and dated "Vallauris 24.12.53"

22
Woman with hat 1961
Femme au chapeau
metal cut-out, folded, and painted 1963
126 x 73 x 41 cm
reverse signed

23
Young woman with outstretched arms 1961
Petite femme au bras écartés
metal cut-out, folded and painted
36.2 x 34.5 x 13 cm

24
Head of a woman 1961
Tête de femme
metal cut-out, folded and painted
28 x 21 x 9.5 cm

25
Reclining woman playing with a cat 1964
Nu couché jouant avec un chat
oil on canvas
114 x 195 cm
signed upper right; dated reverse "10 et 11.5.64"

26
Vase with flowers on a table 1969
Vase de fleurs sur une table
oil on canvas
116 x 89 cm
reverse dated "18 octobre 1969"

27
Reclining nude and man with mask 1969
Nu couché et homme au masque
pencil on paper
50 x 65.5 cm
signed upper left and dated "5.9.69.II"

28
Profile of a woman 1969
Profil de femme
linocut, ink and crayon
75 x 62 cm
signed lower right and signed and inscribed lower left "for Hildy Beyeler 1 April 1970"

Georges Braque

29
Woman reading 1911
Femme lisant
oil on canvas
130 x 81 cm
reverse signed

30
Glass, bottle and journal 1912
Verre, bouteille et journal
charcoal and papier collé
48 x 62 cm
reverse signed

Fernand Léger

31
The railroad crossing 1912
Le passage à niveau
oil on canvas
93 x 81cm
signed and dated lower right; reverse signed, titled and dated

32
Woman in an armchair 1913
La femme au fauteuil
oil on canvas
130 x 197 cm

33
Still life with coloured cylinders 1913
Nature morte aux cylindres colorés
oil on canvas
90 x 72.5 cm
signed and dated lower right
verso: another painting with title, signed and dated 1914

34
Contrast of forms 1913
Contraste de formes
oil on canvas
81 x 65 cm
reverse signed and dated

35
Contrast of forms 1914
Contraste de formes
oil on canvas
61 x 50 cm
initialled and dated lower right

36
The clock 1918
L'horloge
oil on canvas
50.5 x 61.5 cm
signed lower right; originally
signed, titled and dated "mars
18" on the reverse (transferred
to a new support)

37
Still life 1924
Nature morte
oil on canvas
92 x 60 cm
signed and dated lower right

38
Leaves and fruits 1927
Feuilles et fruits
oil on canvas
65 x 54 cm
signed lower right; reverse
titled, signed and inscribed
"I:ETAT"

39
Still life with plaster mask
1927
*Nature morte au masque de
plâtre*
oil on canvas
89 x 130 cm
signed and dated lower right

40
**The two cyclists, mother and
child** 1951
*Les deux cyclistes, la mère et
l'enfant*
oil on canvas
162 x 114 cm
signed and dated lower right

Wassily Kandinsky

41
Fugue 1914
Fuga
oil on canvas
129.5 x 129.5 cm

Piet Mondrian

42
Composition 1, trees 1912–13
Composition 1, arbres
oil on canvas
85.5 x 75 cm
signed lower right; reverse
signed and inscribed on stretcher
"Compositie 1 P. Mondrian"

43
**Composition with blue and
yellow** 1932
Composition avec blue et jaune
oil on canvas
55.5 x 55.5 cm
monogram and date lower
right

Henri Matisse

44
Jeannette IV 1911
bronze
61.5 cm high
Cast no. 1/10
signature and numbered;
casting stamp "F. Costenoble"

45
**Garden at Issy, studio at
Clamart** c. 1917
Jardin à Issy, l'atelier à Clamart
oil on canvas
130 x 89 cm
signed lower left

46
**Seated young woman in
lattice dress** 1939
*Jeune femme assise en robe
de résille*
charcoal on paper
65 x 50 cm
signed and dated upper left
and lower right

47
**White algae on red and green
background** 1947
*Algue blanche sur fond rouge
et vert*
cut-outs of paper, gouache
on paper
52.5 x 40.5 cm
signed lower left

48
Interior with black fern 1948
Intérieur à la fougère noire
116 x 89 cm
oil on canvas
signed and dated lower centre
"Vence 1948"

49
Blue nude I 1952
Nu bleu I
106 x 78 cm
cut-outs of paper, gouache on
paper on canvas
signed and dated lower left

50
Blue nude, the frog 1952
Nu bleu, la grenouille
cut-outs of paper, gouache on
paper on canvas
141 x 134 cm
monogram lower right

Paul Klee

51
The chapel 1917
Die Kapelle
gouache on paper mounted on
cardboard
29.5 x 15 cm
signed upper left; on cardboard
titled, dated, and inscribed
"1917/127 Die Kapelle"

52
Tropical twilight 1921
Tropische Dämmerung
tempera on paper
33.5 x 23 cm
signed lower right

53
Just before the lightning flash
1923
Vor dem Blitz
watercolour
28 x 31.5 cm
signed upper left, dated lower
left and inscribed 1923 150

54
Possessed girl 1924
Besessenes Mädchen
oil and watercolour on paper
mounted on cardboard
43.2 x 29 cm
signed lower left on cardboard
dated lower left and inscribed
"1924 250/S CI"

55
Was fehlt ihm 1930
ink on paper on cardboard
55.5 x 34 cm
on cardboard titled and dated
lower centre and numbered AE8

56
Rising star 1931
Aufgehender Stern
oil on canvas
63 x 50 cm
signed upper right

57
After the flood 1936
Nach der Über-Schwemmung
gouache and watercolour on
paper mounted on cardboard
47.5 x 63 cm
signed upper left; on cardboard
titled, signed and inscribed
"1936 7"

58
Boats in the flood 1937
Boote in der Überflutung
coloured paste on brown paper
on cardboard
49.5 x 32.5 cm
signed lower left; inscribed on
cardboard "1937. V2"

59
Signs in yellow 1937
Zeichen in Gelb
pastel on cotton mounted on
burlap

83.5 x 50.3 cm
signed upper left; reverse titled,
dated and inscribed "1937 U10"

60
Halme 1938
coloured paste on paper
50 x 35 cm
signed lower right

61
A gate 1939
Ein Tor (T O R)
tempera on black primed Ingres
paper mounted on cardboard
31.8 x 14 cm
signed lower right; on cardboard
titled, dated lower left and
inscribed "1939 XX II ein T O R"

62
After glow 1939
Glüht nach
watercolour on paper on
cardboard
29.5 x 21 cm
signed lower right; on cardboard
dated and titled lower centre
and numbered "YY5"

63
O! these rumours! 1939
O! die Gerüchte!
tempera and oil on burlap
75.5 x 55 cm
signed upper right; titled, dated
and signed on stretcher and
inscribed "1939. CD 15"

64
Captive 1940
Gefangen
coloured paste on burlap
mounted on canvas
55 x 50 cm

65
Muddle fish 1940
Schlamm-Assel-Fisch
coloured paste and crayon on
paper mounted on cardboard
34 x 53.5 cm
signed lower right; on cardboard
titled, dated, and inscribed
"1940 G3"

66
**MUMOM sinks drunken into
a chair** 1940
*MUMOM sinkt trunken in den
Sessel*
black paste on paper mounted
on cardboard
29.5 x 21 cm
signed upper right; on cardboard
dated, titled and inscribed
"1940 H1"

Max Ernst

67
Snow flowers 1929
Fleurs de neige
oil on canvas
130 x 130 cm
signed lower right

68
Bird head 1934–35
Oiseau-tête
bronze (cast 1956, no. 9)
53 cm high

69
Humboldt current 1951/52
oil on canvas
35 x 60 cm
signed lower right
verso dedication: "To Peggy
for her 12th wedding/for her
12th of July/ affectionately/
from Max and Ben" [Margaret
[Peggy] and Ben Norris,
Honolulu]

70
Birth of a galaxy 1969
Naissance d'une galaxie
oil on canvas
92 x 73 cm
signed lower right; reverse
titled, signed and dated

Joan Miró

71
**Painting (the Fratellini
brothers)** 1927
*Peinture (personnage: les frères
Fratellini)*
oil on canvas
130 x 97.5 cm
signed and dated lower
centre; reverse signed and
dated

72
Composition (small universe)
1933
Composition (petit univers)
gouache on cardboard
39.7 x 31.5 cm
signed and dated lower right

73
Spanish dancer 1945
Danseuse espagnole
oil on canvas
146 x 114 cm
reverse signed, dated and titled

74
Sun's amorous embrace 1952
*L'etreinte du soleil à
l'amoureuse*
oil on canvas
22 x 16 cm
signed lower right; dated reverse

Jean Dubuffet

75
**[Francis] Ponge as will-o'-the-
wisp** 1947
Ponge feu follet noir
oil on canvas
130 x 97 cm
reverse originally signed, titled
and dated "23 juin 1947"

76
Lady's body–butcher's slab
1950
Corps de dame–pièce de boucherie
oil on canvas
116 x 89 cm
signed and dated lower centre;
reverse signed, dated and titled

77
The lost traveller 1950
Le voyageur égaré
oil on canvas
130 x 195 cm
signed and dated upper left;
reverse dated "21 ou 23 janvier 1950"

78
Extremely rich earth 1956
Le très riche sol
oil on assemblage of canvas
156 x 117 cm
signed and dated upper right
"décembre 1956"; reverse
titled, signed and dated

79
Bus at Montparnasse station
1961
Autobus Gare Montparnasse
gouache on paper
67 x 67 cm
signed and dated lower right

80
Virtual virtue 1963
Vertu virtuelle
oil on canvas
97 x 130 cm
signed and dated lower left

81
Car on a black road 1963
Automobile à la route noire
oil on canvas
195 x 150 cm
signed and dated lower right;
reverse titled, signed, and dated

Alberto Giacometti

82
Seated woman III 1946
Femme assise
bronze
76.7 cm high
Cast no. 2/6
signature and numbered; casting
stamp "Susse"

83
Walking man in the rain 1948
L'homme qui marche sous la pluie
bronze
47 cm high
Cast no. 1/6
signature and numbered

84
Sculptures 1950
pencil on paper
63 x 48 cm
signed lower right

85
The cage (first version) 1950
La cage (premier version)
bronze
91 x 36.5 x 34 cm

86
Interior in Stampa 1951
Intérieur à Stampa
pencil on paper
50 x 32.5 cm
signed and dated lower right

87
The street (street corner of
Rue Hippolyte-Maindron and
Rue du Moulin Vert) 1952
La rue
oil on canvas
73 x 54 cm
signed and dated lower right

88
Woman of Venice VIII 1956
Femme de Venise VIII
bronze
122.3 cm high
Cast no. 6/6
signature and numbered; casting
stamp "Susse"

89
Aika 1959
oil on canvas
92 x 73 cm
signed and dated lower right

90
Monumental head 1960
Grande tête
bronze
95 cm high
Cast no. 6/6
signature and numbered; casting
stamp "Susse"

91
Standing woman III 1960
Femme debout III
bronze
235 cm high
Cast no. 6/6
signature and numbered

92
Walking man II 1960
L'homme qui marche II
bronze
187 cm high
Cast no. 4/6
signature and numbered;
casting stamp "Susse"

93
Caroline 1961
oil on canvas
100 x 81 cm
signed and dated lower right

94
Isaku Yanaihara 1961
oil on canvas
100 x 81 cm
signed and dated lower right

95
Elie Lotar III (seated) 1965
Elie Lotar III (assis)
bronze
67 x 29 x 35 cm
Cast no. 8/8; signature and
numbered;
casting stamp "Susse"

Mark Tobey

96
Forest cathedral 1955
coloured paste on paper
52 x 38 cm
signed and dated lower right

97
White journey 1956
coloured paste on paper
113.5 x 89.5 cm
signed and dated lower right

98
Night flight 1958
coloured paste on paper on
cardboard
27 x 19 cm
signed and dated lower right

Eduardo Chillida

99
From the horizon 1956
Del horizonte
wrought iron
66.5 x 22 x 32 cm
monogram

Francis Bacon

100
Study for portrait of Henrietta
Moraes on red ground 1964
oil on canvas
198 x 147.5 cm
reverse dated and titled

101
Portrait of George Dyer
riding a bicycle 1966
oil on canvas
198 x 147.5 cm
reverse dated and titled

102
Lying figure 1969
oil on canvas
198 x 147.5 cm
reverse signed, dated and titled

103
Sand dune 1983
oil and pastel on canvas
198 x 147.5 cm
reverse signed, dated and titled

Andy Warhol

104
Joseph Beuys 1980
acrylic and silkscreen ink with
diamond dust on canvas
101.5 x 101.5 cm
reverse signed upper right
and dated

Galerie Beyeler
Publications

230

The Art Gallery of New South Wales Foundation
Founder & current Donors

Life Benefactors 1994–
News Limited

Founder Benefactors 1983–1994
Art Gallery Society of
New South Wales
Caltex Australia Pty. Ltd
Government of the State of
New South Wales
Vincent Fairfax Family Foundation
Mr C. Lloyd-Jones
News Limited
Mr & Mrs E.P.T. Simpson
Westfield Holdings Ltd
Westpac Banking Corporation

Benefactors 1994–
Westpac Banking Corporation

Governors 1994–
IBM Australia Limited
Mrs V.N. Kahlbetzer
Merrill Lynch Australia
Penelope & Harry Seidler AC OBE
Isaac & Susie Wakil
Anonymous

Fellows 1994–
Mrs Antoinette Albert
The Late Sir Howard & Lady Beale
Mrs N. Brink
Mr Ken Coles &
Mrs Rowena Danziger
Lady (Vincent) Fairfax OBE
Mr Ian E. Joye
Bernard & Barbara Leser
Y.D. Buchanan May
Reader's Digest (Australia) Pty Limited
Dr & Mrs S. Robertson
M.E. Saywell
Mr & Mrs G.M. Thorp
Transfield Holdings Pty Limited
Bret Walker S.C.
Peter Weiss Pty Ltd
Mr D.G. Wilson

Members 1994–
Mr Ross Adamson
Mr & Mrs J.H. Adair
Sir Alexis Albert
Felicity Atanaskovic
Mr P.H. Cary
Professor & Mrs Malcolm Coppleson
Vesta & Owen Davies
Brian and Philippa France
Mr N.H. Grace
John & Inge Grant
G. Green
Mr Neville Gruzman AM &
Mrs Gruzman
Ian V. Gzell QC
David & Monica Jackson
Mr & Mrs R.H. Kidd
Jeannette & Gordon King
Mr A.G. Legge
Jan McGovern
Megan Machin—in memory of
Joy & Harold Marchant
Mr F.I. Markovic
Mr & Mrs R. Mews
Mrs John Minter
Mr R.H. Minter
Morgan Stanley Australia Ltd
Mr & Mrs Barry Murphy
Mrs K. Packer
John & Faye Parker
Pechiney Pacific Pty Limited
Dr Philip & Dr Valmae Rundle
Lesley Pockley
Mr & Mrs M.T. Sandow
Lisa Simons
Jim & Alice Spigelman
Mr & Dr J. Strong
Max & Nola Tegel
The Hon. T.W. Waddell &
Mrs Thea Waddell OAM
Diana Walder OAM
Mr & Mrs W.D.T. Ward
Mr & Mrs Morris L. West